INTO THE NEST

INTIMATE VIEWS OF THE COURTING, PARENTING, AND
FAMILY LIVES OF FAMILIAR BIRDS

**LAURA ERICKSON
& MARIE READ**

DESIGN BY
EIGHT AND A HALF, BROOKLYN

Storey Publishing

The mission of Storey Publishing is to serve our customers by
publishing practical information that encourages
personal independence in harmony with the environment.

Edited by Deborah Burns

Cover and book design by Eight and a Half, Brooklyn

Indexed by Samantha Miller

© 2015 by Laura Erickson and Marie Read

COVER PHOTOGRAPHY BY

© Cornell Lab of Ornithology-Macaulay Library/
Deborah Arnatt (front), © Edward Rotberg (back,
top), © Dave Welling (back, bottom left),
© Sarah MacLean (back, bottom right), and © Steve
and Dave Maslowski (inside front)

AUTHOR PHOTOGRAPHS BY

© Peter Wrege (M.R.) and © Russell Erickson (L.E.)

INTERIOR PHOTOGRAPHY BY

© Marie Read, except for those credited on page 207

ILLUSTRATIONS BY

© Karin Spijker, Draw & Digit

Species shown on front cover:

Cedar Waxwing family

Back cover: top, Bald Eagle pair; bottom left,
Northern Cardinal pair; bottom right, Herring
Gull hatchlings

Inside front cover: Northern Cardinal eggs

Interior: page 1, Western Tanager; page 4, Red-
tailed Hawk family; page 25, American Crow;
page 26, Blue Jay fledglings

Storey Publishing
210 MASS MoCA Way
North Adams, MA 01247
www.storey.com

Printed in China by Printplus Ltd.
10 9 8 7 6 5 4 3 2 1

Library of Congress Cataloging-in-Publication Data

Erickson, Laura, 1951–
 Into the nest : intimate views of the courting, parenting, and family
 lives of familiar birds / by Laura Erickson and Marie Read.
 pages cm
 Includes index.
 ISBN 978-1-61212-229-8 (pbk. : alk. paper)
 ISBN 978-1-61212-230-4 (ebook) 1. Birds—Behavior. 2. Birds—Sexual
 behavior. 3. Familial
 behavior in animals. I. Read, Marie, 1950 – II. Title.
 QL698.3.E75 2015
 598.15—dc23

 2014033697

CONTENTS

PART ONE
THE FACTS
^{OF}BIRD LIFE

PART TWO
THE FAMILY LIVES
^{OF}SELECTED SPECIES

APPENDIX

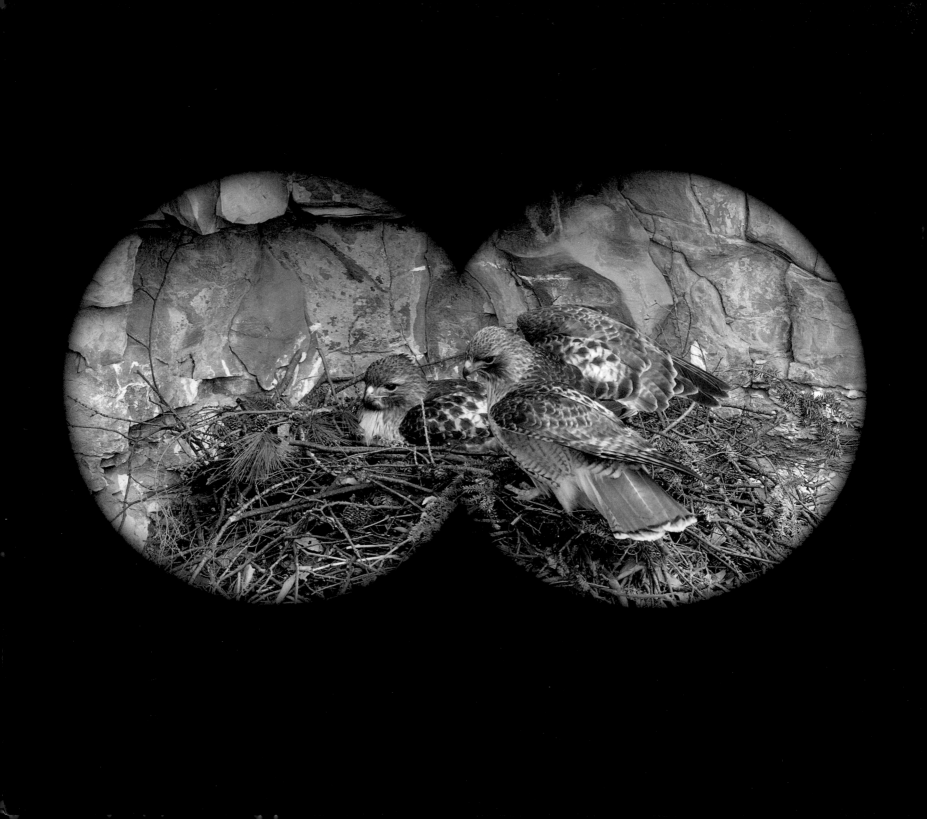

PART ONE

THE FACTS OF BIRD LIFE

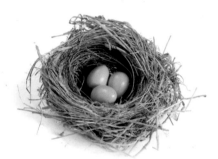

When parents teach their children the facts of life, they often refer to "the birds and the bees," even though birds and bees have entirely different equipment than mammals do and few people have the slightest idea how birds or bees actually "do it." This book aims to shed light on the family lives of birds, a topic that has captured our collective imagination and enriched our language despite being shrouded in mystery.

THE FACTS OF BIRD LIFE

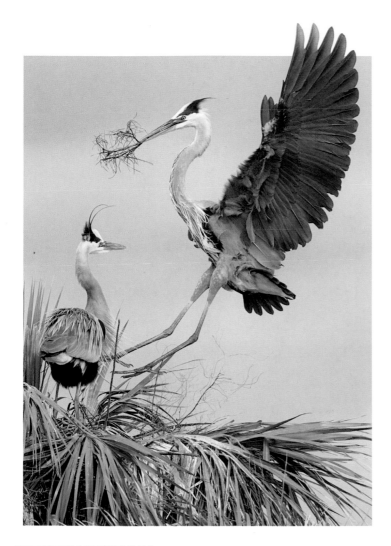

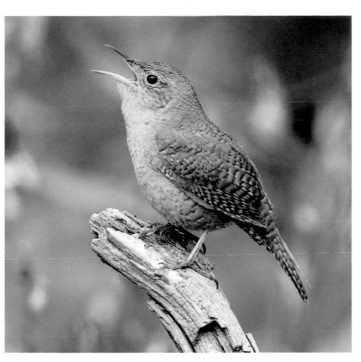

The processes of bird reproduction are so intertwined that it's difficult to separate them out. For example:

— *A male House Wren's territory and nest cavities are his primary ways to attract a mate.*

— *Herons include nest-building as part of courtship.*

— *Feeding a prospective mate during courtship helps prime an Evening Grosbeak to feed nestlings.*

— *Success or failure in rearing their young influences whether a pair of robins will stay together the following breeding season.*

This book focuses on the varying ways some familiar species conduct their family lives. Evolution provided each species with different strategies, but in every case the goal, to produce new birds to carry on the parents' genes, is the same.

DIVERSE LIFESTYLES

Every species has its own approach to every aspect of reproduction: finding mates, claiming and defending territories (or not claiming one at all), finding or building a nest or other structure in which to deposit eggs, protecting and incubating those eggs (or finding another bird to do it in certain cases), and feeding, protecting, and "educating" the young. In some species, the reproductive process can last a few weeks from start to finish; in others, it lasts for longer than a year.

COURTING AND MATING

Eastern Bluebird
pair

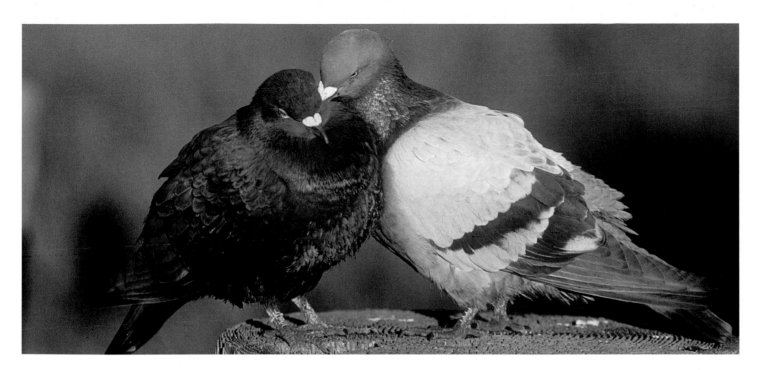

In many species, such as owls, parrots, and these Rock Pigeons, preening the mate is an important part of courtship. This behavior, called allopreening, can help strengthen the bond between the male and female and synchronize them physiologically for breeding.

Selecting the right mate is fundamental to a bird's success in keeping its genes alive. Gaudy plumage, healthy feathers, lively singing, and energetic courtship displays play a role in helping females identify the strongest, healthiest males and, in some species, the best potential co-parents. Females often don't display obvious (to human eyes) signals of fitness, but a female's responses to a male's advances help him see how healthy she is and how well she'll raise young.

MATE FIDELITY

The fittest male hummingbirds mate with several females. Producing sperm is simpler and less physically taxing than producing eggs, so males may be less concerned than females about the fitness of a potential partner.

In other species, monogamy (one male paired to one female) is the norm. Male crows, swans, and geese commit for life to one mate, and so are as motivated as females to select the fittest mate available. In many species where pairs mate for life, the plumage of both sexes is identical, at least to our eyes.

Far more species are serial monogamists. These birds pair for a single breeding season or raise one brood together and then find new mates to raise another brood that same season.

In the far north, where summer is brief, Bald Eagles must find a mate that will be physiologically synchronized with them almost as soon as they arrive on territory in spring. They must have enough time to produce fertile eggs and raise the young.

32 years, the oldest known wild Whooping Crane lived to be 28, and one Mourning Dove wearing a U.S. Fish and Wildlife Service leg band survived for more than 30 years. Even tiny birds can have surprisingly long lives: Black-capped Chickadees have lived longer than 11 years, and one miniscule Broad-tailed Hummingbird banded in Colorado was re-trapped, alive and healthy, 12 years later.

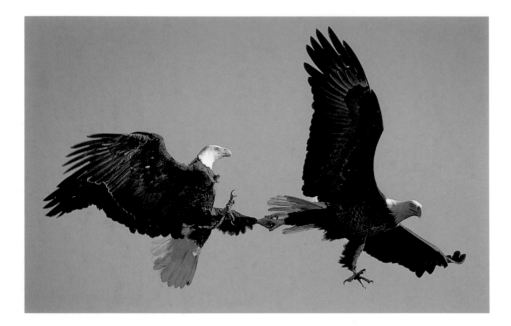

Sky dancing, performed here by a pair of Bald Eagles, is an essential aspect of courtship, synchronizing hormonal levels.

Rather than advertising a territory, as do wrens, robins, and blackbirds, birds of this species invest weeks, months, or even years in choosing a mate. Once they commit, they can count on that mate as long as they both survive. Those that remain together throughout winter start courtship behaviors during migration, so both birds will be ready for reproduction soon after they arrive.

Few eagle pairs remain together during winter, but both adults return faithfully to the same territory and nest every spring. Dramatic courtship flights and more practical behaviors, such as repairing the nest, help cement their bond and synchronize their hormonal levels. By returning to the same nest year after year, they don't need to rebuild from scratch.

PAIRING FOR LIFE

Whether birds mate for life depends partly on whether both can survive the winter and find each other the following breeding season. The oldest known wild Bald Eagle survived more than

SIZING UP A POTENTIAL PARTNER

Each species uses a unique repertoire of cues to evaluate potential mates. For example:

A MALE CHICKADEE THAT SINGS FREQUENTLY in midwinter demonstrates his ability to get everything he needs with time and energy to spare.

Northern Mockingbird

A MOCKINGBIRD WITH MANY MIMICKED SOUNDS in his repertoire proves he can learn well and has survived a wide variety of situations, and so should survive new challenges in the future.

A HUMMINGBIRD WITH POWERFUL AND PERSISTENT FLIGHT DISPLAYS is strong and focused. He won't help raise young, but if his mate nests near his territory, she benefits from his vigorous defense of nearby nectar-bearing flowers, reducing her time away from the nest.

A ROBIN OR BLACKBIRD'S HIGH-QUALITY TERRITORY is a good guarantee that chicks will thrive on rich food and shelter resources.

THE FACTS OF BIRD LIFE

American Crows seem steadfast: they mate for life and often stay year-round on the same territory. They also build a community, maintaining relations with their young and neighbors throughout their lives.

Despite their potential longevity, the overall mortality rate for many of these small birds is high, and most songbirds and hummingbirds cannot plan on their mate returning year after year. Some songbirds, such as American Crows and Florida Scrub-Jays, mate for life, often remaining on the same territory year-round. Only if their mate dies do they search for a replacement.

Pairs of many songbirds, such as robins, remain together throughout a whole nesting season, raising two or more broods of chicks. Either or both adults may return to the same or a nearby territory the following year, but neither seems to expect to see their previous mate again; birds of these species often select a new mate each year.

Some species form shorter bonds. A pair of House Wrens raises one batch of young until the chicks leave the nest. After that, one parent, often the female, moves to another territory with a new mate while the remaining parent, often the male, continues to feed and care for the still-dependent fledglings as he attracts a new mate. By splitting up like this, wrens may maximize the number of young produced by both over the course of the summer.

Some birds form very weak or brief attachments with mates. Many male ducks remain with their mates only until the females start incubating or until the eggs hatch. Male grouse and woodcocks display to attract as many females as they can. After mating, the females go off and nest without any assistance.

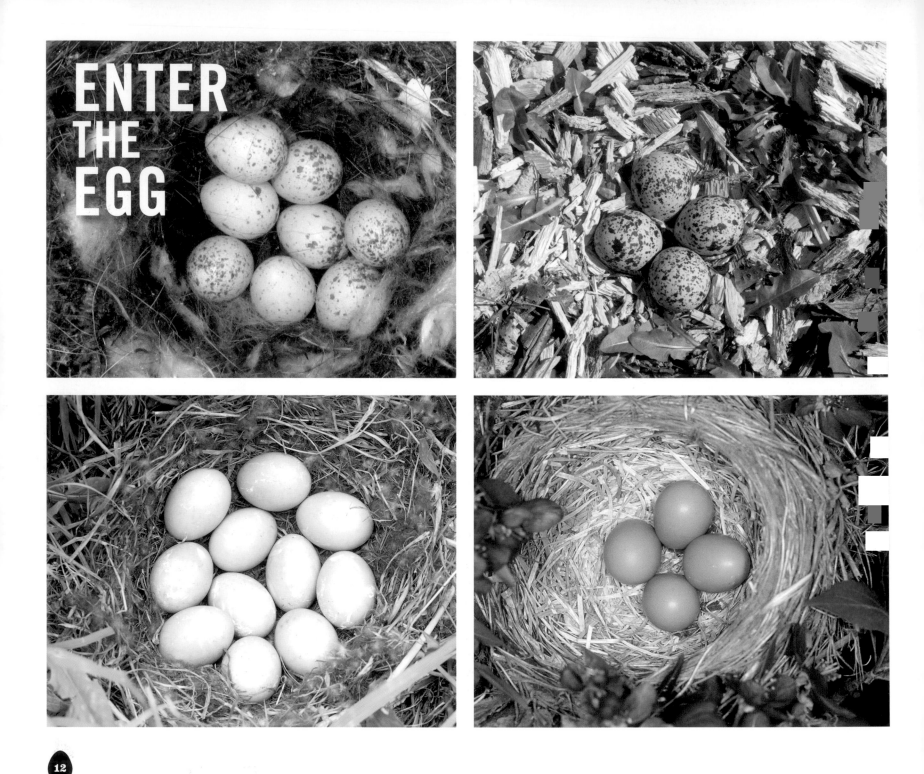

ENTER THE EGG

During most of the year, the sex organs of both male and female birds are excess baggage that would slow them down in flight, so except during breeding season, those organs shrink. Most female birds have one functional ovary which, during most of the year, resembles a tiny cluster of grapes. Each "grape" is an ovum, which may grow and develop, until by ovulation, it's an entire yolk: a huge, single cell that, if fertilized by sperm present before or very soon after ovulation, will turn into a chick.

EGGS DON'T COME CHEAP

With birds, ovulation always leads to production of an entire egg, which exacts a heavy physical toll on females whether it's fertilized or not. A female Ruddy Duck produces a clutch of eggs that, together, weigh more than she does. Unlike pet parakeets or domesticated chickens, wild birds can't afford to ovulate even once without a strong likelihood that the egg will be fertilized and develop into a healthy chick. Human females may ovulate monthly for years before becoming pregnant, but most birds have physiological adaptations that prevent ovulation until:

— the time of year is right so proper foods are available for their chicks;

— they have found a suitable territory that will provide all they need for constructing a nest and raising young;

— they have secured or constructed a safe location on that territory to deposit their clutch of eggs (usually a nest);

— they have found and mated with a suitable male who can contribute excellent genes to the young and perform the tasks necessary to raise young successfully.

Pairs usually start mating within days of the female's first ovulation. Sperm remain viable inside her body for days or weeks even at high body temperatures, so if a female loses her mate after mating, she may still produce fertile eggs.

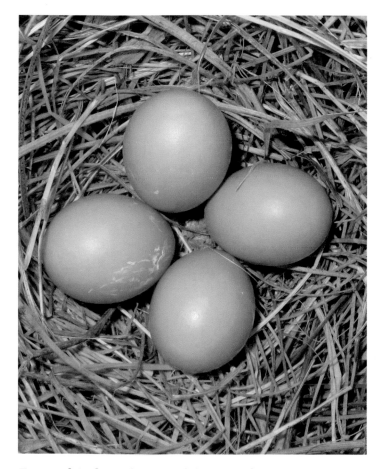

Every bird in the world, be it hummingbird or ostrich, penguin or condor, chickadee or turkey, has something in common: each emerged from an egg. And every one of those eggs started as a single-celled ovum (plural: ova) that popped out of the mother bird's ovary at ovulation.

OPPOSITE PAGE
A diversity of eggs, clockwise from top left: Black-capped Chickadee, Killdeer, American Robin, Mallard

LEFT
Eggs, like these of the Eastern Bluebird, look the same whether fertilized or not.

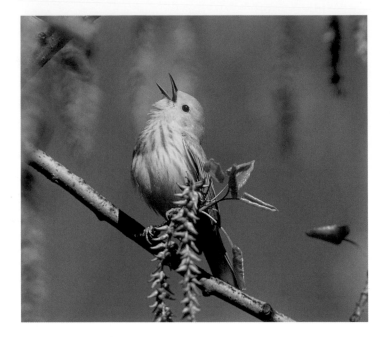

TRIGGERS

When female hormones kick in at the start of the breeding season, stimulated by environmental and behavioral triggers, a few ova start swelling. Increasing day length during late winter and spring is the most universal trigger. But ovulation usually waits until stimulated by key behaviors such as displaying, song duetting, presenting and accepting nest materials to and from a mate, and building the nest.

Depending on the species, courting behaviors may stimulate both male and female hormonal levels and synchronize the pair physiologically. This ensures that females will be producing eggs precisely when males are producing sperm to fertilize them, after the nest is ready to lay them in.

FAMILY SECRETS
DEADBEAT DAD?

Male hummingbirds are famous for not establishing a bond with their mates or visiting the nest and young, but they serve important functions that may contribute to the survival of their offspring. If a female nests near a strongly territorial male who tolerates her, he will chase other hummingbirds away from nectar-producing flowers but let her drink her fill, minimizing the time she spends off the nest.

Some male hummingbirds are so pugnacious that they dive-bomb Bald Eagles, but they often defer to females of their own species. These tiny birds are difficult to track individually by sight, so it's not certain whether males are more deferential to their own mates than to other females, nor how likely it is that hummingbirds return to the same territories or mates year after year.

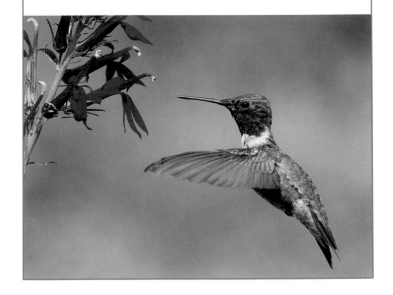

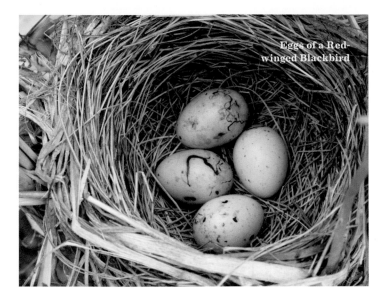

Eggs of a Red-winged Blackbird

OVUM TO EGG

We refer to the **ovum** as the "egg" in mammals, but with birds this is confusing, because a bird's egg includes much more than an ovum. If sperm reaches the upper part of the **oviduct** (the tubular passageway from the ovary to the outside of the body) as the ovum passes through, it may fertilize the egg.

Fertilized or not, the ovum gradually makes its way along the oviduct, whose walls first secrete **albumen** (egg white) and then the minerals that form the shell. Finally the finished egg reaches the **cloaca** — an expandable, multipurpose chamber in both males and females that provides an entrance into the oviduct for sperm (in females), and an exit from the body for eggs (in females), sperm (in males), and droppings (in both). This process is the same whether the female has mated or not, and the eggs she lays look the same whether they've been fertilized or not.

EGG-SPEDITION

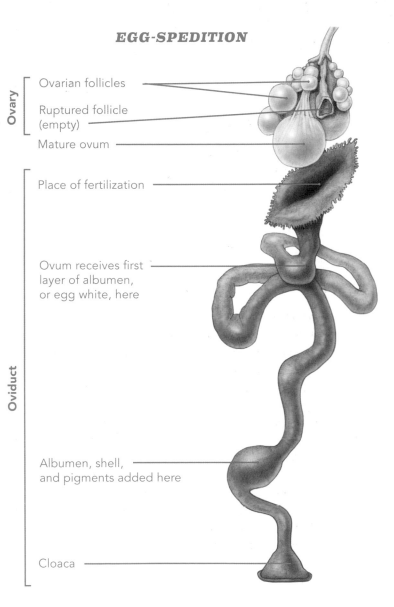

Ovary
- Ovarian follicles
- Ruptured follicle (empty)
- Mature ovum

Oviduct
- Place of fertilization
- Ovum receives first layer of albumen, or egg white, here
- Albumen, shell, and pigments added here
- Cloaca

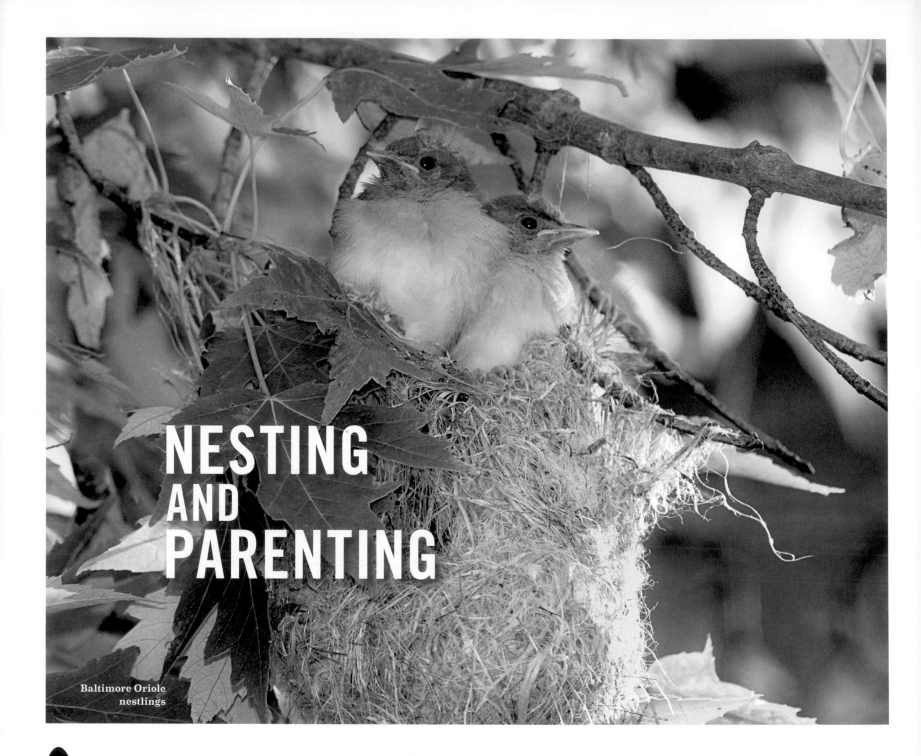

NESTING AND PARENTING

Baltimore Oriole
nestlings

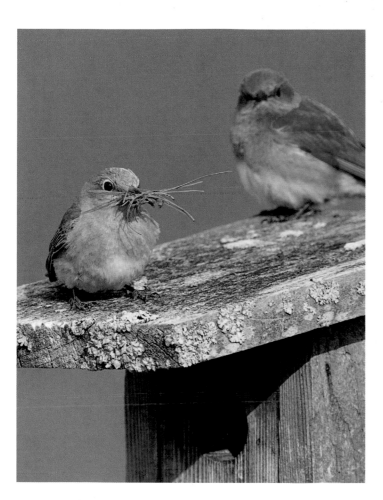

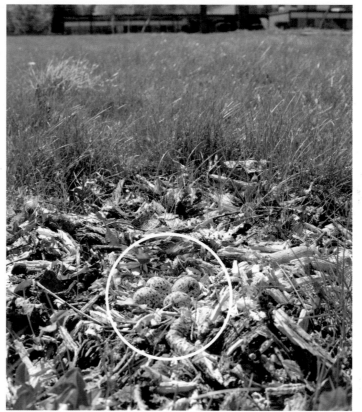

LEFT
A female Eastern Bluebird brings pine needles to weave into the nest (inside the nestbox) while her mate looks on.

RIGHT
Killdeer lay and incubate eggs right out in the open.

Before most female birds ovulate, they need a safe place to deposit and incubate their eggs until hatching. Depending on the species, nest-building can be the responsibility of the mother, both parents, or the father.

Some species make primitive nests, while others erect elaborate structures that can take weeks or months to complete. Some build no nest at all. A female Brown-headed Cowbird lays each of her many eggs in a different bird's nest, but first she does her research. She studies all the birds in her area, choosing nests to parasitize with parents that are likely to warm and protect her eggs until hatching.

The type of nest a bird constructs depends on many factors. Birds that produce precocial chicks often do not build as sturdy nests as birds producing altricial chicks (see box on page 22). Some species with precocial young, such as the Killdeer, make just a shallow scrape in sand, gravel, or dirt in which to lay the eggs. To protect against predators, they trust in the adults' distraction displays and the eggs' and adults' **cryptic** coloration (coloring that conceals or disguises them).

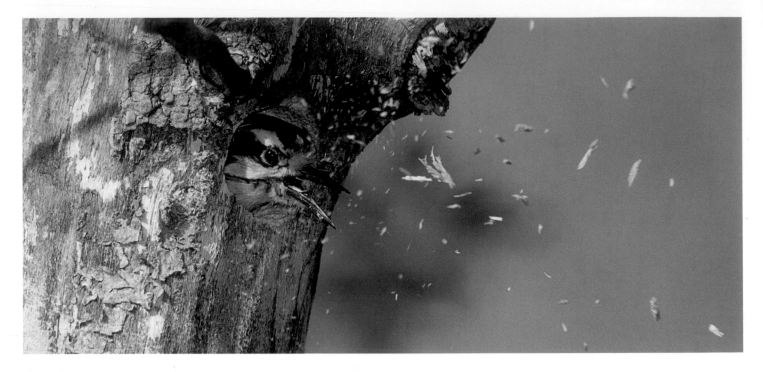

The hole this Downy Woodpecker excavates may later be adopted — and adapted — by a chickadee, bluebird, or swallow.

HOW TO BUILD A NEST

The shape and strength of a bird's bill and feet limit what kinds of materials it can gather and carry, and local habitats determine what nesting materials are available. In some species, birds produce some of their own nest materials, plucking loose belly feathers to line the nest.

The tiny hummingbird female works with lightweight materials that she can easily maneuver and manipulate. The nest must be very tight to hold in her body heat, yet it has to expand to hold her two nestlings as they grow to her size before fledging. She binds thistle down with stretchy spider silk, inserting bits of lichen and moss for sturdiness and camouflage. The nest enlarges during chickhood from an incubator to a crib to a "big kid bed" and will not be reused (except occasionally as a support platform) for a new brood.

Many birds build a new nest each year, and, like hummingbirds, some even build new nests for each of two or three broods in a single season. Nests can become breeding grounds for parasites and germs, and materials can degenerate with weather and nestling activity.

Bald Eagles and Great Blue Herons, on the other hand, repair and rebuild year after year, so their stick nest grows larger and heavier with time. To make it last a lifetime, eagles choose long-lived, sturdy trees such as white pines when they start from scratch.

Most birds with precocial young nest on the ground, so the chicks can easily see and follow the parents. Wood Ducks, mergansers, and some other waterfowl nest in large cavities and nest boxes high in trees. The female often lines the floor with soft down feathers plucked from her belly and breast.

LIFE IN A CAVITY

Woodpeckers excavate cavities for nesting, and also for nighttime roosting throughout the year. Chickadees may move into a birdhouse or small woodpecker cavity but often peck out their own cavity. That tiny chickadee bill packs a wallop!

WHO LIVES HERE?

Birders often identify nests by the construction materials. Inside a birdhouse, a nest lined with feathers (from gulls, chickens, or other larger birds) points to Tree Swallows. One built with bits of trash likely belongs to House Sparrows. A nest with lots of green moss, located on or in a building, was almost definitely built by an Eastern Phoebe.

A combination of nest materials and egg color can help identify many nests, but the simplest way to identify a nest in use is to wait patiently for the parents to arrive.

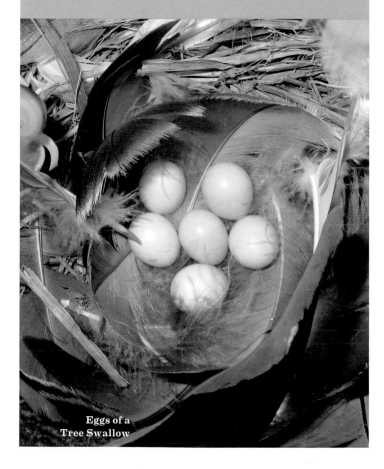

Eggs of a
Tree Swallow

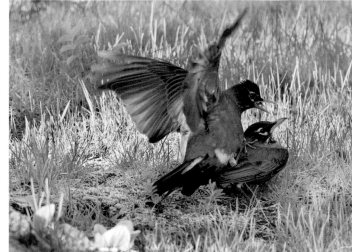

An American Robin pair copulates on the ground. Until the eggs are laid, the male stays close to the female and they copulate daily, often after the male's dawn singing. He may first perform a strutting courtship display around the female on the ground, flicking his wings and tail.

Some birds that nest within cavities, such as all three North American bluebird species, do not have the physical adaptations for excavating. Bluebirds tend to choose unoccupied cavities, while House Sparrows and European Starlings often appropriate ones in use, destroying the nest, killing the young, and sometimes even attacking the adults. Unlike woodpeckers, most of these birds build a nest within the cavity.

Kestrels and screech-owls also nest in cavities or nest boxes, without adding nesting materials.

HOW BIRDS MATE

Most birds copulate (mate) frequently before and during egg production, but few do so conspicuously, since they would be vulnerable to predation when not on their guard. Some, such as Great Blue Herons, mate on the nest during nest construction, because nest-building stimulates hormonal levels. Some waterfowl mate on the water; Chimney Swifts, occasionally, in the air. Bald Eagles don't mate during their dramatic midair courtship rituals (see pages 10 and 41); actual copulation takes place on solid ground or a sturdy branch.

During the nesting season, most females ovulate once every day or two, laying one egg 12 to 36 hours later, depending on the species.

In the act of mating, the male sits on the female's back, flapping his wings or gripping her feathers to keep his balance. She twists her tail upwards and he turns his tail toward hers so that their cloacas meet in what ornithologists romantically call the **cloacal kiss**. As that happens, millions of sperm enter her body and swim into the oviduct, working their way toward the ovary.

Sperm can survive in the oviduct for several days or even weeks. When one fertilizes an ovum, many of the remaining sperm may be pushed out by the descending egg, so birds tend to mate a few times a day while the female is producing eggs.

Many cavity nesters produce pure white eggs, which may help entering parents spot them in the darkness. Most other eggs are colored in ways that may hide them from potential predators.

Eggshell colors are usually produced by pigments secreted in the oviduct. These pigments, which may also strengthen the shell, usually come from the breakdown of normal body fluids such as bile and hemoglobin.

LAYING AND INCUBATING EGGS

During the nesting season most females ovulate once every day or two and lay an egg 12 to 36 hours later, depending on the species. Ovulation ends when the female has laid an entire clutch, whose number of eggs also varies by species. Some species produce many more eggs in years when food is plentiful than when it's scarce. Snowy Owls that lay only three or four eggs most years may produce up to eleven in a single clutch when food is abundant.

Females of some species are **determinate layers**: they'll produce a certain number of eggs and stop. For example, Mourning Doves always lay two eggs. If one is removed, the female won't replace it. Other species are **indeterminate layers**. The familiar barnyard chicken can produce eggs indefinitely if they're consistently removed.

If eggs are not removed, a hen will stop laying after her clutch numbers about twelve and will grow **broody**, meaning she'll start sitting on the eggs to incubate them. Many indeterminate layers with smaller broods (such as Northern Flickers) don't start incubating until they've completed the clutch, and if eggs are removed, they will continue laying until the nest contains the right number.

INSIDE THE EGG

Chicks don't develop very much within an egg until their temperature reaches 98 to 100°F (37 to 38°C). Maintaining that steady temperature is the purpose of incubation. Many nesting birds develop a bare patch of skin on the belly, called the **brood patch** or **incubation patch**, so they can press hot skin directly against the eggs or young without feathers blocking body heat.

THE FACTS OF BIRD LIFE

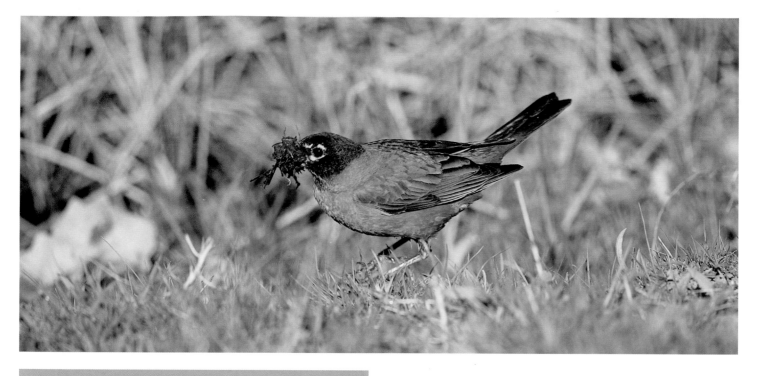

Some male American Robins help gather nesting materials, but the females do the actual building.

WHO'S MINDING THE NEST? PARENTAL ROLES

With hummingbirds, grouse, and many ducks, the female raises young without any help from the male after mating. Other birds divide responsibilities. Female robins build the nest (often using materials brought by the male) and incubate the eggs, but both parents feed and care for nestlings. The male robin takes primary responsibility for the fledglings as the female lays and then incubates the next clutch of eggs. Those eggs hatch just as the first fledglings have grown enough to go their own way, so the male can now help her raise the new brood.

See Part Two (page 27) for details on how different bird species divide up parenting duties.

Most birds' internal temperature is above 100°F (38°C), usually from 104 to 108°F (40 to 42°C) and sometimes even higher.

Within the egg, tiny cells divide around a small part of the surface of the yolk. The developing embryo is soon visible as distinct from the yolk, but remains attached at the abdomen to the **yolk sac**, from which the chick obtains all its nourishment inside the egg. The yolk sac is usually absorbed into the body just before the chick hatches.

The on-duty parent turns each egg several times a day. This keeps the eggs uniformly warm and moist and prevents deformities caused by the embryo settling against and sticking to the membrane lining the inner shell.

Many hummingbirds, owls, and hawks start incubating when they lay the first egg. That egg hatches a day or two before the second, which hatches a day or two before the third, so the oldest chick has a significant head start. In many other species, incubation starts with the final or the penultimate (second to last) egg. Eggs in those clutches hatch out within hours of each other, so the nestlings remain the same size.

HATCHING TIME

Within an egg, the growing chick's body fits perfectly in the tight space between the shrinking yolk and the shrinking albumen. Depending on the length of the bill and legs, and the relative size of the body and head, chicks of different species fit in different ways. A Great Blue Heron chick's head, for example, is bowed forward, and its bill, with a hard, rasp-like **egg tooth** on the tip, rests near its feet. Birds with shorter bills aren't bent so dramatically.

As hatching nears, a chick scrapes its egg tooth against the inner shell until it finally **pips**, that is, pushes out a little hole. At this point, many species peep persistently while squirming to slowly expand that pip into a crack.

It may take more than 24 hours for the crack to grow large enough for hatching. Often in one final push, the little hatchling straightens out, separating the shell into two or more fragments. The next step is to shake off any bits of shell. Then the little bird may take a long nap as any downy feathers dry before mustering the energy to straighten out, or even to stand up, in the case of precocial chicks. Freedom at last!

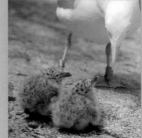

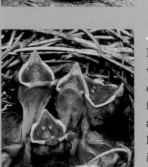

READY OR NOT

Precocial chicks, like these Herring Gulls, hatch with thick down and follow their parents away from the nest soon after hatching. They are referred to as chicks, rather than nestlings or fledglings.

Altricial chicks, like these Northern Cardinals, hatch with sparse feathers and closed eyes, and cannot leave the nest for at least a week or two. They are called *nestlings* before they leave the nest, and then *fledglings* while they are still dependent on their parents.

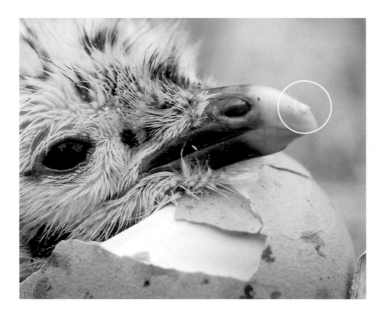

At the tip of the upper bill is the egg tooth — not a real tooth — which helped this hatchling gull break out of the egg. Within a few days, it is absorbed into the growing bill or it falls off.

MEALTIME

Different species have different ways of feeding their young. The two basic strategies relate to how developed the young are when they hatch.

ALTRICIAL CHICKS

Altricial chicks hatch with virtually no feathers and their eyes sealed shut, capable only of raising their heads and opening their mouths for feedings. Woodpeckers are an extreme example. Their eggs are smaller than eggs of similarly sized birds, and the chicks hatch with no down whatsoever and are exceptionally tiny and undeveloped. The incubation time must be as short as possible because while the adult is sitting tight on the eggs, there's very little air exchange deep inside the cavity and carbon dioxide levels are high. Once the eggs hatch, the frequent comings and goings of the parents feeding their young promote oxygen exchange.

THE FACTS OF BIRD LIFE

Songbirds, herons, hawks, owls, hummingbirds, and parrots also produce altricial young. Altricial nestlings are most uncoordinated when they first hatch, capable of only one or two specific movements. When they feel something alight on the nest, or sense a shadow cast over them, they bounce up with their mouths agape. After they swallow, many altricial chicks immediately back up, often wagging their tail or making other obvious movements, and poop. Doing this so quickly after swallowing ensures that a parent will still be present to clean up the mess.

Most altricial chicks have brightly colored mouth-linings (often called the **gape**) and most parents have a powerful instinct to shove food into those bright mouths. What they feed the nestlings depends on the species.

PRECOCIAL CHICKS

Everything an altricial chick eats must be found and carried by its parents to the nest. The situation is quite different for birds with precocial young.

These chicks hatch already covered with thick down. They open their eyes within minutes and can walk fairly well within hours. Because they develop more fully inside the egg than altricial chicks do, incubation takes much longer than with similarly sized altricial species. The incubating parent(s) are often cryptically colored, trusting to camouflage for protection during the lengthy incubation.

When the chicks hatch, they **imprint** on a parent (usually their mother), memorizing her features, and follow her to food and safe resting places. Ducklings, grouse, chickens, and many other precocial chicks pick up food morsels on their own; in cranes, gulls, and some others, the adults search for the items and pass them to their chicks beak to beak.

PRECOCIAL KINDERGARTEN

Precocial birds must learn one thing while they're still inside the nest — who their attending parent (usually their mother) is. As soon as they see and hear her, they imprint on her, and as soon as their down dries they follow her out into the big, wide world.

With every little waddling step they're learning: how to negotiate rocks and pitfalls; how to pick out bits of food and ignore stones and other non-edibles; how to recognize danger; and how to respond to each threat, whether it's hawks overhead, foxes creeping nearby, snakes, storms, wildfires, or thorns and barbed wire fences. Many baby birds succumb to such perils, but the ones that survive each encounter are more prepared for the next one.

Precocial chicks learn to socialize with others of their species, to interpret the different vocalizations and recognize sounds in their environment. They learn how to find the best places for eating, resting, hiding out, and bathing, and how to hunt for prey or locate other food sources.

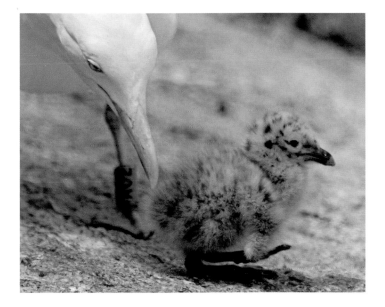

This 3-day-old semi-precocial Herring Gull chick is walking near the nest but still needs its parents to feed it.

This adult Great Blue Heron just caught this fish. It will swallow it head first. When it's caught a lot of fish, it will return to the nest to regurgitate the semi-digested fish to its young.

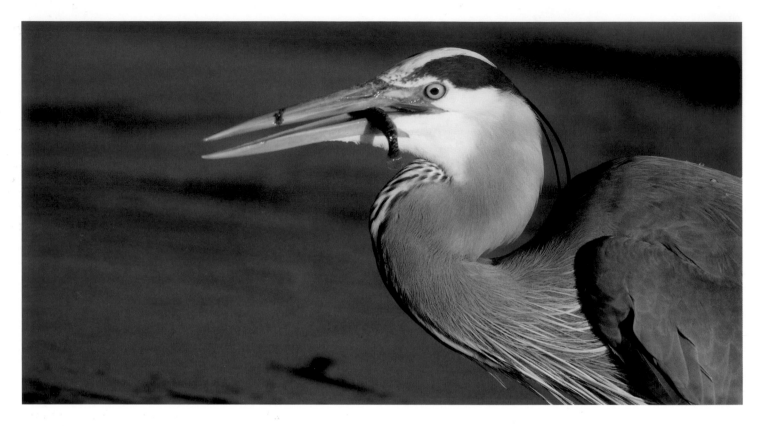

FEEDING STYLES

Feeding behaviors vary widely even among species that feed their chicks the same thing. For example, Bald Eagles grab their fish in powerful, grasping talons, or feet. They can easily carry even large fish a few miles to their nest. When an eagle delivers a fish to the nest, it rips off chunks with its sharp, curved bill to feed the chicks.

Herons cannot carry fish with their feet or bill. Instead, parents swallow as many fish as they can during a feeding bout, and then fly to the nest and regurgitate the catch. While nestlings are tiny, adults may hold the fish in their stomachs for up to a few hours before depositing them, so the meal will be like chunky baby food. Within a few days of hatching, the chicks start grabbing huge chunks, and the parents start regurgitating fish while they are still fresh and intact.

CHICK EDUCATION

When people "rescue" a baby bird and try to raise it themselves, they're making a tragic mistake. Parent birds give their young far more than food and protection from predators; they also provide an education. Baby birds, like children, go through critical stages of development, and suffer when deprived of the right kinds of stimulation at each stage. This is one of many reasons why it is illegal for unlicensed people to keep wild birds in the U.S. If you find a baby bird that is definitely orphaned or injured, you may be able to find a licensed rehabilitator via this website: www.owra.org/find-a-wildlife-rehabilitator.

LEARNING TO NAVIGATE

Fledglings (and even some nestlings) of night-migrating species pay attention to the night sky. Over time they memorize star patterns and learn that one star remains fixed. Polaris, the North Star, defines north for them. We know this because scientists have raised birds in planetariums, experimentally rotating the stars around Betelgeuse instead of Polaris. These chicks oriented using Betelgeuse as "north."

Many migrants also have tiny particles of magnetite in their brains, constituting an actual inner compass that comes in handy in clouds or fog. Their celestial navigation system, however, may be even more precise. People do no favors by "rescuing" baby migratory songbirds and keeping them indoors where they cannot absorb the lessons of the night sky. This is just one reason it's so important to return baby birds to their nest or bring them to a licensed wildlife rehabilitator.

ALTRICIAL INFANCY

Unlike the adventurous precocial chicks, altricial birds spend their critical first weeks inside the nest. Even before opening their eyes, they absorb some of their species' vocalizations and notice environmental sounds. After they open their eyes, they practice striking at and picking up objects. They study how the fibers composing their nest are woven together, and may start learning which environmental cues indicate danger. Once they leave the nest, virtually all altricial chicks remain with one or both parents for days or weeks (in some cases, months) as they hone other skills.

Young birds need varying degrees of instruction from their parents in how to survive on their own. Some, such as cranes, geese, and some swallows, migrate south with their parents and stay together the first winter. Others may separate just a day or two after fledging. Most young birds practice foraging for food for a while under their parents' protection, but eventually the family scatters. For most species, the longer young birds remain with their parents, learning all their parents can show them, the more likely they are to survive.

PARTING WAYS

In most altricial species, families break up a few weeks after the chicks fledge; in most precocial species, the chicks go their separate ways soon after they start flying. The vast majority of baby birds do not make it to their first birthday, but life expectancy rises dramatically for those that do make it to that benchmark. Survivors eventually start the entire cycle all over again. And so it goes.

THE FAMILY LIVES OF SELECTED SPECIES

More than 700 bird species breed in North America, and it was not easy to choose a reasonable number to profile. We aimed to include familiar birds with a variety of fascinating approaches to family life. From tiny hummingbirds to enormous herons and eagles, each species has unique constraints and abilities that determine how and where it can build its nest, find food, deliver it to the young, and educate the new generation. Some of the pleasure in studying birds comes from observing differences among species and pondering the reasons. The more you know about them, the more fun it will be to observe them on your own!

MALLARD

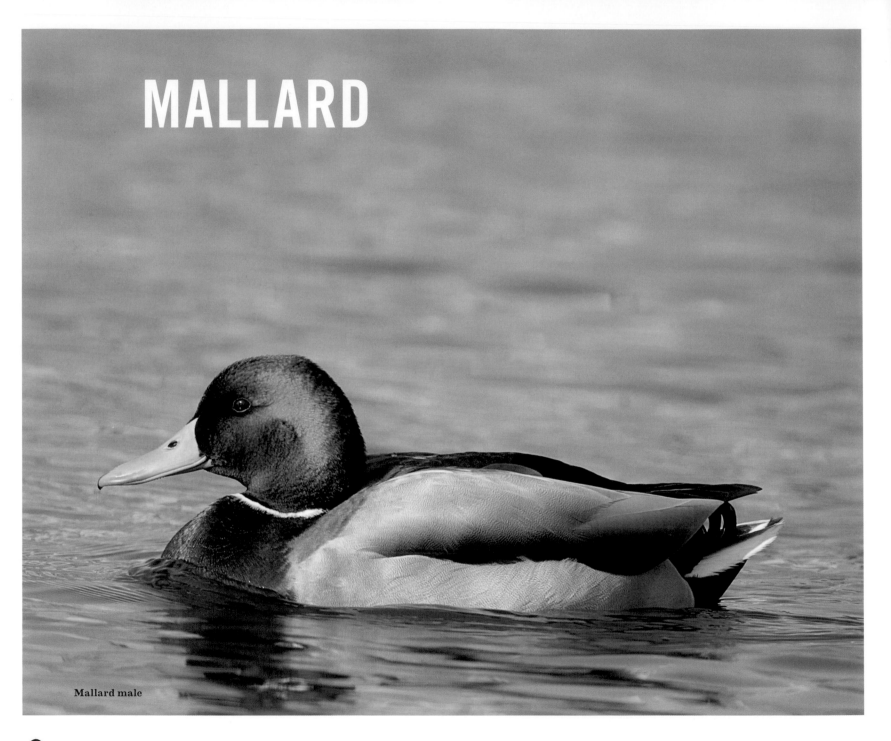

Mallard male

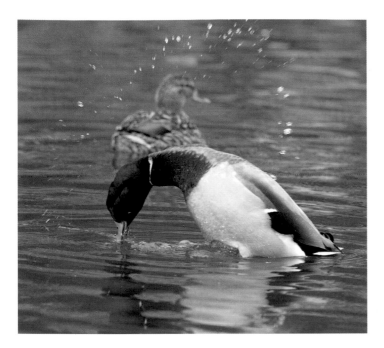

Mallards were one of the very first domesticated birds, in part because their bodies are large and their meat is tasty, but also because males are so geared up for mating that they are comparatively easy to breed in captivity. Wild Mallards readily mate with any farm ducks available. Urbanized ducks, which are somewhat larger than truly wild Mallards and bear a wider white neckband, have some domestic ancestors.

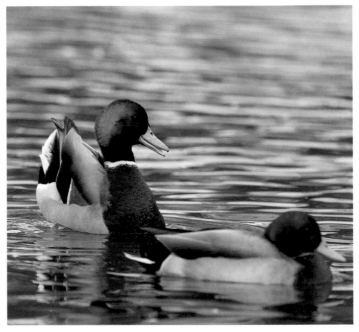

PAIRING UP

The *mall* in the word *Mallard* is derived from Old French, meaning masculine or male, and the *-ard* usually has a scornful connotation, as in *drunkard* or *sluggard*. Those who named them may have felt that Mallards epitomize the worst of masculinity.

Some unpaired males will force their attentions on any females they can; groups of males trying to mate with an undefended female may even drown her. And some males that successfully attract a mate also visit other females. In one study, blood tests on ducklings confirmed that about 48 percent of Mallard broods had more than one father.

During fall or early winter, a Mallard hen chooses her mate on their wintering grounds or her migratory route. Males (**drakes**) display to and sometimes even grab onto any and every female they can find. Each female seems to choose a mate based on the vigor of his displays and on his attentiveness: he'll be the one with the best genes, and the one most likely to protect her. He will follow her from their wintering grounds to where she hatched. When females choose wisely, the pairs seem fairly devoted during the weeks they're together.

LEFT
This drake is performing the grunt-whistle courtship display, lasting about a second. He dips his bill, arches his neck, and lifts his body almost out of the water. Suddenly he flips an arc of droplets into the air and whistles sharply before settling back into normal swimming posture with a deep grunt.

RIGHT
In the head-up-tail-up courtship display, the drake whistles loudly as he lifts his head, neck, and rump with tail feathers fanned. Finally he lifts his wings to show off the bright blue wing patch called the *speculum*.

TOP LEFT
Mallards usually display in groups. Here they are performing both the grunt-whistle and the head-up-tail-up display.

TOP RIGHT
The Mallard's quintessential *quack-quack-quack* is made by the female — often a series of two to ten quacks that start loud and get softer. During courtship, she may give a double quack.

BOTTOM
Like other ducks, Mallards mate on water, with the male clinging to the female's head or neck for balance. Most male birds have only a cloaca, but male ducks have a corkscrew-shaped penis that emerges during mating. Underwater, the male curves his tail down as the female curves hers up so that his penis can enter her cloaca and transfer sperm.

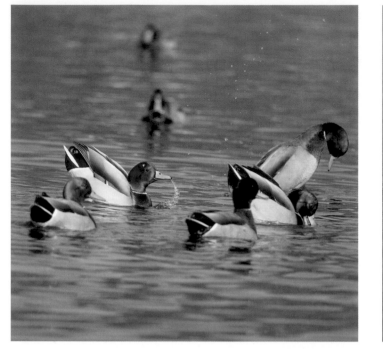

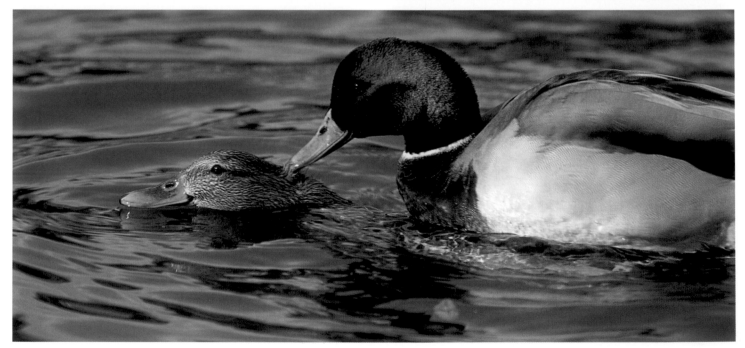

THE DRAKE'S PROGRESS

Mallard drakes generally stay bonded with their mate only through incubation. The female doesn't need the male for protection once she leaves the nest, and his gaudy plumage could attract predators. So males fly off to join other males; this is when they molt. Before shedding their flight feathers, they replace their brightest body feathers with drab ones. In this **eclipse plumage**, *they'll look like females for several weeks.*

NESTING

It takes the female Mallard as long as two weeks to produce her clutch. She sits on the nest for up to an hour every morning to lay one egg and then leaves for the day, covering the growing clutch with a downy blanket made from her own breast and belly feathers. This both camouflages them and protects them from extreme temperatures, rain, and drying out. Unless there's a hard freeze, the eggs stay healthy. Some Mallard eggs have successfully hatched even after the shell cracked from freezing.

PARENTING

The mother doesn't begin incubating until the clutch is complete and her body stops ovulating. The embryos start to develop when she maintains their termperature at 98 to 100°F (37 to 38°C). After about four weeks of steady incubation they will hatch.

Ducklings are precocial, hatching with a dense covering of downy feathers. The morning after they hatch, the whole family waddles off, never to return to the nest, so it's critical that all the young hatch on the same day. To synchronize hatching, the ducklings start vocalizing within their egg before they even **pip** (make the first hole in the shell), and the mother calls back to them. The eggs hatch in the order they were laid, all within a few hours. The mother broods them almost constantly during this vulnerable time, her warmth and the oils from her own feathers helping them to stay warm and to dry off quickly. They remain in the nest overnight and then leave it forever.

MALLARD MAYHEM

Sometimes two territorial Mallard drakes chase a paired female, twisting and turning at high speed as her actual mate tries to keep up. If the female can't escape, the pursuing males may force her to mate with them, on water or even on land.

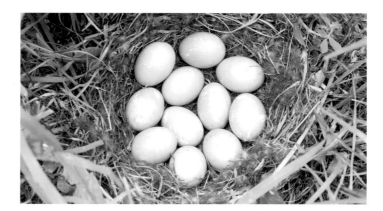

This nest, composed of grassy fibers and the mother duck's own feathers, contains 11 eggs. A typical clutch has 5 to 11 eggs, but some have as many as 13.

The mother's soft calls do more than help synchronize hatching — they help the baby ducks to **imprint** on her. When they leave the nest, they follow her wherever she goes. Imprinting in ducklings is critical not just in ensuring that they will stay close to their mother; it also gives the ducklings their sense of species identity. As adults, males are most attracted to birds that look just like their mother.

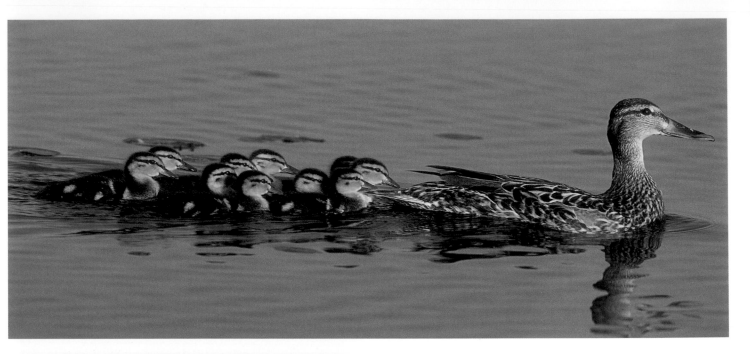

TOP
A Mallard hen leads her 10 newly hatched ducklings. They can walk and swim within hours of hatching, and these are able to follow their mother as far as two miles over land to reach water. They bunch up close to her for safety.

BOTTOM
These ducklings are less than two weeks old. They can maintain their body temperature now, so she can leave them for up to 30 minutes at a time. When she calls an alarm, they crowd around and beneath her, scurry to the water's edge, hide in thick vegetation, or freeze in place.

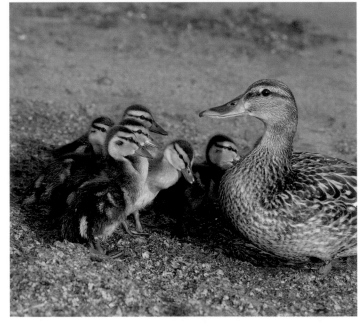

EARLY CHILDHOOD EDUCATION

Able to feed themselves, Mallard ducklings don't beg from their mothers. From the time they leave the nest, they peck at dark spots and small objects; the mother's job is to bring them to the best feeding areas and protect them. They find most of their food in water, so their mother first brings them to a pond or other small body of water with plenty of fish eggs, water bugs, and other high-protein foods. At around 25 days old, they'll add pondweeds and seeds to the menu.

Females molt after their young have hatched, when the mothers no longer need extra insulation. Ducklings can't fly for about two months anyway, and the mother must stay close to them, so it's an ideal time for her to shed her old flight feathers and grow new ones.

Even with the best maternal care, baby ducks are vulnerable to predation, which is why families usually contain many more tiny ducklings than larger ducklings. It's a shock to see a baby duck disappear right before our eyes, pulled

underwater from its family by a snapping turtle or predatory fish. Fortunately, ducks produce large clutches, so the species thrives despite predation.

Within a week after hatching, Mallard ducklings double their weight, and by the end of the second week, they've quadrupled it! Their thick down keeps their skin dry when they're swimming, but they get cold easily at first, so the mother broods them frequently during the first two weeks. By the time they're too big to crowd under her, they can regulate their own temperature. They remain downy for about 25 days, are fully feathered by around 46, and can fly after about 60.

Mother ducks are usually very attentive, but take occasional breaks. Sometimes a few mothers get together in what seems like the avian version of a coffee klatch, leaving two or more broods of ducklings together. Usually when the mothers return, the ducklings sort out into the right families, but in an emergency or if one mother is late in returning, some ducklings may end up joining, temporarily or permanently, another family.

FLIGHT PATH

The mother duck usually stays with her ducklings until they can fly. Their survival rate is higher the longer they remain with her.

By summer's end, Mallard families have dispersed. At this point, as they start associating in large flocks, adult males are already revved up for breeding, and females start choosing new mates all over again.

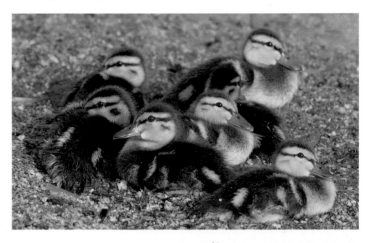

TOP
These duckings are resting, appropriately, in duckweed.

BOTTOM
This female Mallard is swimming with her growing ducklings. You can still see a bit of down through the young birds' feathers. This helps us estimate their age at somewhere between 25 and 46 days.

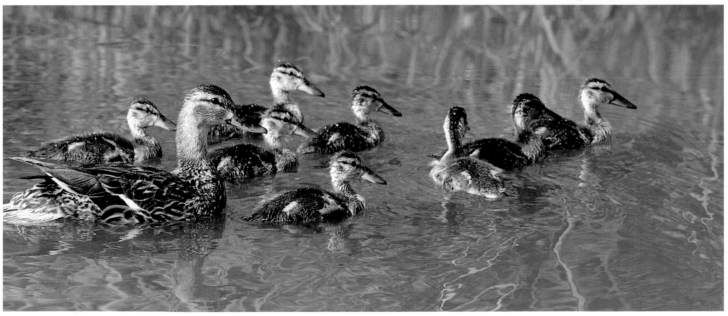

GREAT BLUE HERON

Great Blue Heron
adult

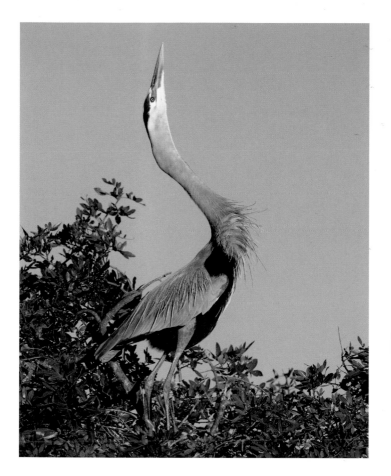

Flowers are a traditional, romantic gift for human lovers. Great Blue Herons would be more likely to say it with sticks (see page 7). The beautiful interplay between the romantic and the practical infuses their entire courtship.

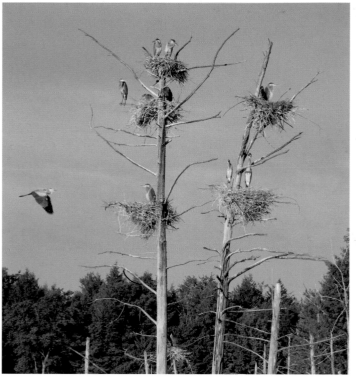

LEFT
A male performs the stretch display to potential mates passing his nest. Once a pair forms, the bird on the nest performs this display to its approaching mate, but not to other birds.

RIGHT
Great Blue Herons often nest in colonies called **heronries** or, less precisely, **rookeries**, which may consist of dozens or even hundreds of nests. They usually nest in trees but sometimes nest in bushes and mangroves or on the ground, Osprey nest platforms, channel markers, and other natural and human-made structures.

Great Blue Herons nest in trees, often at a distance from the best feeding grounds. Their nest must be fairly substantial to provide a safe platform for their eggs and then for the nestlings, which remain in the nest for seven to eight weeks and, as fledglings, return to it for feedings for a few weeks more.

PAIRING UP AND NESTING

Herons seem to prefer using nests built in previous years, adding sticks throughout the season. They use large sticks for the actual structure, laying tiny twigs, usually broken off from larger sticks, flat on the floor to close gaps that could entrap an egg or chick.

Both sexes work on the nest, though males bring most of the sticks and females do most of the construction. Several pairs may build nests in the same tree, though they defend the area immediately surrounding their own nests by raising their crests and jabbing at too-close birds with their bills.

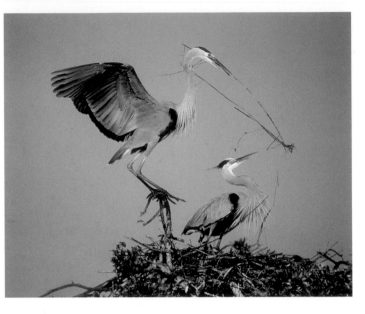

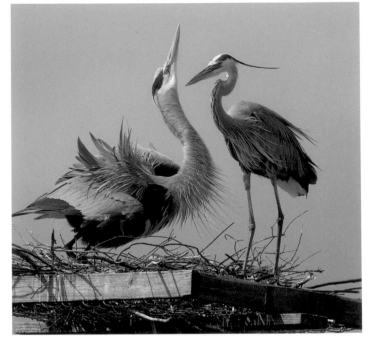

When a female is on the nest and the male flies in with a stick, she performs a **stretch display**, accepts the stick, and wedges it into the nest. The pair may also perform other elaborate displays together: raising and lowering specialized feathers called **nuptial plumes**, stretching necks upward, or clacking bills. These behaviors stimulate the hormonal levels of both birds to trigger ovulation and sperm production and maintain their bond.

The nest is never "finished" and the herons never stop adding on and improving it, but it is ready when the floor is secure enough that eggs won't fall through or get wedged. That seems to trigger the female's receptivity to mating.

> ## The nest is never "finished," and the herons never stop adding on and improving it.

At that point, she will accept a new stick from the male, add it to the nest, and then crouch, ready to mate. The male climbs on her back, balancing by holding on to her head, neck, or long nuptial plumes at the back of her head. Nearly all mating occurs on the nest after the exchange of one of those all-important sticks.

PARENTING

The female seems to struggle during egg-laying, arching her back and shuddering. When the male returns to the nest after she's laid the egg, he often flies off to bring more sticks. The pair mates frequently during the days around egg-laying. The female lays a new egg about every two days until her clutch of two to six eggs is complete. The parents take turns incubating, each usually on the nest for several hours at a time.

One early spring night a foot of snow fell in the Cornell Lab's Sapsucker Woods while a male heron was incubating. He remained on the nest all night except for once, when he stood up, shook the snow off his head and back, and peered all around. After seven or so minutes, he sank back down to incubate again. It stopped snowing in the morning, but snow remained in a circle around the eggs most of the day. The male sat steadily without being relieved by the female all day. Finally, in late afternoon, he flew off. People watching him via

the Cornell Lab's online nest cam feared that he was giving up, but less than a minute later he returned, and five minutes or so after that, his mate flew in from the same direction. She took over, he went off to finally have a bite to eat, and all the eggs hatched safely the following week.

Inside an egg, the growing chick's long bill has forced its head down; the bill's tip, with its raspy little egg tooth, rests near the bird's feet. When it's time to hatch, the chick scrapes the egg tooth against the inner shell until it finally pips, that is, pushes out a little hole in the shell. Calling or clacking its bill, it squirms as it works to expand that pip into a crack encircling one end of the egg.

It may take 24 hours for the crack to go almost all the way around, when the chick can finally push off that end of the shell. The bigger shell fragment may stay on the tiny hatchling's head for several minutes before it can wriggle out from it. Because of its shape and how it covers the hatchling's head, some people have nicknamed that piece of shell the "shellmet." If the chick can't get it off, a parent will finally pick it off and toss it away.

After hatching, the tiny chick may sleep for a while. A second chick may hatch that same day if the parents delayed incubation until the second egg was laid. Eventually, the parent that has been attending the nest stands in front of the chicks with his or her bill touching the nest floor in front of them. The chicks tap the beak, stimulating the adult to regurgitate a pile of pre-digested fish onto the nest floor.

When Great Blue Herons are catching fish, they swallow them where they catch them. The food goes down the

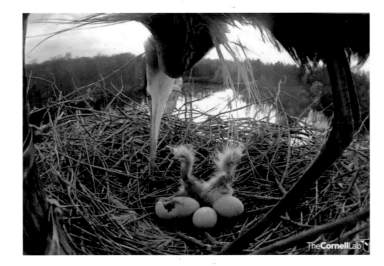

esophagus and enters the proventriculus, the upper chamber of their two-part stomach, where acids and other secretions start digesting the material. (The other chamber is called the gizzard. This muscular stomach helps squeeze the nourishing elements of the food into the intestines. Anything left over is spit up as a pellet; heron digestive juices break down most fish scales and bones.)

While chicks are tiny, the adults may wait a few hours after hunting before feeding them to allow the fish to soften before presenting them to the chicks. As the chicks grow, the parents give them more time to eat and start regurgitating fish that haven't been softened in their stomachs as long.

Two of the five eggs in this nest have hatched. A third young heron has pipped its egg and is now working on making a wide crack. When the crack is long enough, the chick can push off the smaller shell fragment with its feet to hatch. The parents feed the tiny chicks small, infrequent meals at this stage of development. Viewers watched this scene live on the Cornell Lab of Ornithology's website: AllAboutBirds.org/cams.

LEFT
These 2-week-old herons can sit up and look around. They're starting to pay attention to the world around them. Their plumage is still downy.

RIGHT
These half-grown Great Blue Heron nestlings tap their parent's bill, which stimulates the adult to regurgitate its stomach contents. A large, fairly undigested fish may fill a chick's stomach even as one end remains in its esophagus. This can immobilize the chick for many minutes as it digests the meal.

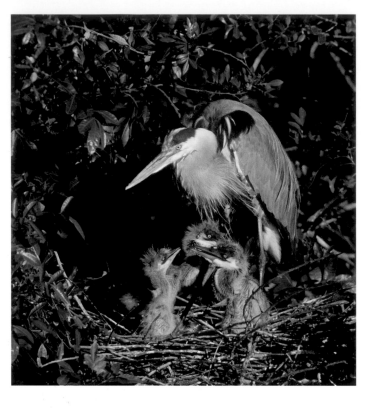

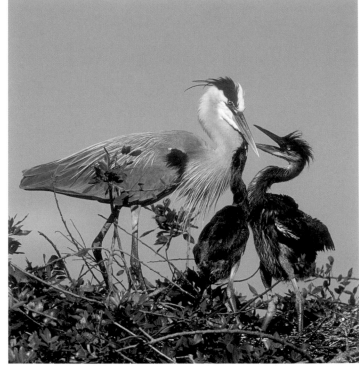

TABLE MANNERS

In a close study of one nesting pair, the parents nearly always deposited the food closest to the tiniest two chicks in a brood of five. The smallest, which hatched a few days after all the others, grew more slowly than the rest. Even though the largest chicks grabbed food voraciously and got the lion's share, the smallest became very quick at grabbing what it could. Hunting was good that season, and despite the significant size differences, all five chicks successfully fledged. Some researchers have reported aggression between nest mates, but **siblicide** is far rarer in Great Blue Herons than in some other herons and egrets.

FEEDING A GROWING FAMILY

By the time the chicks are a month or so old, the parents are regurgitating large, fully intact, almost fresh fish that the chicks swallow whole. Sometimes a long fish will fill a chick's stomach and esophagus, stretching its neck upright so it looks like a fuzzy bowling pin. After eating their fill, the chicks topple over in what Thanksgiving feasters might call a "food coma."

As the chicks grow larger and hungrier, the parents spend more time away. When a chick notices a parent returning, it clacks its beak, and soon the whole brood joins in. At hatching, the chicks' legs remain bent, so they can't venture to the edge of the nest. By the time they're three weeks old, they start walking around, their strong feet grabbing tight to sticks so even when near the edge, they virtually never fall out. Adult herons seldom feed chicks away from the nest.

FLIGHT PATH

Heron chicks start flapping their wings when a month old, and in another month can fly fairly well, even on their maiden voyage. The youngest siblings may be much slower to fledge than their elders. The young return for extra meals for weeks, but eventually develop their own fishing skills and become independent.

Some adult herons return to the same nest or colony year after year. One male, identifiable because he's missing one rear toe and one front claw, returned to his nest in Sapsucker Woods in upstate New York for five years; by the end of that season he'd successfully fledged 20 chicks. Studies of banded herons at colonies indicate that adults select new mates every year.

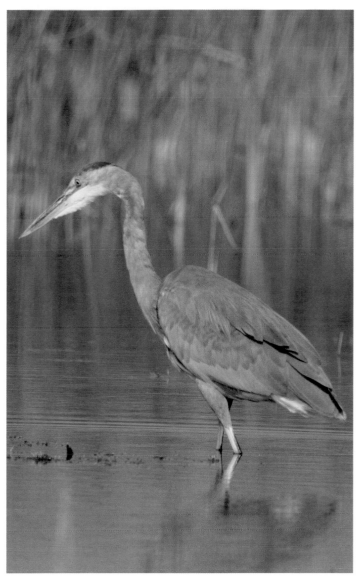

LEFT
As heron chicks approach full size and grow more coordinated, they often start grabbing at food before the adult can even spit it out.

RIGHT
After Great Blue Herons fledge, it takes time for them to perfect their fishing skills. During the first two months after leaving the nest, they strike at prey about as often as adults do, but successfully capture prey only half as often. For weeks they can rely on supplemental meals from their parents at the nest.

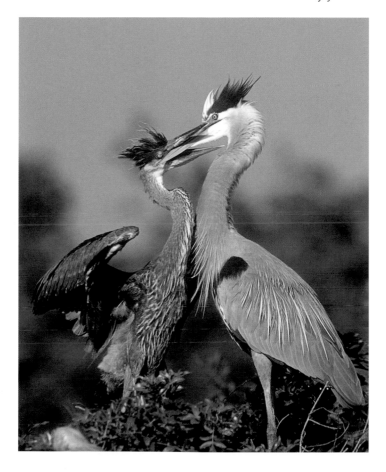

RED-TAILED HAWK,
BALD EAGLE,
AND
TURKEY VULTURE

Red-tailed Hawk
adult

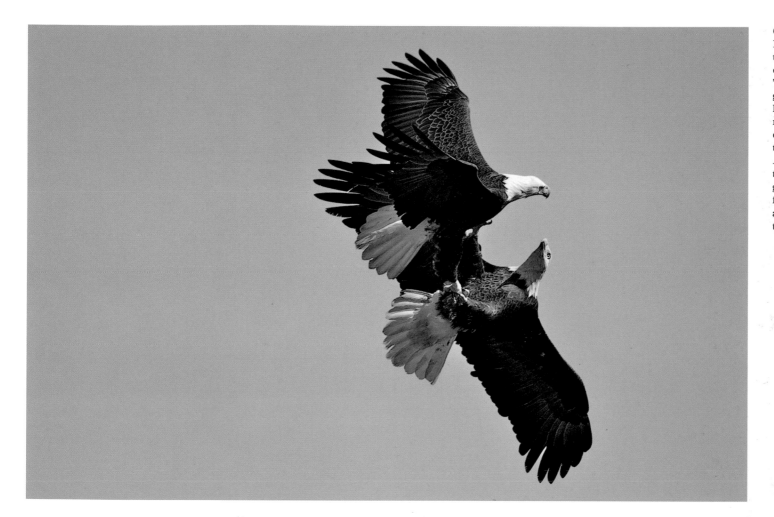

Courting Bald Eagles perform their dramatic cartwheel display. The birds soar to a great height, then lock talons and rapidly cartwheel or spiral together toward the ground. At the last minute, they release their grip, break away from each other, and swoop up into the air again.

Belonging to an order of day-active birds of prey, hawks, eagles, and vultures have sharp, "toothed" bills designed to tear animals apart. All but vultures are also armed with mighty talons designed to grab and carry prey. Despite these formidable weapons, birds in this group are extremely gentle and nurturing with their chicks.

PAIRING UP

To get close enough to mate, a male and female raptor must put themselves at the mercy of each other's sharp bill and talons without a second thought.

To ensure survival of the species, hawks and their relatives have complex courting behaviors that start at a safe distance. The birds steadily draw closer only as both clearly signal that they're focused on bonding and mating, not hunting. Displays include sharing sticks, working on the nest, vocalizations, and flight displays.

TOP
The Red-tailed
Hawks' dramatic
sky dance begins
with the courting
pair soaring
in wide circles
together at high
altitude. The male
performs a series
of steep roller
coaster–like dives
and climbs, then
slowly approaches
the female from
above, extending
his legs (as in this
photo); he then
touches or grasps
her briefly.

BOTTOM
Bald Eagle nests
are among the
largest of all birds'
nests, usually 5 to
6 feet in diameter
and 2 to 4 feet tall.
The nest may take
three months to
build, and is often
reused year after
year, with the birds
adding material so
the nest becomes
enormously bulky
and heavy.

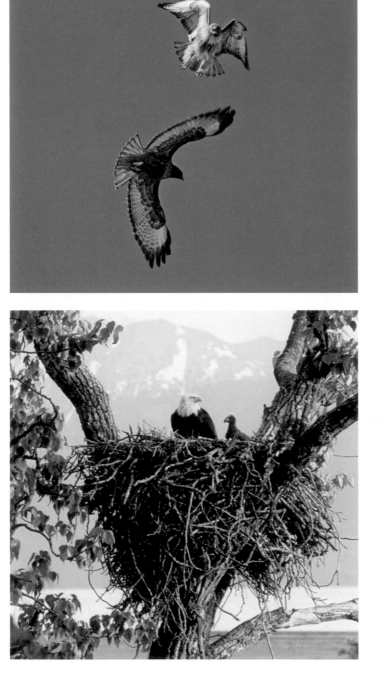

HIGH-FLYING COURTSHIP

As Bald Eagles increasingly commit to their mate, they perform spectacular sky dances with acrobatic flight displays and high-pitched screams. Once the pair is bonded and physiologically ready, they mate on the ground, a sturdy branch, or the nest.

Red-tailed Hawks have a thrilling flight display, too, males making a steep dive from great height, then shooting upward to do it all over again. Sometimes, the pair clasps one another's beaks or talons and then spirals rapidly toward the ground before letting go and pulling away. Piercing screams or rasping calls often accompany the sky dance.

Flight displays not only help synchronize a pair's hormonal levels and behavioral repertoire, but also assure each bird that its mate is completely trustworthy. Red-tails mate for life, but if one of the pair dies the other quickly finds a new partner.

NESTING

Diurnal raptors choose a nest site with a good view of the surrounding landscape and open access from above. Rural red-tails build their nests in the tops of tall trees in mature forests, often near open country with agricultural areas, or on cliff ledges in areas where trees are scarce. In Arizona, they nest in tall saguaro cacti. Urban and suburban red-tails nest on a wide variety of artificial structures, including buildings, window ledges, utility line towers, stadium lighting pylons, windmills, and billboards.

Hawks build their nests from sticks picked up from the ground or broken-off trees. Some species work sprigs of fresh greenery onto the nest to repel parasites or other pests or to signal to competitors, when the nest is unoccupied, that it is owned and currently defended.

Unlike hawks' talons, vultures' feet are not designed for carrying. Since these birds lay their eggs on the ground inside caves, under fallen logs, or in other large, protected crevices, they don't need to carry nesting materials. Neither do they carry carcasses, since they feed on decaying meat on the ground where they find it, and then regurgitate it to feed their young.

PARENTING

These three diurnal raptors incubate for four or five weeks, starting with the first egg laid. That chick hatches first and grows for one to three days before the second hatches.

In nests with three chicks, the third rarely lives long enough to fledge because when it hatches, the older ones are already big and assertive. Hawks and eagles peck at smaller siblings. In lean times, older chicks may kill and even eat smaller ones, but when food is abundant, all three chicks may survive.

Eagle and hawk parents bite off tiny chunks of meat to feed the fluffy little nestlings, and as the chicks grow, they receive bigger scraps. Vultures consume decaying carcasses and then regurgitate them to feed their young. The chicks gobble the glop like the delectable baby food that it is to their palates.

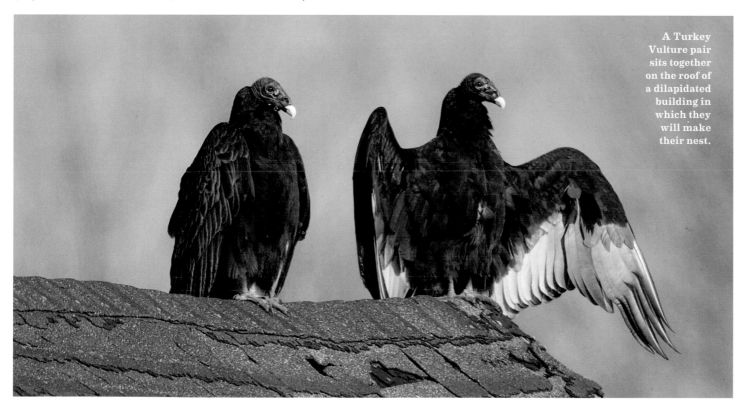

A Turkey Vulture pair sits together on the roof of a dilapidated building in which they will make their nest.

RED-TAILED HAWK, BALD EAGLE, AND TURKEY VULTURE

A Red-tailed Hawk feeds two small, downy nestlings in their nest on a fire escape overlooking a park in the Bronx, New York. The young hatch covered with white down and with their eyes open. They are weak and helpless at first but soon can bob up and down, waving their wings and peeping excitedly when expecting to be fed.

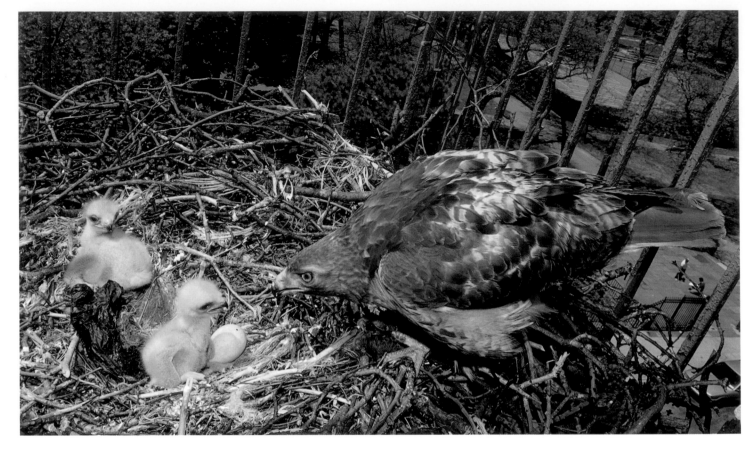

FLIGHT PATH

Since female hawks are larger than males, they often take longer to fledge. Birds of prey need time and a lot of practice to get good at hunting. Juvenile red-tails stay with their parents for up to ten weeks after fledging, sometimes much longer where they are year-round residents.

Red-tailed Hawks consume a wide range of prey, from snakes to fairly large birds and mammals. Fledglings may be awkward hunters at first, but they learn fast. By mid-summer when they fledge, they can practice on abundant and inexperienced prey animals, such as baby rabbits.

Since Turkey Vultures eat carrion, they don't have to worry about pursuing and killing prey. Young birds observe what adult vultures are doing, follow them to carcasses, and, little by little, learn the sights and smells that will help them detect dead animals on their own.

Bald Eagle young learn to pick up and feed on dead and dying fish floating on the water before they start catching live fish. Eagles also feed on carrion and soon learn how to find these meals with their keen eyes.

Eventually the young go their separate ways. Some researchers believe vultures mate for life, though it's not known for sure. Bald Eagles may or may not wander south with their mates in winter, but they faithfully return to the same nest and mate as long as they both live. Non-migratory Red-tailed Hawks seem to mate for life, but it's not certain whether migratory ones do.

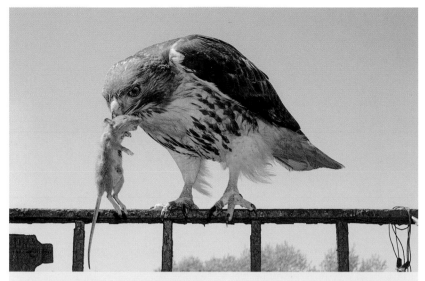

LUNCH IS SERVED. The female Red-tailed Hawk delivers a freshly killed rat to her nest on a Bronx fire escape. Urban red-tails make a good living dining on pigeons, rats, squirrels, and other small mammals found in cities, and thus play an important role in pest control.

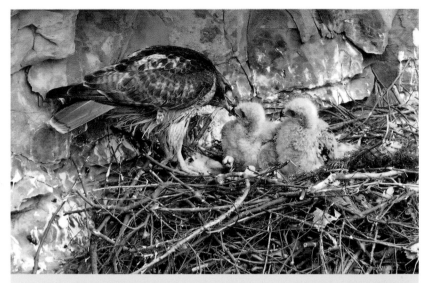

DIRECT DELIVERY. The female feeds her half-grown chicks at the nest. Feathers, still partly enclosed in sheaths, are visible on the wings. For the first four to five weeks, she tears apart and offers the prey (here, a chipmunk) piece by piece to the nestlings.

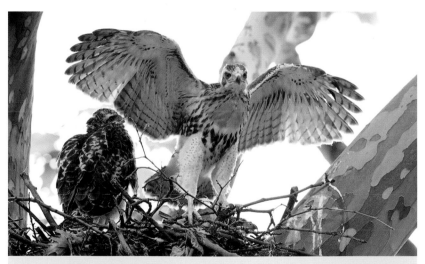

FLIGHT PRACTICE. By about 30 days of age, young red-tails regularly stretch and exercise their wings, even jumping up and down and flapping vigorously as if about to take flight. They leave the nest at 42 to 46 days old, but usually remain nearby, taking only short flights to follow their parents, begging for food. It may be two more weeks before they fly strongly.

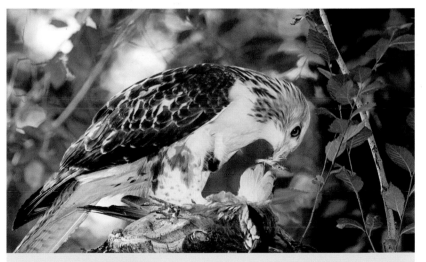

HUNTING SUCCESS. A juvenile Red-tailed Hawk feeds on a Rock Pigeon. The young hawk makes its first hunting forays about four weeks after fledging, but it continues to get the majority of its food from its parents for about a month, until it is finally hunting successfully.

KILLDEER

Killdeer adult

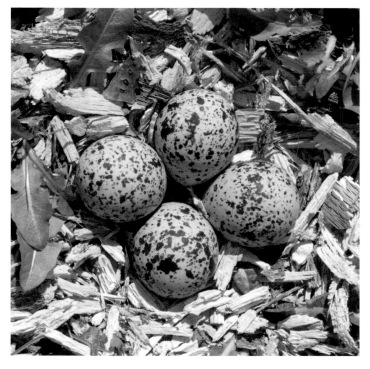

Eggs and tiny chicks are always vulnerable, but none seem more defenseless to our eyes than those out in the open on the ground, with no sheltering nest or nearby vegetation to protect them. Yet ground-nesting birds have strategies to overcome many of the dangers. Killdeer have so successfully adapted to modern farms, towns, and cities that they're probably more common today than when Columbus landed.

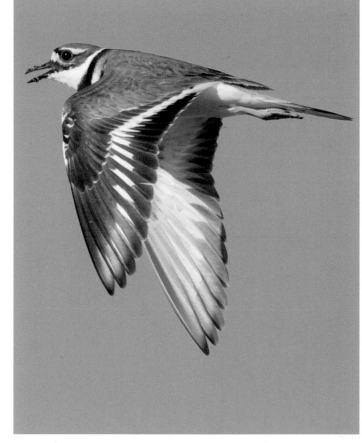

Killdeer are fairly tolerant of people. Before urbanization, they were most often found on mudflats, short-grass prairies and meadows, and spits of land jutting into waterways, but they now also frequent construction sites, gravel roads and driveways, rock-ballasted rooftops, lawns, pastures, golf courses, and sporting fields. They usually lay their eggs on bare ground where they'll be camouflaged against soil and gravel.

PAIRING UP AND NESTING

Unattached migratory Killdeer form pair bonds on their nesting grounds when they arrive in spring. Mated pairs from the previous year sometimes winter together (especially in the South, in non-migratory populations) and arrive together at their nesting site.

LEFT
To make its nest scrape, a Killdeer squats and shoves backwards with one foot after the other, creating a shallow circular depression. The male starts a number of scrapes, usually in slightly higher spots than the surroundings; the pair selects one for the nest.

RIGHT
During the scrape ceremony the male Killdeer trills to invite the female to inspect the scrape he made. He bows, tail spread, as she approaches and settles onto the scrape. Then he picks up small stones and tosses them over his shoulder. The pair changes places, repeats the sequence (sometimes many times), and then copulates.

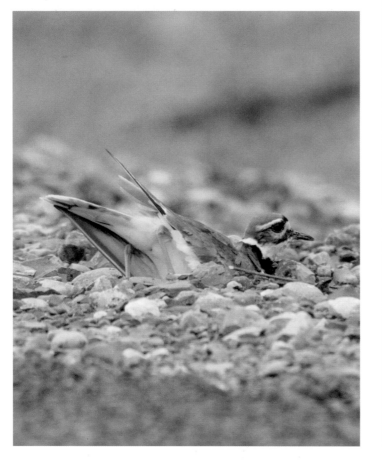

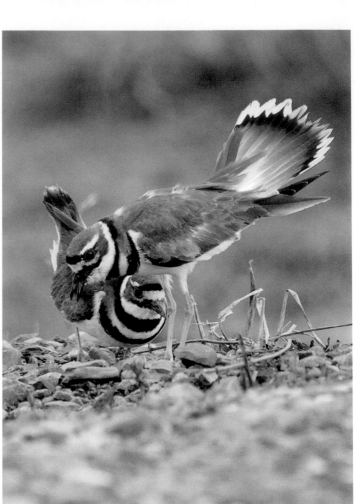

The main courtship display, the **scrape ceremony**, helps the pair find a suitable nest site and is followed by mating. Unlike many birds, established pairs of Killdeer may copulate in winter and at other times when fertilization isn't at issue, and well after incubation has begun.

The nest is little more than a simple scrape in the ground when the first egg is laid. Over time, the birds add light-colored pebbles, bits of twigs, shell or bone fragments, weed stems, or tiny human-made objects, possibly to camouflage the nest further or to cool it off. The little pebbles also effectively raise the nest, making it less prone to flooding in heavy rain.

Incubation lasts for 22 to 29 days, depending on weather and how often disturbances take the parents off the nest. On hot days, the parents may soak their belly feathers in water to moisten and cool the eggs; in intense heat they may stand above and shade the eggs without incubating them.

TRICKS TO THWART PREDATORS
Many animals eat Killdeer eggs and chicks, including snakes, opossums, raccoons, skunks, weasels, cats, foxes, coyotes, dogs, gulls, owls, kestrels, magpies, crows, ravens, and shrikes. Killdeer parents use two strategies to protect their young.

THE FAMILY LIVES OF SELECTED SPECIES

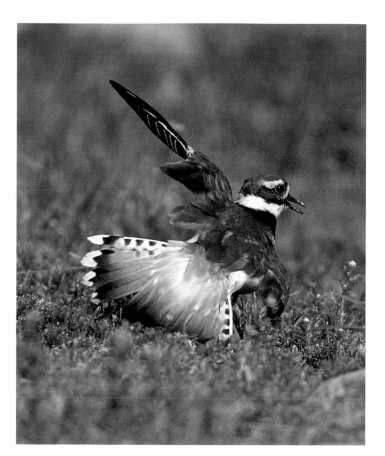

Predation isn't the only way a mammal can destroy a Killdeer's young: large herbivores such as deer, cows, and bison may unwittingly step on them. Killdeer use their **ungulate display** to deal with this danger, staying on the nest until it seems threatened, and then rushing toward the animal while giving loud screams. At least one nineteenth century observer noted a Killdeer effectively parting a stampeding bison herd down the middle with this display.

LEFT
A Killdeer tries to distract a predator away from its nest by feigning injury: flapping one wing while leaning to the side and calling plaintively.

RIGHT
Settling onto its pebbly scrape, a Killdeer spreads its belly feathers and lays the bare skin of its brood patch against the eggs, transferring maximum heat from its body. The parents take turns incubating the eggs. The male usually takes night duty.

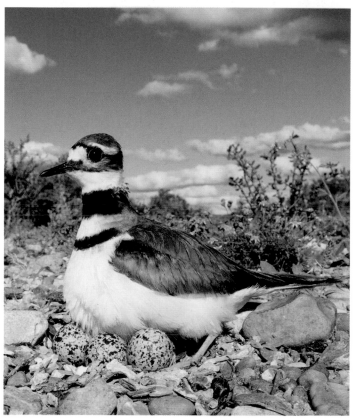

FALSE BROODING. When a nesting Killdeer notices a predator, it quietly runs from the nest and may settle into another scrape, perhaps one created during courtship, as if incubating eggs or brooding chicks there.

DISTRACTION DISPLAYS. If the predator approaches the nest, the Killdeer performs distraction displays, especially an injury-feigning display. Appearing injured and easy to catch, the bird usually draws the pursuer away from eggs or chicks and then flies safely off.

A newly hatched Killdeer chick snuggles up to its parent. Once all the chicks have hatched (usually in less than eight hours), their parents lead them away from the nest to feeding areas. They usually do not return to the nest.

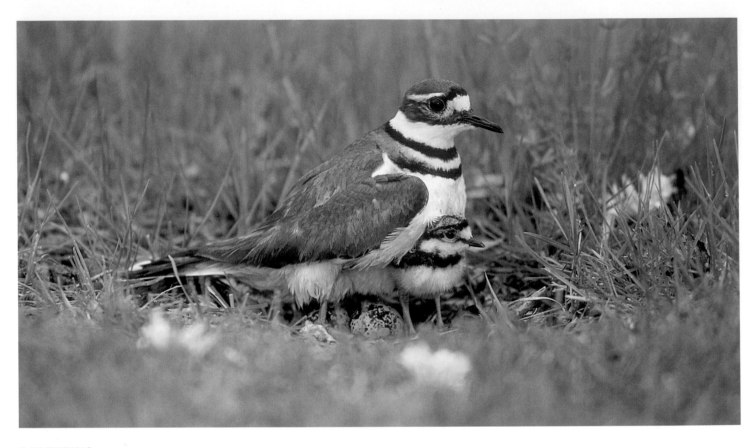

PARENTING

Inside the shell the chick starts peeping and may pip the egg up to three days before hatching. All four chicks hatch within eight hours. The parents lead them off the nest to feeding areas several hours after hatching; if they hatch late in the day or evening, they'll remain in the nest overnight.

Chicks from rooftop nests must get down to the ground to reach food. In one case where Killdeer nested on a Mississippi rooftop, the chicks invariably fell into a rain gutter surrounding the roof soon after leaving the nest. A parent on the ground called into the downspout, and the chicks, hearing it, leaped into the top of the downspout, sliding down to the parent below.

Newly hatched Killdeer chicks are downy and active as soon as they dry off, but cannot effectively **thermoregulate**, or control their own body temperature, at first. Both parents brood them for the first three days after hatching and after that in chilly or rainy weather; they also shade the chicks in the heat.

Killdeer do not feed their chicks but instead lead them to feeding areas to pick up small invertebrates for themselves. Their thick, fuzzy natal down persists among normal feathers for weeks or months after the bird is wearing its basic plumage.

FLIGHT PATH

Young Killdeer fly when about three to four weeks old. They remain with their parents at least until then, but chicks in second and third nestings can remain with their parents even longer — in one study, for 81 days.

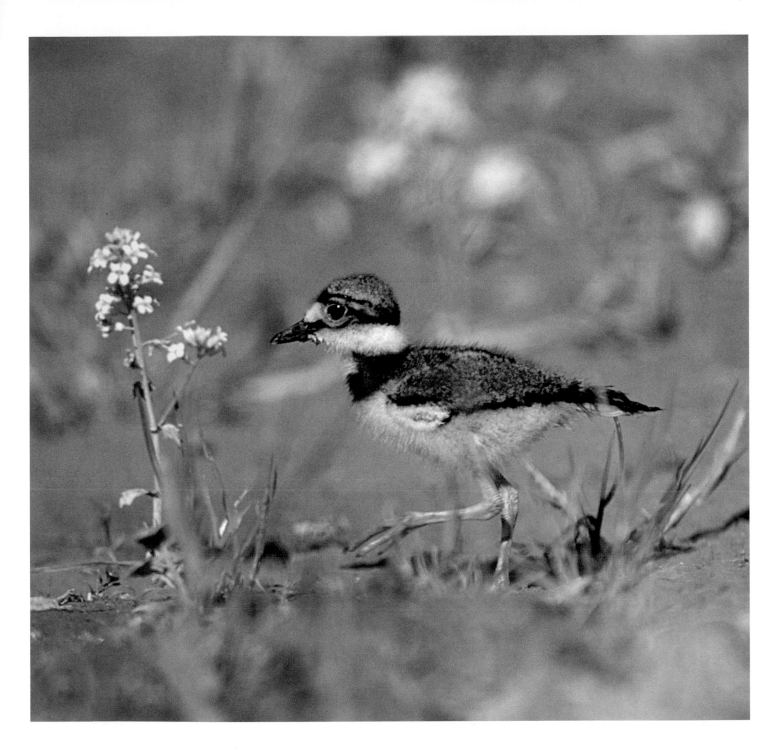

This Killdeer chick, about a week old, will remain closely associated with its parents and siblings at least until it can fly, at between 20 and 30 days of age. Some Killdeer families remain together much longer.

HERRING GULL

Herring Gull
adult

One of the larger gull species, Herring Gulls are the most common breeding gull in the northeastern United States and much of Canada. Eating mostly fish and other aquatic creatures, they are famous for dropping crabs, clams, and other food items that are too large to be swallowed whole onto rocks or hard surfaces to break them open.

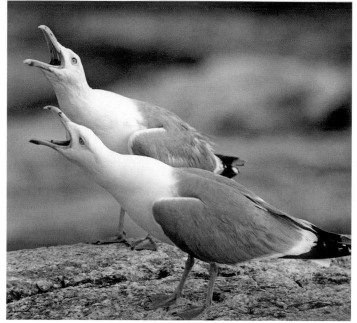

Like other gulls, Herring Gulls spend a lot of time at dumps and landfills, but most use the sites more for roosting, socializing, and just loafing around than for dining. Sociable throughout the year, during the non-breeding seasons, gulls gather in huge flocks wherever food is easy to find.

PAIRING UP

As the breeding season approaches, each unattached male gravitates to an established colony to seek a small, undefended territory where he can nest. Then he must attract a female who will select and defend the nest site within the territory with him. Previously mated pairs return to the previous year's nest site.

Courtship is simple and to the point. The female approaches the male, begging for food and tossing her head, and he regurgitates food for her. Her acceptance of the food may immediately trigger copulation. Courtship feeding not only seals their pair bond but also supplements her nutrition while her body is producing eggs. The pair defend the territory together with threatening postures and strident calls, which may escalate into chases and fights with rivals on the ground and in midair.

Before egg-laying begins, the female Herring Gull often begs from her mate, approaching him in a hunched posture and repeatedly flicking her head upward, giving a plaintive *klee-ew* with each flick. The male then feeds her. This supplementary feeding may help her during egg formation.

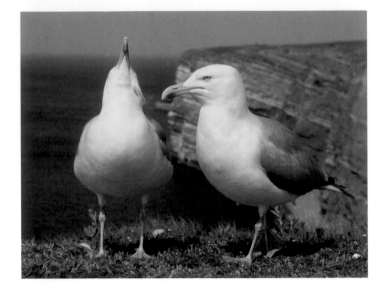

NESTING

Herring Gulls often build their nest next to a rock, log, or bush, probably for protection from both the wind and predators. The pair create a few scrapes on the ground and may fill them with bits of vegetation. When a scrape seems ready, the builder performs a **choke display**, lowering its head and jerking it rhythmically while swelling its throat making a deep *huoh-huoh-huoh* call. When the other finds it acceptable, it joins in the display, and that becomes the scrape where the female will lay her eggs.

The female lays her first egg early one morning once the nest is fairly complete, but the pair may continue adding grasses, feathers, plastic, rope, and other strand-like material throughout incubation. She lays the second egg (often the heaviest in the clutch) two days later, and the third (usually the smallest) two days after that.

PARENTING

Both parents share incubation duties equally, starting when the first egg is laid. Each develops three brood patches, but at first the feathers haven't all dropped and the skin isn't yet **vascularized** (it lacks the network of blood vessels necessary to transfer body heat). So the first two eggs start developing at about the same time and generally hatch at about the same time, about 30 days after the first egg was laid.

The third chick, hatching a day or two later, obtains less food and grows more slowly than the other two and is more likely to die when food isn't adequate. If the smallest isn't getting enough food, it may wander off its parents' territory. In about 30 to 40 percent of these cases, however, another pair will "adopt" that chick and care for it.

Gull chicks are **semi-precocial:** they hatch covered with thick down and with their eyes open. They can move about much more freely than altricial chicks but aren't nearly as mobile as precocial chicks. They must rely on their parents for food. After the first few hours chicks may wander near the nest, and within a week, they can run about their parents' territory freely.

The parents find or catch food and eat it away from the territory, and also offer regurgitated blobs to the chicks at the nest. Eventually the chicks manage some entire fish and other items, including refuse. Chicks that are fed garbage grow more slowly and have greater mortality than those fed natural diets.

THE FAMILY LIVES OF SELECTED SPECIES

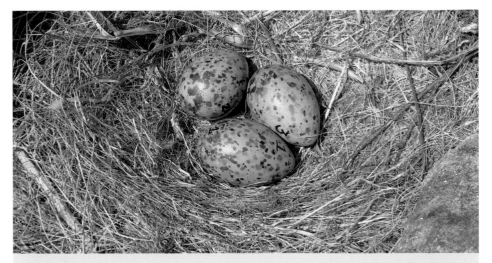

NEAR HATCHING. A grass-lined Herring Gull nest with three eggs, numbered by scientists to identify the order in which they were laid. Studies such as this have established that the first two eggs hatch on the same day, the third usually a couple of days later.

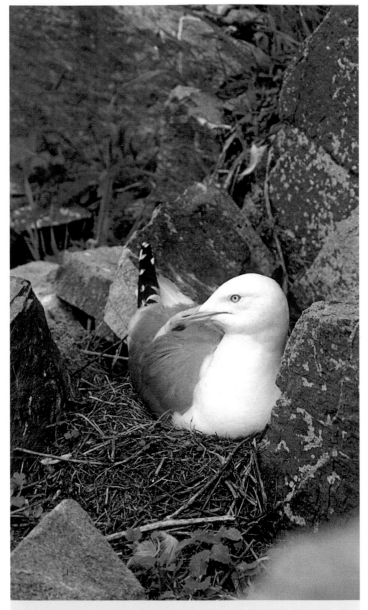

INCUBATING. An adult Herring Gull incubates on its nest in a rock crevice. Incubation lasts 31 to 32 days; both parents share duties, although the female usually incubates overnight.

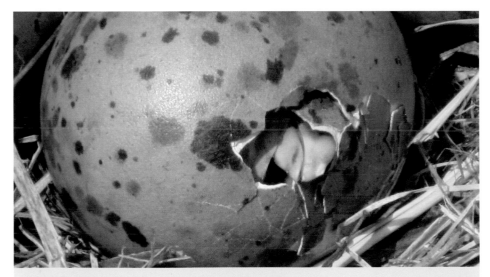

PIPPING. The tiny beak of a hatching Herring Gull, with the white egg tooth at the tip, emerges from the egg. It may take two days for the chick to create that pipped hole after the first tiny cracks in the shell are visible.

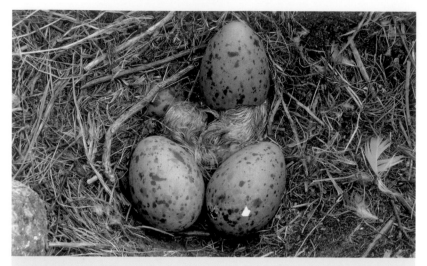

HATCHING. The eggshell at the top of the photo has finally broken and the chick, wet and exhausted, has pushed its way out using its feet. Meanwhile, the second egg (lower right) is pipped and another chick will soon emerge. The third egg should hatch in two days or so.

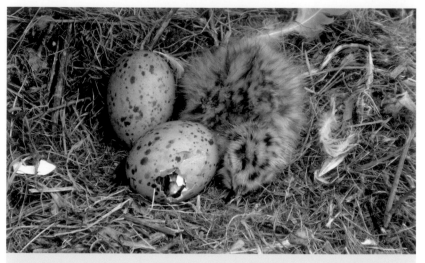

RESTING. The first chick is dry, and a second chick's bill (with egg tooth) is visible through the pip in its egg. The parents watch over the hatching chicks but give no assistance, although they may remove the empty eggshells from the nest.

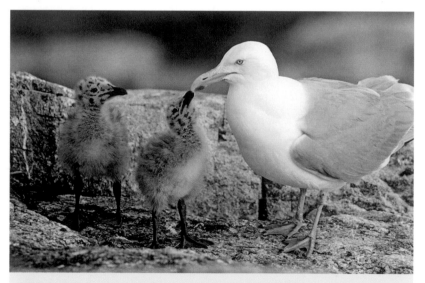

FEEDING. Less than 10 days old, a Herring Gull chick begs for food by pecking at the red spot on the lower mandible of its parent's bill. This may stimulate the adult to regurgitate food, or it may help younger chicks orient themselves during feeding.

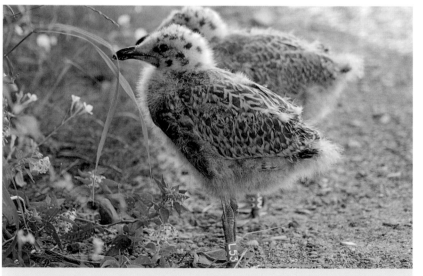

FORAGING. Herring Gull chicks at 20–25 days. By this age they have partially developed wing feathers, as well as fully feathered backs and underparts, but their heads retain the natal down and their tail feathers are barely beginning to emerge. Green leg bands identify these individuals as part of a research population.

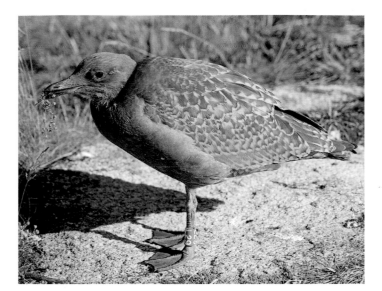

FLIGHT PATH

Herring Gull chicks leave the nesting territory on their first flight at about 45 to 50 days. At this point, their bodies are fully grown and they're usually heavier than their parents, though their wings and tail feathers aren't their full length yet. Some of these chicks may continue to associate with and beg from their parents for up to six months more, while others end up in groups with other young birds.

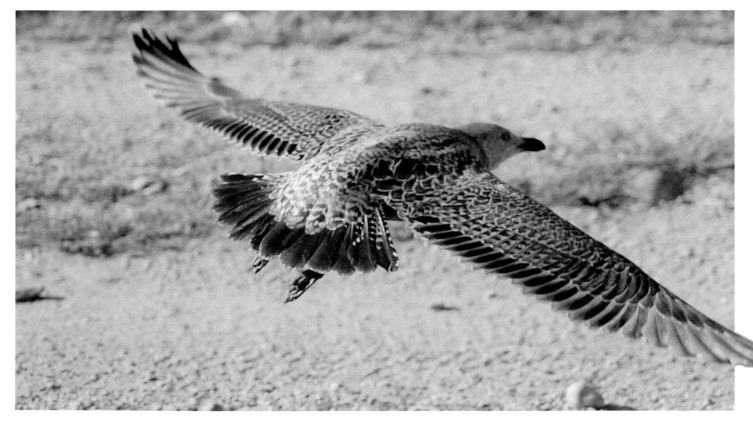

ROCK PIGEON AND MOURNING DOVE

Mourning Dove
adult

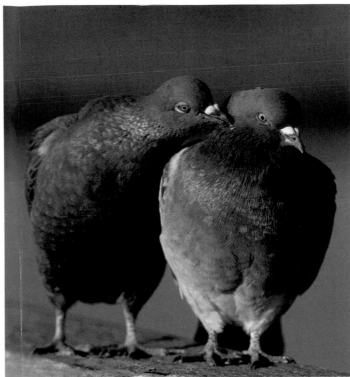

Although among the most abundant birds on the continent, Rock Pigeons and Mourning Doves are situated at opposite ends of the "bird popularity spectrum." The Rock Pigeon's North American population has been estimated at 12 million, which people consider far too many; some even call pigeons "flying rats" and other disparaging names.

The Mourning Dove is far more abundant, its population estimated at 100 million, but it's one of the most treasured of backyard birds for its gentle ways and lovely calls. It's also the most heavily hunted game bird in North America. About 20 million are harvested each year, far more than the total population of Rock Pigeons.

Doves are a favorite among natural predators as well, so most Mourning Doves don't survive their first year. Those that do make it through all the challenges associated with each season have better prospects; after that first treacherous year, their life expectancy goes up dramatically. Many Mourning Doves bearing U.S. Fish and Wildlife Service numbered leg bands are known to have survived over 10 years, and one lived to be at least 30 years old. Rock Pigeons are not similarly banded, but people who breed and race them note that they often live well into their 30s. Feral pigeons that elude urban Peregrine Falcons and rat poison may survive similar lengths of time.

PAIRING UP AND NESTING

Rock Pigeons and Mourning Doves are sociable, feeding, bathing, and roosting in flocks. This simplifies the task of finding an appropriate mate.

ROCK PIGEONS

Female pigeons select their mate from the males that strut and display around them. Both sexes seem to prefer a mate that is about their own size and the youngest of the experienced adults available.

An analysis of Pigeon Watch data from the Cornell Lab of Ornithology indicates that nearly 40 percent of all pigeon pairs are of matching colors, a trend strongest in birds of the dominant plumage, but other studies find that birds prefer mates with plumage different from their own. It's hard for us to infer what the pigeons' actual preferences are, and they're not talking.

In early courtship, male pigeons bow and coo near a female while circling her many times. If she likes one, eventually she lets him preen her feathers, and she preens his. This mutual preening, or **allopreening**, strengthens the bond between them. If they maintain their mutual interest, the male feeds the female, sealing their pair bond.

Sometimes unattached males display at already paired females and drive them, pushily separating them from their mates. People who breed racing pigeons are careful to make sure paired pigeons fly only with other paired pigeons so they don't get any inadvertent matings with unattached males.

As a pair bond is forming between two pigeons, the male searches out a good nest site: generally a flat surface under cover. Pigeons often nest on human-made structures, in nooks, crannies, or on ledges, often beneath the eaves or overhangs of buildings, under bridges, in stairwells, or on rain gutters. Rural pigeons may nest on cliff ledges or in barns and other farm buildings.

If everything clicks and the female accepts the nest site, they mate, often right out in the open. After copulation, male Rock Pigeons often take off in a dramatic display flight.

MOURNING DOVES

In a study of captive doves, the dominant male and dominant female virtually always paired up and nested; lower-ranking pairs did not nest. In wild dove populations, males often outnumber females; unattached males spend a lot of time advertising each day by cooing from a conspicuous perch and then making a noisy flap-glide display flight. When a female alights near a displaying male, he usually approaches, his body raised and his head and tail held horizontally, and then bows his head and body. She may fly away (he'll follow), ignore him, peck him, or crouch to allow mating.

After forming their bond they loaf around together for a few days while she gets physiologically ready to ovulate, and then they build their nest in a tree, shrub, hanging basket or other man-made structure, or on the ground. The male brings her nesting materials and then sits on her back as she puts them in place, literally looking over her shoulder as she works.

Mourning Dove nests are astonishingly flimsy. Some nests in trees and shrubs are so poorly constructed that one or both eggs fall through the loosely woven bottom. Pigeon nests are always on a solid substrate, so flimsiness isn't a problem.

PIGEON OR DOVE?

Pigeons and doves all belong to the family Columbidae. People usually call larger species pigeons and ones with pointed tails doves, but there is no rule; the Eurasian Collared-Dove is large and the extinct Passenger Pigeon had a pointed tail. For many decades, the common city pigeon was called the Rock Dove; the American Ornithologists' Union officially changed its name to Rock Pigeon in 2003.

PARENTING

Doves and pigeons lay two eggs in a clutch, and both parents take turns incubating, starting after the second egg is laid. In both species, the two spend about the same number of daylight hours on the eggs, the male taking the mid-morning to late afternoon shift while the female does night duty, from late afternoon until mid-morning. Dove eggs hatch in about 14 days; pigeons in 19.

LEFT
A Mourning Dove squab sits with its parent on a nest built on a light fixture. The youngster is well feathered enough that it no longer needs much brooding. Developing crown feathers suggest it is at least 10 days old, but it will not take its first flight until 13 to 15 days old.

RIGHT
After copulation, a male pigeon flies near his nest site with wings held above his body in a V-shape. On takeoff, he loudly claps his wings together several times.

Baby pigeons and doves, called **squabs**, are altricial, hatching with their eyes closed and their downy feathers very sparse. On the first day, they make little peeping sounds while barely lifting their heads and opening their bills for feedings, and they can't regulate their body temperatures. At least one parent is present to brood them more than 99 percent of the time. Their eyes open at four to five days old.

FEEDING THE FAMILY

Rock Pigeon and Mourning Dove parents of both sexes feed the young a cheesy substance called **pigeon milk** or **crop milk**, produced in an enlarged chamber of the esophagus called the **crop**. This chamber is present in many species for food storage. In nesting pigeons and doves, however, the crop lining produces secretions and sloughs off cells to make this substance, which resembles yellowish cottage cheese and is rich in protein, fat, antioxidants, and immune-enhancing components. Squabs may face each other, each drinking from opposite sides of the parent's bill simultaneously. Doves and pigeons are among the only birds that can suck, an ability that simplifies their feeding on crop milk.

During the first week, Rock Pigeon parents feed their nestlings large servings of crop milk three or four times each day. The parents eat soon after feeding the young and then fast before feeding them again, and thus no seeds are mixed with the crop milk. By the second week, the feeding rate drops to

ORIGINS OF THE SPECIES

Rock Pigeons were nowhere to be found on the North American continent when Columbus arrived. In the early 1600s, colonists started bringing domesticated pigeons across the ocean for food and sport. Those that escaped captivity established feral populations. Now pigeons are everywhere people have settled on the continent, and especially abundant in urban settings. In their natural range in Europe, Asia, and Africa, Rock Pigeons nest on cliffs in crevices and caves; in America, they're more likely to nest in crevices under bridges and on buildings.

Mourning Doves are native birds, nesting in a wide array of natural habitats, steering clear only of dense forests. They have adapted to a wide variety of nesting sites as well, usually in trees but sometimes directly on the ground or on human-made structures.

HOUSEKEEPING HABITS

Baby pigeons and doves produce their droppings in pellet form, not in fecal sacs. Rock Pigeon parents ignore nest sanitation. The pellets, which accumulate as the parents produce brood after brood in the same nest, get stomped into the nesting materials and substrate, cementing the structure together. Mourning Dove parents eat the pellets of very young nestlings but ignore those of older nestlings. Those droppings accumulate around the edge of the nest. Mourning Doves usually build a new nest for each brood, only occasionally reusing one.

twice each day, though the young call and beg persistently. Little by little, as the chicks develop and get increasingly coordinated, regurgitated seeds will be mixed in with the crop milk.

Mourning Dove chicks start getting seeds mixed in with crop milk after about four days. The young fledge when 13 to 15 days old and continue to be fed by their parents (mostly the father) for another two weeks. Young, independent Mourning Doves associate with other young doves. Their scalloped plumage and slightly smaller size make them easy to distinguish from adults.

FLIGHT PATH

In summer, pigeons take their first flight when 25 to 32 days old; they may remain in the nest up to 45 days in winter. Within days of leaving, young pigeons can forage for themselves. By the time they are mingling with other street pigeons, they're hard to distinguish from adults. A week or two later, the parents are already brooding new eggs.

Rock Pigeons can nest year-round, even in cold climates, as long as food for the parents is reasonably abundant and their nest site sheltered. Mourning Doves have a long breeding season, usually from February through October, shorter in the north, longer in the south. In both species, birds reach sexual maturity within months; males and females that hatch early in the year may start a whole new nesting cycle of their own that same year.

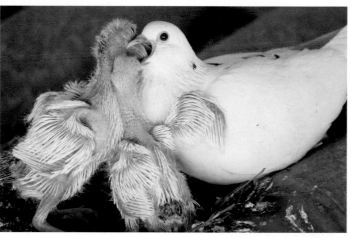

TOP
A newly hatched Rock Pigeon squab nestles next to an unhatched egg. The second egg usually hatches within a few hours. Notice the hole below the dark circular bulge of the still-closed eye: this is the bird's ear opening.

MIDDLE
Two growing squabs plunge their bills into the parent's open bill. For the first four days after hatching, young pigeons are fed only crop milk, which is rich in fat, protein and vitamins. Notice the developing feathers on the squabs' wings and bodies.

BOTTOM
Two Rock Pigeon squabs about 14 days old. Their heads are still downy, but by now their wing and body feathers are well grown, although each feather is still encased by its sheath at the base. At this stage, they can walk well and often pursue the adults, begging for food.

GREAT HORNED OWL

Great Horned Owl
adult

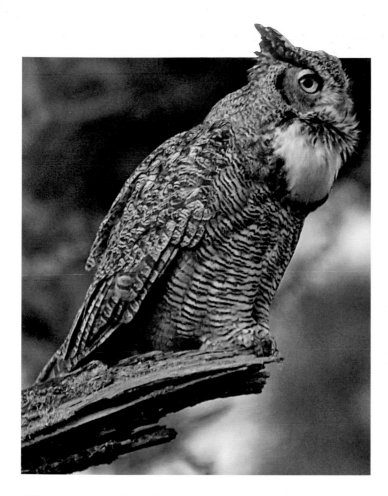

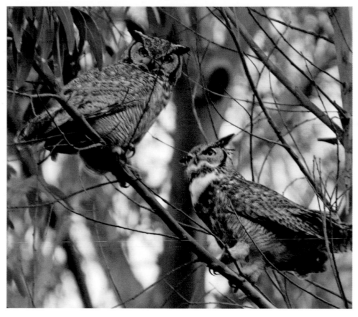

Nicknamed the "feathered tiger," the Great Horned Owl is one of the fiercest birds in the world. Females weigh less than 4 pounds and males less than 3, but they often tackle huge prey, including herons, ducks and geese, and large rabbits and hares. They also hunt tiny mice and frogs and large insects, spiders, and scorpions. Despite their powerful talons and killing ways, Great Horned Owls are surprisingly tender with mates and their young.

PAIRING UP AND NESTING

On Valentine's Day, when other birds' hormonal levels are at their lowest, Great Horned Owls in the northern states are courting and even starting to lay eggs. They've been nesting since December or January in the South, and even late November in southern Florida. This unusually early breeding means extra time for the owlets to learn to hunt and catch prey.

Once he locates a likely nest site, the male hoots to initiate courting. The site is usually an abandoned Red-tailed Hawk or raven nest, but he may select a tree snag, rotted-out cavity, artificial platform, stick nest in a Great Blue Heron colony, or even a hay loft.

A LITTLE NIGHT MUSIC

Territorial hooting begins very early in the year, sometimes even in late autumn. Several weeks before egg-laying, the pair starts hooting back and forth together in duets, sometimes lasting an hour. The female's voice is higher-pitched than her mate's. Females are significantly larger than males but the males have a larger skull width, which may be why their voices are deeper. Males often hoot very close to the nest.

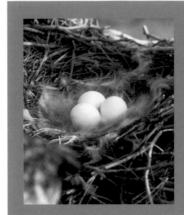

NIGHT LIFE

The female owl rarely leaves her nest during the early phase of incubation. Later, she'll depart for longer periods to hunt, and when she returns, the round white eggs are easy for her to spot in low light.

BOTTOM LEFT A female Great Horned Owl incubates her eggs in a hole at the top of a tree stump.

BOTTOM RIGHT Two recently hatched Great Horned Owl nestlings with their mother in a nest in a saguaro cactus. Young owls are altricial, hatching covered with white down. Their eyes remain closed until nine to eleven days of age, and they are brooded by their mother for the first two weeks after hatching.

Courtship escalates as the male calls more frequently (averaging 2.7 calls per minute). Suddenly the female flies to a high perch in a nearby tree, and within a minute the male follows. As they mate, the male flaps his wings to maintain his balance on her back, his beak nuzzling feathers on her nape. Both continue hooting throughout copulation, which lasts four to seven seconds.

The duets and synchronized courtship behaviors may keep both birds fully focused on mating, to prevent injuries from their powerful, sharp talons and bill. The pair bond between two Great Horned Owls can last several years, probably for life, which expedites the courtship process in future years.

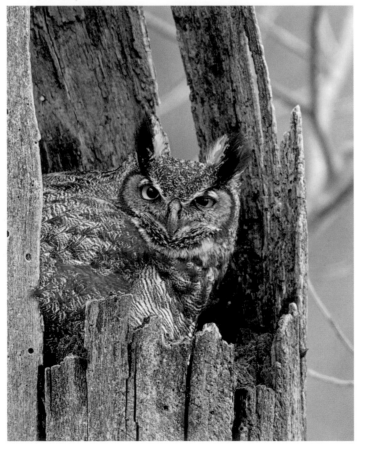

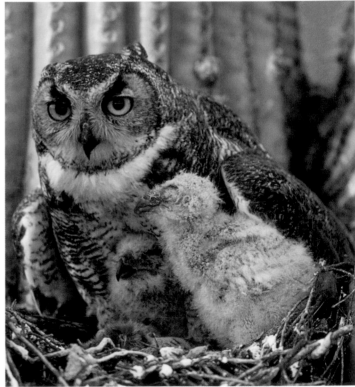

THE FAMILY LIVES OF SELECTED SPECIES

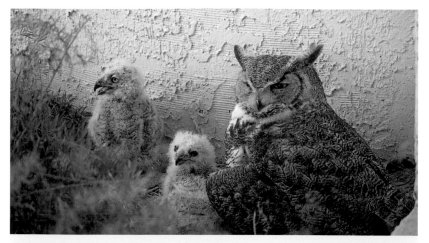

2 WEEKS OLD. This female is brooding one of her nestlings under her wing. This nest is in a window planter outside of a church in Arizona, where Great Horned Owls have nested nearly every year for 26 years.

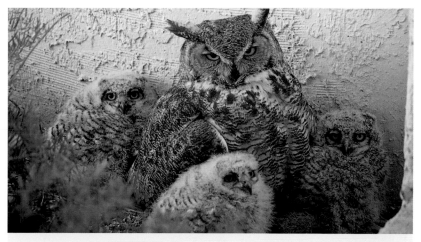

3 WEEKS OLD. The same owlets now have more barred body plumage and the first feathers that will become the "horns." The slightly downier one in front was probably the last hatched of the brood.

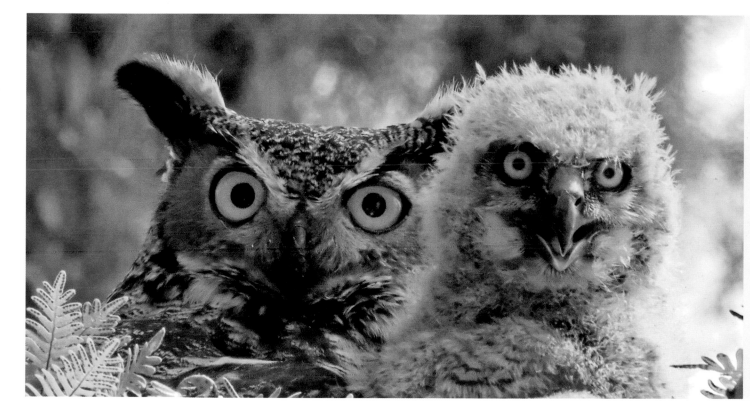

4 WEEKS OLD. With its mother in their nest in a coniferous tree, a Great Horned Owl nestling hisses and snaps at an approaching intruder. By now it can feed itself with prey brought by the adults, although its mother may continue to tear larger prey and feed it in small pieces for another week or so.

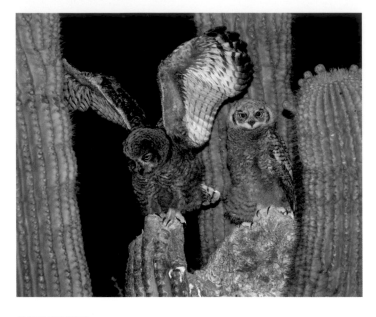

LEFT
A large owlet exercises its wings on a broken saguaro arm above its nest. The young can climb well by 40 days old and often clamber out along a tree branch or a ledge (hence they are called **branchers**). Their feet are specially adapted for this: one of their three forward-facing toes is opposable, like the human thumb. Owlets are fully feathered and can fly short distances when about 45 to 49 days old.

RIGHT
A Great Horned Owl brings a meadow vole to feed its two owlets in a nest on bales of straw in a barn. At first the male brings all the food and the female tears it into pieces for the young. If he doesn't bring enough food as the young grow more demanding, she may leave the nest to hunt as well.

PARENTING

Established pairs often roost near one another, and frequently nuzzle and preen each other's facial feathers. This allopreening is typical of many owls, unlike most other birds of prey.

Great Horned Owls lay their eggs in winter, and females start incubating after laying the first egg. Air temperatures may be lower than −25°F (−31.7°C), but the mother owl keeps the eggs at a full 98°F (36.6°C). The eggs start cooling as soon as she leaves the nest, but they are surprisingly hardy. One scientist observed a female leaving her nest for 20 minutes (to help her mate hoot at a neighboring male) when the temperature was −13°F (−25.0°C), yet the eggs all hatched. Usually she's off the nest for only a few minutes at a time; her mate brings all her food.

Incubation lasts on average 33 days. The eggs hatch about two days apart, probably in the order in which they were laid. The female usually broods them almost continuously for at least the first two weeks. The bare skin of her brood patch transfers her body heat to the eggs and chicks, holding their temperature at about 98°F (37°C).

She will gradually taper off brooding, except in northern areas or during cold or inclement weather. When she returns to the nest, she carefully covers the young and makes a soft

hut-hut-hut call to which the young respond with faint whimpers. The vocal interplay probably helps ensure that she doesn't hurt any of them as she eases herself down on them in the dark.

FEEDING THE FAMILY

The nestlings grow rapidly, and the first to hatch has almost tripled its weight before the second hatches. Assertive, larger chicks may grab the lion's share, even as the mother is feeding the smaller ones. Occasionally when food is scarce, the oldest chicks may kill and eat the smallest.

The white down of newly hatched chicks turns into grayish or yellowish plumage, still thick and downy, in eight days, and the future ear tufts are obvious patches by three weeks. By 11 weeks, the nestlings have clearly defined facial discs and white bibs.

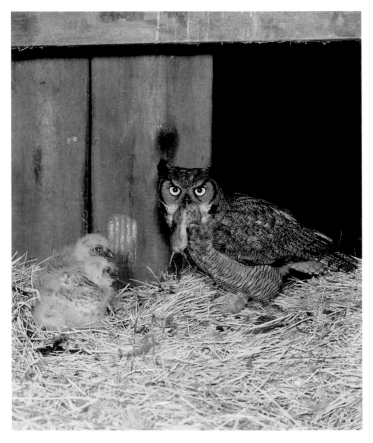

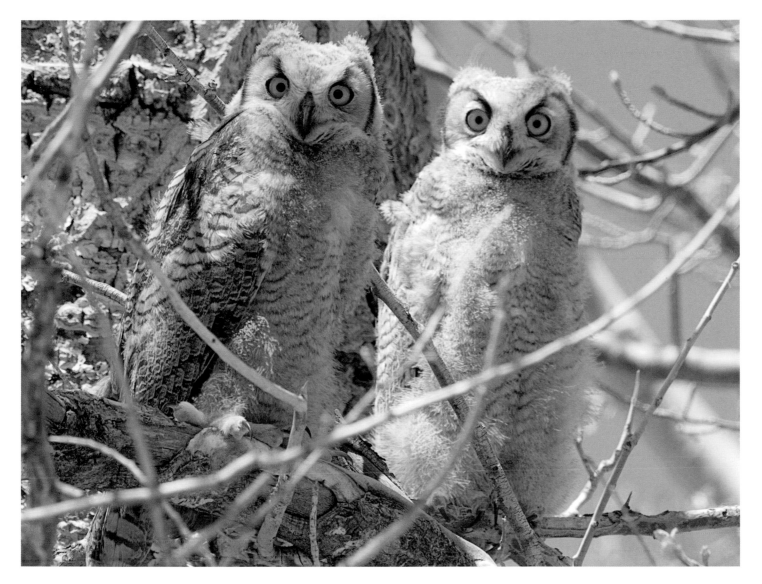

At first, fledglings stay close together, often roosting in the same tree, apart from their parents. They give begging calls while flying after the adults, who leave prey for them to dismember, even into September, when Great Horned Owl chicks almost everywhere are close to six months old.

FLIGHT PATH

The owlets make their first weak flights soon after branching. By fall, their area of exploration has expanded greatly, and eventually they disperse altogether from where they hatched.

Soon after the young disperse, adult males start territorial hooting. This probably helps discourage displaced adult males and inexperienced, soon-to-be-breeding males from moving onto their territories. Females take the lead in banishing any females from the territory.

It may take young owls several years before they are strong and experienced enough to claim and defend their own territory, so most owls don't breed until they're two years old or older.

HUMMINGBIRDS

Anna's Hummingbird
male

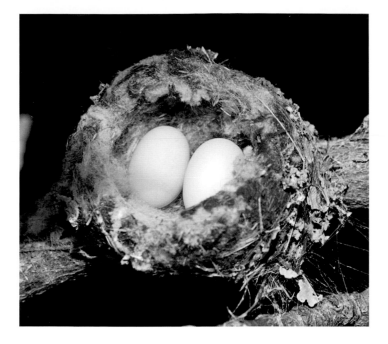

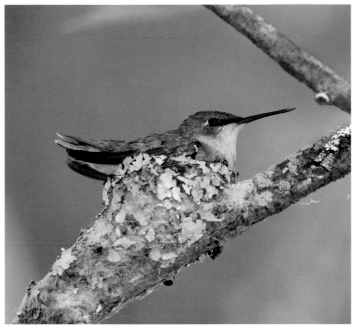

LEFT
Shown actual size, this Ruby-throated Hummingbird nest is made of plant down lashed together with spiderwebs (visible in lower right corner). The female shaped the nest with her body, smoothing the rim by pressing it between her neck and chest. She camouflaged the outside with lichens and moss.

RIGHT
A Ruby-throated Hummingbird female incubates her eggs. Notice how well this nest blends in with the supporting branch.

The hummingbird is a tiny dynamo. At rest, a Ruby-throated Hummingbird's heart beats about 250 times every minute; this rises to 1,200 beats per minute in flight. Males chase other birds from hummingbird feeders, force competitors from flowers, and attack other species — even dive-bombing Bald Eagles, which weigh 1,600 times as much as they do.

PAIRING UP

Hummingbirds are highly territorial during the breeding season, focusing around a food source. The male doesn't form a pair bond with females drawn to his territory; he remains with each only for courtship and copulation, after which the females nest and raise the young themselves.

Despite the lack of a pair bond, females who happen to nest near a male's territory may benefit from his presence. Female hummingbirds are larger than males, and when they flare the white patches in their tails, the males sometimes seem deferential, allowing them access to flowers that the male has been defending against other competitors. But females are perfectly competent to build the nest, incubate the eggs, and raise and feed the young without male assistance.

To entice females to mate, male hummingbirds perform conspicuous **dive displays** high in the air — soaring more than 100 feet, plunging toward the ground, pulling up and snapping their wings, singing buzzily all the time. They may repeat the entire display as many as 40 times in one bout. The female watches, and copulation often follows.

HUMMINGBIRDS

71

WHAT HUMMINGBIRDS LOOK FOR IN A NEIGHBORHOOD

Feeders are an important food source for hummingbirds, especially at both ends of the breeding season. Even the best feeding station, however, will not entice hummingbirds to nest in your backyard. Two other elements seem most desirable: the presence of a sapsucker, and an abundance of spiders.

Sapsuckers are woodpeckers that drill holes in hardwood trees. In early spring, those holes well with sugary sap and attract insects, both essential food sources for hummingbirds arriving on their breeding grounds.

Although hummingbirds may snap up some tiny spiderlings ballooning through the air, the spiders' main contribution is nesting materials. Hummingbirds construct their nest from bits of lichens, mosses, thistle and dandelion down, and sometimes pine resin, woven together with spider silk. The sticky gossamer binds the nest to the supporting branch and camouflaging vegetation.

Spider silk is also extraordinarily stretchy. The female needs tight quarters with thick insulation at first, to retain her body heat as she incubates her two tiny eggs and broods the tiny, naked nestlings. As they feather out, the nest must stretch to fit the chicks' growing bodies. They'll both be almost as large as their mother before they leave the nest!

NESTING

To find the hidden nests of Ruby-throated and Rufous Hummingbirds, watch where females fly when they leave your feeder during the nesting season, and try to follow them. The female ruby-throat takes six to ten days to build the nest, usually on top of a branch 10 to 40 feet above ground; near human habitation, hummingbird nests have been found on loops of chain, wire, or electric cords.

The nests of Anna's Hummingbirds are much easier to find, often built in areas of high human activity, probably due to their dependence on feeders and ornamental plants during the nesting season and to the high human population along the Pacific coast.

The incubation period for Ruby-throated Hummingbirds averages 13 days; it's longer, about 16 days, for Rufous and Anna's Hummingbirds. Female ruby-throats and rufous begin incubation when they lay the first egg, so it hatches a day or two before the second egg; some Anna's delay incubation until the second egg is laid.

PARENTING

Nestlings hatch with very few feathers and eyes sealed shut. At first they huddle on the nest floor with virtually no activity between feeding bouts, but they lift their heads and open their mouths when the female arrives for feedings, and by the second or third day can back off the nest to poop.

The female feeds the nestlings a slurry of nectar, semi-digested tiny insects, and spiders via regurgitation, pumping gently and slowly at first but more vigorously as the chicks grow. At first, the mother broods the chicks most of the time, usually leaving only for feeding bouts, but as they feather out she spends less and less time warming them. When the nestlings are 15 to 16 days old, she starts bringing them small insects, holding them between her upper and lower bill. Insects provide a necessary source of protein while the young are growing.

HATCHING. A newly hatched Ruby-throated Hummingbird nestles next to an egg that will hatch a day or two after the first. The tiny nestlings are altricial, naked and gray-skinned except for two thin tracts of yellowish white, hairlike feathers along their backs. The nestling's eyes won't open until it's about nine days old.

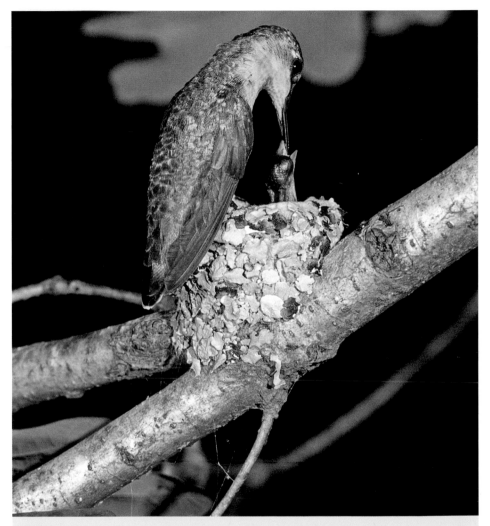

FEEDING. A female ruby-throat feeds a newly hatched nestling whose eyes are still closed. She will provide all parental care with no help from the male. She feeds by regurgitation, inserting her bill into that of the nestling. Notice how short the youngster's bill is at this age; it will not reach full adult length until about 30 days after fledging.

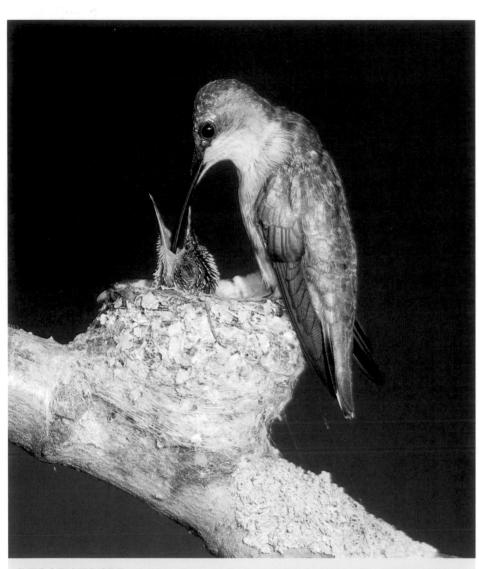

NEAR FLEDGING. One of two Ruby-throated Hummingbird nestlings tries out its wings while standing in the nest. The young birds start exercising their wings when about 15 days old, and the first chick leaves the nest when 18 to 22 days old. The younger one may remain for another day or two.

FLIGHT PATH

Anna's and Ruby-throated Hummingbird nestlings fledge about 20 days after hatching. Rufous Hummingbirds fledge at 15 to 19 days, the faster progress probably a result of the longer daylight hours for foraging in the species' northern breeding range.

When the first hummingbird in a nest fledges, it usually stays near the nest until its sibling fledges; together they depend on the female for another week or two. In summer, when two or three female/juvenile hummingbirds appear together at a feeder without squabbling, chances are they are a family.

7 TO 9 DAYS OLD. A Ruby-throated Hummingbird female feeds a nestling whose head bristles with pinfeathers. Its eyes are only just starting to open and its bill is lengthening. At this age, when the young birds' feathers are finally developing, she broods them less and less.

At summer's end ruby-throats, including those that hatched just months earlier, migrate on their own to the Yucatan Peninsula and then as far south as Costa Rica. For many, the flight path crosses the Gulf of Mexico, a treacherous, nonstop journey of more than 500 miles, during hurricane season; they make the same trip back the following spring. Ruby-throated Hummingbirds wearing U.S. Fish and Wildlife Service leg bands have survived more than nine years; those individuals made this arduous journey at least 18 times.

Adult male hummingbirds typically migrate ahead of adult females, which are still busy raising young. They migrate after their bodies have recuperated after their last brood fledges. The juveniles migrate last, already pugnacious and ready to face the big, wide world entirely on their own.

TOP
A fledgling Ruby-throated Hummingbird about 19 days old begs from its mother. When they first fledge, the young outweigh their mother, but even though she continues to feed them, they lose weight rapidly due to their sudden increase in activity before they have the skills to forage for themselves.

BOTTOM
A juvenile Ruby-throated Hummingbird feeds from a trumpet vine flower in late summer.

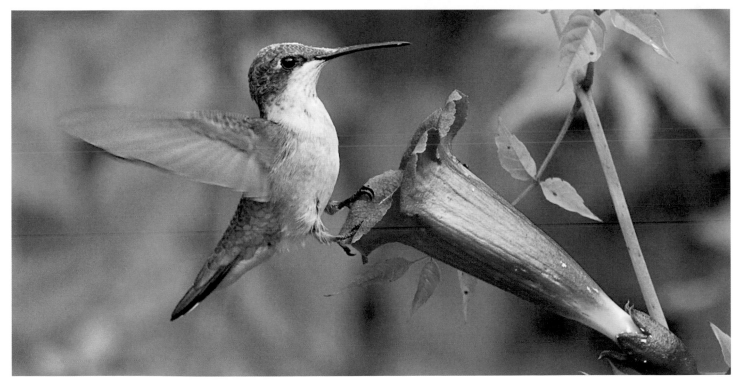

WOODPECKERS

Downy Woodpecker
male

DOWNY
AND
HAIRY WOODPECKERS

Two Downy Woodpeckers perform a bill waving display. During territorial disputes, these woodpeckers hitch jerkily around tree trunks in pursuit of each other, fanning their tails and waving their bills, calling agitatedly.

On the first days of January, when in northern latitudes the mercury has shrunk to the thermometer's lowest depths, days are already growing longer. The worst of winter may be yet to come, but even on frigid mornings, we can hear a welcome sign of spring: the courtship drumming of a Hairy or Downy Woodpecker. Neither species will begin nesting until spring, but those rapid staccato beats are a promise of warmer days ahead.

PAIRING UP

The louder a woodpecker's drumming, the farther the sound carries, helping it defend a larger territory — and attract a potential mate from farther away. Woodpeckers usually have a favorite, particularly resonant drumming spot, such as a hollow snag or a bark-free area on a dead tree trunk, or another noisy surface such as a metal gutter, drainpipe, street sign, or utility pole.

Hairy and Downy Woodpeckers look bewilderingly alike, but they differ in size and, more helpfully, in bill length. The Hairy Woodpecker's bill is almost as long as its head, while the bill on downies is noticeably shorter.

Not migratory, Hairy and Downy Woodpeckers tend to spend their lives in a relatively small area. Both species start drumming in mid-winter and seem to bond (or re-bond) with their mate at that time, but courtship doesn't get serious until early spring. A Hairy Woodpecker male starts making a sputtering call, and when close to his mate, he erects the bright red feathers on his nape and spreads his white outer tail feathers. Courting downies perform **butterfly flights**, one following the other as they fly between the trees with slow, fluttering wing beats that resemble a flying butterfly.

A male Hairy Woodpecker raps emphatically and rhythmically with his bill. By late winter, both male and female Downy and Hairy Woodpeckers begin drumming to establish territories. A bark-free area on a dead trunk makes a particularly resonant drumming spot.

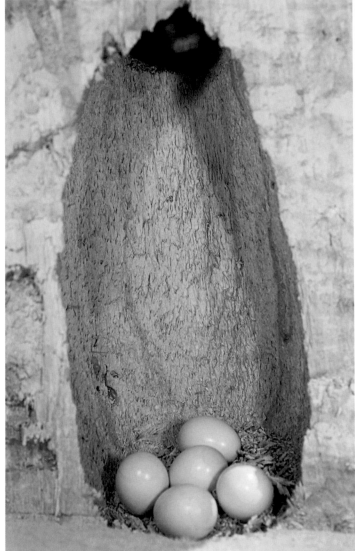

EGGS. Woodpeckers (downies, in this sequence) do not line their nests but cushion the nest floor with a bed of woodchips. The eggs are glossy white and round, not pointed at one end. After about 12 days they hatch, usually at about the same time, but sometimes over a period of up to 48 hours.

NESTING

Often the female Downy Woodpecker chooses the nest site, but the pair usually investigates several likely spots together first. Hairy Woodpeckers begin nesting a week or two earlier than downies. In both species, the male and female take turns digging the nest, carving out the round entry hole to be just large enough for them to pass in and out. The finished cavity is slightly pear-shaped, 6 to 12 inches (15–30 cm) deep for downies, with a narrow entrance at the top. It typically takes about two to three weeks to excavate, but some birds can finish in just seven days.

Both species lay an average of three to five shiny white eggs, laying them on the cavity floor without any additional nesting materials added. No camouflage is needed inside a cavity, and the shiny, white surface may help adults see them better in the dim light within.

THE FAMILY LIVES OF SELECTED SPECIES

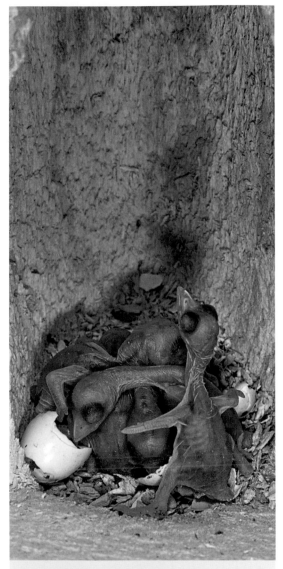

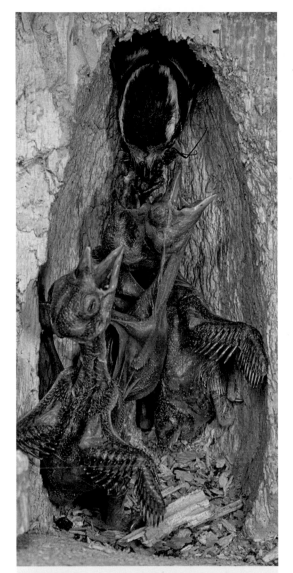

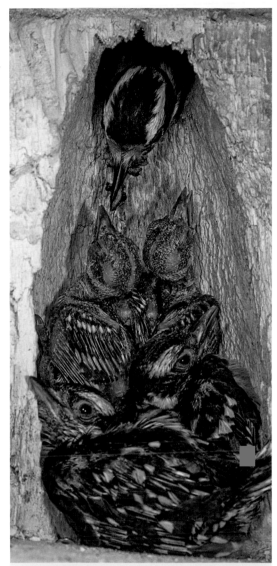

NEWLY HATCHED. Woodpecker young are even less developed at hatching than other altricial species. Their thin skin is translucent, their skeleton and internal organs surprisingly visible through it. Their dark, still-closed eyes bulge from the skull. Adults drop the eggshells away from the nest.

1 WEEK OLD. The female Downy Woodpecker reaches through the cavity entrance to feed her nestlings. Dark areas on their backs and crowns are tracts of feathers developing under the skin. Flight feathers on the wings have broken through the skin. Still enclosed in sheaths, they're called pinfeathers. The nestlings' eyes are just starting to open.

15–16 DAYS OLD. The female brings a beakful of caterpillars to her nestlings. All four probably hatched on the same day, the less-developed two in back most likely third and fourth. Downy Woodpecker nestlings grow fast from the beginning, so a few hours' head start gives the first-hatched a competitive edge.

THE INS AND OUTS OF CAVITIES

A nest cavity protects eggs and nestlings from rain, wind, extreme temperatures, and predators better than an open-cup nest does, but it has disadvantages, too. During long bouts of incubation, carbon dioxide can build up to levels that would be dangerous for many birds. Fortunately, cavity nesters and their young are fairly well adapted to high CO_2 levels, and to minimize the danger, the eggs hatch much sooner than eggs of most similar-sized species. As parents fly in and out, air exchange increases dramatically.

Few species other than woodpeckers excavate their own cavities, so even non-predators sometimes kill woodpeckers and their young to steal their cavities. House Sparrows and European Starlings are the worst culprits, but squirrels, mice, and some other birds will also occasionally take over an active woodpecker cavity. Hairy and Downy Woodpeckers build spare cavities to use as nighttime roosts throughout the year and backup nest holes when one is stolen.

Hairies often nest in living trees with fungal rot on the inside. They can hammer the entrance hole into wood too hard for squirrels to chew into, and then scoop out the rotted heartwood for

They start begging when a parent blocks the entrance hole, a signal that a feeding is nigh.

the interior chamber. Aspens are ideal because they so quickly develop heart rot. Unfortunately, sapsuckers and flying squirrels also prefer aspens, and Hairy Woodpecker cavities are an ideal size for both these competitors. Hairies can more effectively exclude these species if they build their cavity beneath a curved limb.

Downies usually choose a dead branch on a dead or a living tree. Being larger, hairies more often use the trunk than a limb.

PARENTING

As with other woodpeckers, after the female lays the penultimate egg, both parents share incubation, the male taking night duty. The eggs hatch in only about 12 days. Woodpecker hatchlings are less well developed than hatchlings of other species, and utterly unfeathered, due to this short incubation.

COMMUNITY SERVICE

Woodpeckers provide critical ecological services to the animal communities around them. The cavities they excavate for roosting and nesting provide shelter for bluebirds, Great Crested Flycatchers, flying squirrels, and various tree frogs. By pecking into the wood to pull out insects for themselves, they open up access to the inner wood for smaller birds with weaker bills. In turn, both Hairy and Downy Woodpeckers benefit from associating with Pileated Woodpeckers; they can dig out insects from much deeper in the wood by working the holes made by the larger bird.

The **gape** (open mouth) is thicker on woodpecker chicks than in most baby birds, broadened by pearly white to pinkish oral flanges that may give the parents a wider target in the darkness of the cavity. Though the nestlings' eyes are sealed shut for a few days after hatching and not fully open for another week, the young birds can still discern the differences between dark and light. They start begging when a parent blocks the entrance hole, a signal that a feeding is nigh. By the second day, they can lift their heads to beg.

FEEDING THE FAMILY

Hairy Woodpeckers hatch at close to the same time, and none get preferential feedings (see box on the next page). In contrast, first-hatched downies are fed large meals immediately after hatching, and may double their weight the first day. Even though all the eggs usually hatch that same day, the first nestling or two get a significant competitive edge. This developmental gap grows as the bigger nestlings continue to dominate their smaller siblings, begging more strongly and monopolizing the adults' food deliveries.

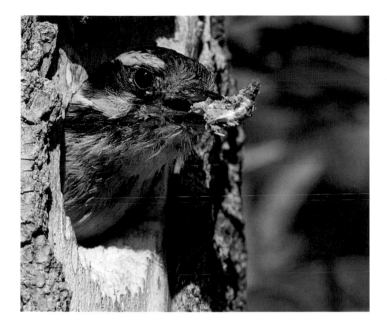

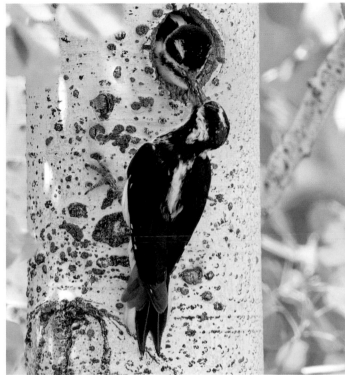

Hairy Woodpeckers feed their nestlings about seven times per hour; Downy Woodpeckers about 11 or 12 times per hour. For the first several days, the parents take turns brooding the tiny nestlings almost constantly. As their eyes open and their feathers develop, the nestlings start literally climbing the walls and jockeying noisily for position at the nest hole.

FLIGHT PATH

For two to three days before fledging, the nestlings take turns sitting in the entrance, begging constantly with raspy voices, watching for their parents to approach with food. Feeding is noisy and boisterous, and the young birds aggressively lunge at the adult. Gradually the adults return less often with food, enticing the chicks to start fledging. The first flight is usually brief; the fledgling lands on the nearest tree and remains motionless for much of the day. The adults feed it occasionally as they continue feeding the siblings still in the nest. Downy Woodpeckers fledge at about 18 to 21 days; Hairy Woodpeckers when about a month old.

FAMILY SECRETS
LESSON IN SHARING

Very young Hairy Woodpecker nestlings arrange themselves so that all get fed fairly equally. Facing one another in the center of the nest, each one drapes its long neck on a sibling, creating something of a circular stack. When parents arrive to feed them, the head of the chick that has waited the longest for a feeding will be at the top of the heap, and that chick will get fed first. After it takes a mouthful, it lowers its head, putting it at the bottom.

The parents feed whichever chick is at the top of the pile, but because of the chicks' arrangement, they all tend to grow at the same rate and stay a similar size.

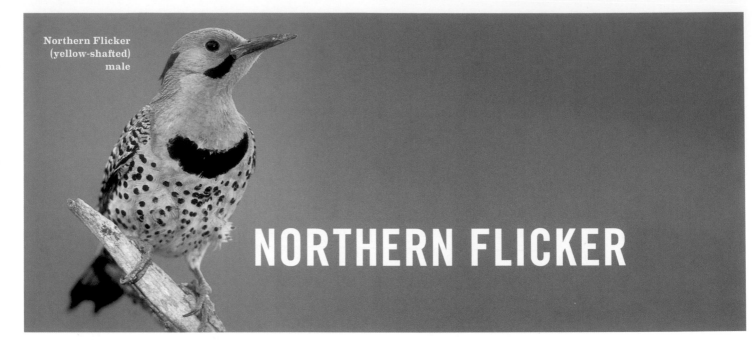

Northern Flicker
(yellow-shafted)
male

NORTHERN FLICKER

The state bird of Alabama, the Northern Flicker spends a lot of time on the ground, but it's a woodpecker through and through. The wing and tail feathers of birds from the eastern half of the continent have brilliant yellow shafts; those from the West have red shafts.

PAIRING UP AND NESTING

A flicker's bright **feather shafts** (thick, central stems) serve as more than mere decorations; their brilliance may indicate a healthy diet and thus a bird's fitness as a potential provider and protector. Interestingly, in areas where both red- and yellow-shafted birds live, birds don't seem to prefer one color over the other, so hybridization is common. Bright wings and tail, along with the large white rump, are often flashed in territorial displays, and the colors may be more important for territorial defense than for attracting a mate.

In spring, flickers become territorial and start performing various behavior rituals. In the wicka dance, several flickers call flicking wings and tail and flaunting yellow or red feathers. The dancers may be two pairs squabbling over a nest tree, two same-sex flickers competing over a potential mate, or a pair selecting a nest site. When two flickers settle into a nest tree, they defend the space with loud, long-calling vocalizations, drumming, displays, and more dances and duels.

Flickers usually nest in open habitats with trees nearby, including open woodlands, forest edges, parks, and backyards.

They are not strong excavators, so they select dead or diseased trees where decay has softened the wood and made it easier to dig. The nest is typically 6 to 15 feet off the ground but can be much higher. Both sexes share the work, the male usually taking the dominant role. Mating takes place on and off throughout the day, often on a nearby horizontal branch.

PARENTING

The female lays one egg per day. Flickers are a well-studied **indeterminate layer**: if one egg is removed each day, the female replaces it. (One female laid a total of 71 eggs!) If all the eggs are removed at once after incubation has started, it will take a week for her to begin laying again. This may happen more than once in a season, but not after early July.

As soon as a female starts incubating, ovulation stops. Both parents develop a large, oval brood patch and share incubation duties. They take turns during the day, but the male always takes the night shift, so incubates about two-thirds of the time.

FEEDING A GROWING FAMILY

Growing nestlings form a circle within the nest, facing outward, resting their chins and beaks upward on the nest wall. As they grow, their parents cannot fit into the cavity to brood them; soon they reach in only for feedings, regurgitating fairly large loads of insect mash with many ants.

FLIGHT PATH

When the nestlings are 18 to 19 days old, the tips of their bills are visible at the entrance. Their heads stick out at 21 days old. By now the feathers are developed and the breast spots obvious, and the parents no longer enter the cavity at all; they feed the chicks at the entrance hole. By the time the nestlings leave the nest at 24 to 27 days old, they look like small adults with slightly softer, duller plumage. We aren't certain how long wild flickers remain with their parents in migratory populations, nor whether pairs remain together over the winter. Studies of marked birds show that when both birds of a pair return to the same area the following year, they usually re-establish their pair bond; "divorces" occur in about 25 percent of pairs.

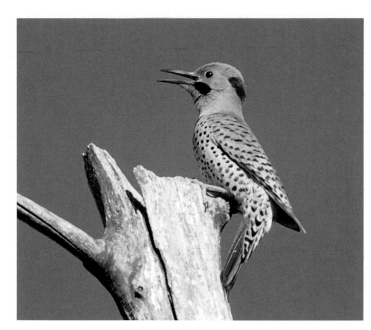

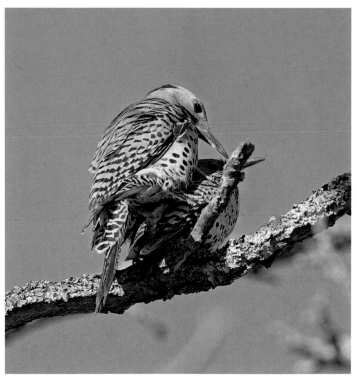

TOP
A territorial male flicker gives the long call, a long series of piercingly loud sounds, *wik, wik, wik, wik...*, from a tree stub above his nest site. Both male and female flickers call from prominent perches to establish territories and attract mates; they also both drum on wood or metal surfaces.

BOTTOM
A pair of Northern Flickers copulates on a branch near their nest. Mating among birds is usually very brief and rarely observed. The female flicker solicits by crouching, leaning forward, and raising her tail slightly to expose her cloaca. The male hops onto her back, maneuvers his tail under hers, sometimes grasping the feathers on her head for balance, then briefly touches his cloaca to hers.

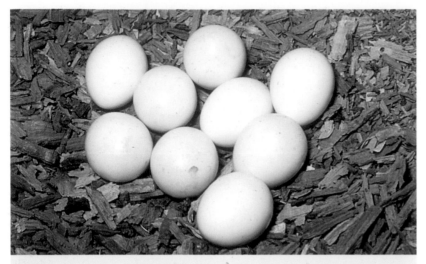

EGGS. Like other woodpeckers, flickers deposit their eggs directly on the nest floor, with no nest material other than the woodchips left over from excavation. The nine eggs in this nest are an above-average clutch. Both adults incubate for 11 to 13 days.

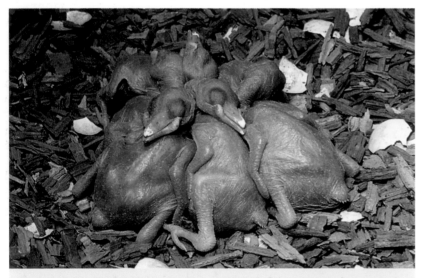

NEWLY HATCHED. Nestlings lie in a heap on the cavity floor among fragments of eggshells. They have a white tip on the bill, the egg tooth, used to crack and then push out of the shell. The egg tooth disappears after a few days. Woodpecker nestlings are altricial, hatching bare and with their eyes closed, and require almost constant brooding at first.

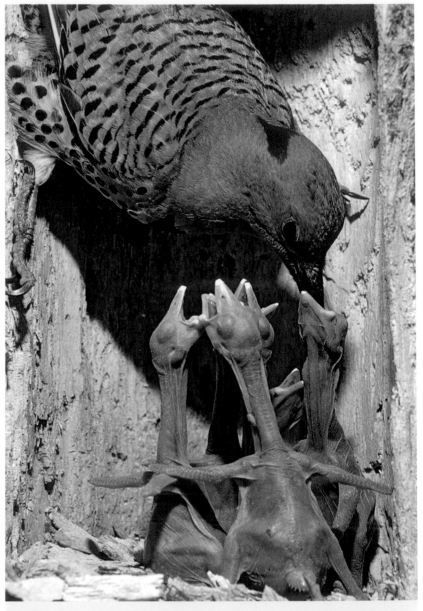

4 DAYS OLD. Five flicker nestlings reach up, begging and waving their tiny wing buds as the female feeds them. Their eyes are still closed, but the beginnings of feather tracts are visible as dark areas against the pink skin covering their wings, and one nestling shows the start of a tail.

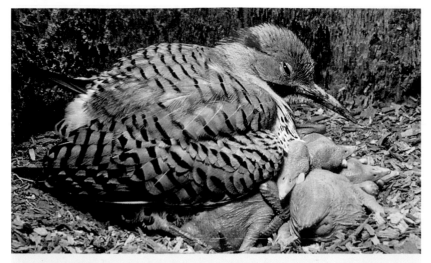

8 DAYS OLD. Feathers fluffed out, an adult male Northern Flicker squats over his nestlings, brooding them. The nestlings cannot regulate their own temperatures at first. A parent broods them almost constantly until their insulating feathers have grown in.

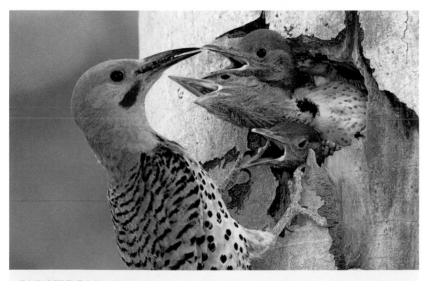

21 DAYS OLD. Three flicker nestlings beg as their father regurgitates ants and ant larvae, some recognizable in his bill. Flicker nestlings peer out of the nest entrance and are fed there by the time they're 16 to 21 days old, but won't fledge until they are 24 to 27 days old, at which point they are fairly strong fliers.

FLEDGLINGS. Fledgling Northern Flickers wait to be fed. Researchers believe the fledglings become independent of their parents about two weeks after leaving the nest.

PEREGRINE FALCON

Peregrine Falcon
adult male

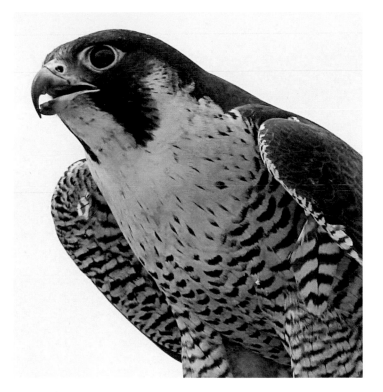

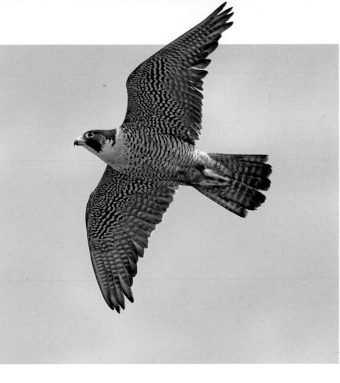

The fastest known bird in the world, the Peregrine Falcon was on the edge of extinction in the 1970s. DDT was one culprit, resulting in extremely thin-shelled eggs that didn't hatch. Humans also killed peregrines to protect their racing and messenger pigeons. But thanks to the work of researchers and falconers, the species is now thriving — an iconic example of the success of the Endangered Species Act when a species is given full protection and research and management to restore it are fully funded.

For many centuries, peregrines have been a favorite choice in the ancient sport of falconry, which has its own terminology: the female peregrine is simply a **falcon**, the male is a **tiercel**, and a nestling is an **eyas** (plural **eyases**). This long history means that wild as well as captive-bred and reintroduced Peregrine Falcons are more thoroughly understood than other birds of prey.

The most migratory peregrines nest on the Arctic tundra and winter in South America, traveling as far as 7,000 miles every spring and fall, often through countries with few protections for migratory birds and weak environmental safeguards. Many reintroduction programs try to release birds from other populations that will not leave North America in winter.

PAIRING UP AND NESTING

As courtship begins, the male peregrine is usually first to claim a cliff, ledge, or nest box. If unattached, he perches prominently near the site, frequently making a loud advertisement wail. When a female flies in, the two perch side by side, peep softly, gently nibble each other's bill or feet, and preen one another. Soon they will perform head bows and a variety of displays.

A peregrine female snacks on prey brought by her mate while he copulates with her on a ledge near their nest site. While mating, the male makes chittering sounds and the female emits wailing calls (unless she has her mouth full of food at the time).

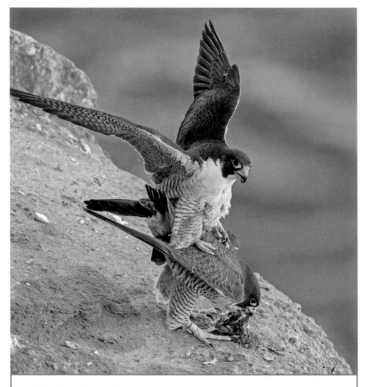

FAMILY SECRETS
COURTING WITH TALONS

The falcon's talons, capable of killing large ducks and even geese, could prove lethal if the male is not very careful while balancing himself atop the female during copulation. He must flap his wings high above his body to balance without pushing himself off. He closes his toes and supports himself on his leg bones (tarsi), disarming those mighty weapons.

The male may start several nest scrapes, but both birds complete the chosen one, squatting and pushing the material backward with their feet. Even when peregrines reuse an abandoned stick nest, they still go through the same scraping motions. This functions the same as nest-building in other birds, helps cement the bond between the pair, and prepares them physiologically for egg and sperm production.

Before copulation and egg-laying, the pair engages in thrilling aerial displays, soaring in loop-the-loops and figure eights. The acrobatics may include **fight playing**, in which they lock talons, touch breasts, momentarily lock bills, or simply tag one another in flight. The male also feeds the female in flight.

The pair starts hunting cooperatively. At first they search for prey at some distance apart, but soon the male begins diving at flocks of birds as the female circles above. If one bird breaks off from the flock, the female stoops, grabbing it at high speed.

The smaller male is faster than the female and more agile in flight. He does most of the hunting for the family during incubation and while nestlings are tiny. The larger female is better suited for protecting the nest against intruders; her heft also helps with heat transfer during incubation and brooding and gives the male a bigger platform for balancing, his claws pulled in, during copulation.

After about two weeks of copulating, the female begins laying eggs. Her body probably doesn't ovulate until there's certainty that the eggs will be fertilized.

PARENTING

In cold areas, incubation may begin with the first or second egg, but in more temperate areas it begins with the penultimate egg. Both sexes have brood patches and both incubate, the female more than the male. Parents roll eggs to reposition or turn them.

Chicks peep from within the egg before hatching, becoming louder after the egg starts cracking. It can take more than 72 hours for an egg to hatch after the first pip, averaging about 48 hours. Usually at least one chick hatches a day or two after the others, and is smaller and weaker than the others. In one study of nests of four, about half of last-hatched chicks died before fledging.

At hatching, chicks are covered with off-white, thick down and their eyes are closed. When they are 10 days old, the adults

THE FAMILY LIVES OF SELECTED SPECIES

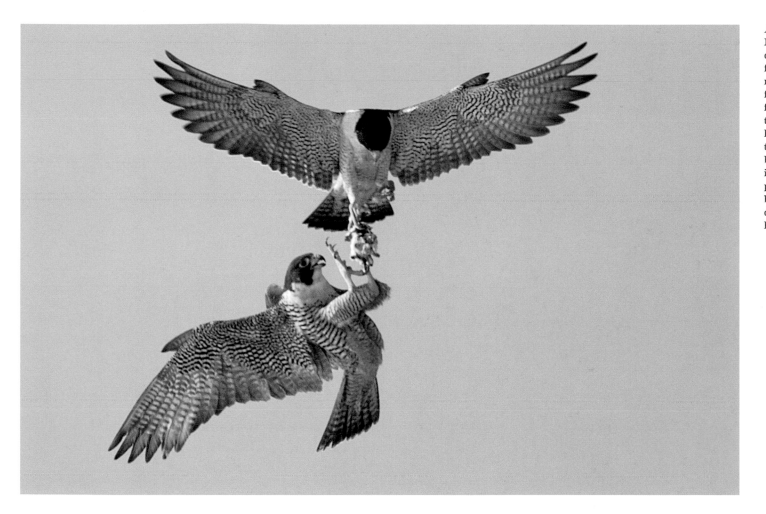

A courting pair of Peregrine Falcons during an aerial food transfer. The male may pass the food directly to the female from foot to foot, as shown here, or from bill to bill or foot to bill; she rolls over in flight to take the prey. Sometimes he may simply drop the food to her from above.

brood them less and spend more time hunting for them. At this point, some of the wing and tail feathers are emerging, still bound in sheaths. The contour feathers that will cover their bodies start showing through the down around the time the birds are 20 days old.

For the first several days, the parents feed them bits of muscle torn from prey animals; at two to three weeks old, the chicks can tear apart chunks of meat and bone on their own.

The parents hunt a huge variety of birds, including shorebirds, game birds, ducks, grebes, gulls, pigeons, cuckoos, and nighthawks, as well as many songbirds. They also capture bats, and sometimes steal mammals and fish from hawks.

On traditional peregrine nest ledges, excrement and food debris accumulate below, in a pile that can rise over 10 feet. Dating of peregrine debris in Australia suggested that material at the bottom of one pile was more than 16,000 years old.

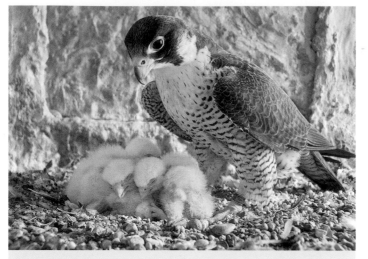

HATCHING. A Peregrine Falcon parent about to brood its four newly hatched nestlings. Semi-altricial, they hatch covered with down like precocial chicks, but are helpless, unable to sit or feed themselves. Their eyes remain slit-like for about 5 days, when they open fully.

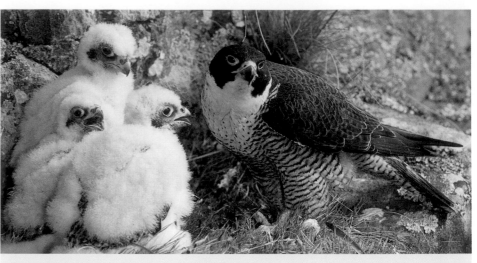

10–20 DAYS OLD. Three Peregrine Falcon nestlings beg from their parent at their nest scrape on a rock ledge. Dark feathers are visible around the edges of their thick down. During the first few weeks, the adults tear the prey into pieces that the young can swallow and digest, leaving out any bones.

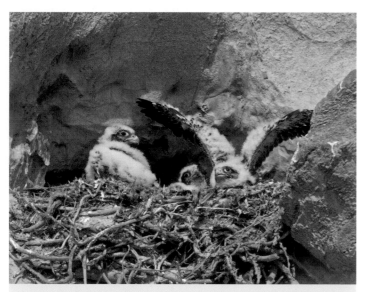

30–35 DAYS OLD. A peregrine nestling, half feathered and half downy, exercises its wings while its two siblings watch. This nest, perhaps originally built by ravens, eagles, or Red-tailed Hawks, is tucked into a rock crevice.

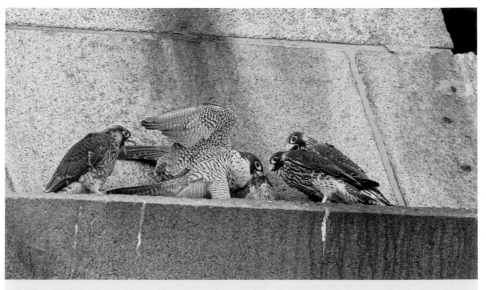

CITY KIDS. The mother Peregrine Falcon delivers prey to her three noisily begging fledglings on a ledge below their nest on the Brooklyn Bridge. Urban peregrines eat pigeons, starlings, and other common species such as robins, jays, and doves.

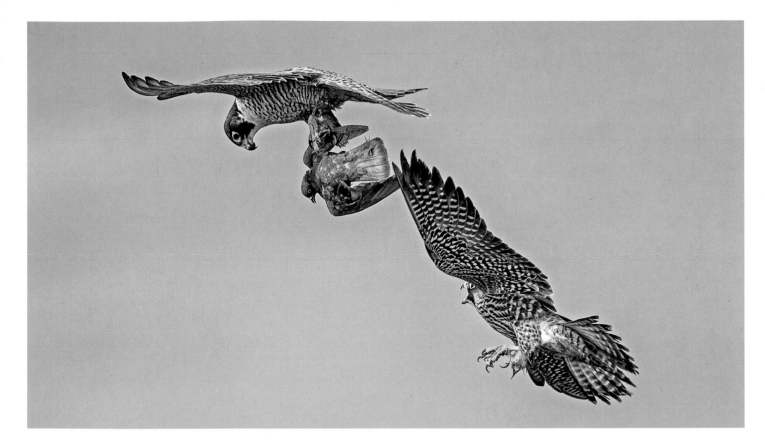

An adult Peregrine Falcon (at top) carries a freshly killed Rock Pigeon, while its fledgling flies up screaming to take the prey. Within 10 days of their first flight, the young falcons chase after their parents, begging for food by giving wailing calls.

FLIGHT PATH

Peregrine Falcon young are semi-altricial, with no clear point when they change from nestlings to fledglings. Some chicks may wander away from the nest scrape at only 10 days old, but most remain close for at least 24 days. Perhaps to encourage exploration and movement, the parents often deliver food some distance from the chicks. In nestboxes on buildings, the young falcons may start clambering along windowsills and ledges, occasionally making tentative jumps. Peregrines make their first flight when 35 to 42 days old.

Females gain weight more rapidly than males, but males develop more quickly and usually fledge a few days to a week before their sisters. The males' smaller size and greater dexterity help them avoid accidents; female fledglings are found grounded more often than males.

Within 10 days, the fledglings start pursuing their parents for food. As the young become more adept in flight, the parents start dropping both dead and live birds in midair. This may be part of basic training, or simply a way to protect themselves from the youthful, talon-wielding attackers.

Peregrine Falcon pairs usually remain mated as long as they both survive. One or both may migrate, but come nesting season, the two gravitate to the nest they've used in previous years. It's up to each to defend its position at that nest against competitors of its own sex, but over time, peregrines learn every nook and cranny of the territory and grow increasingly skillful at defending it.

PHOEBES

Eastern Phoebe
male

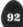

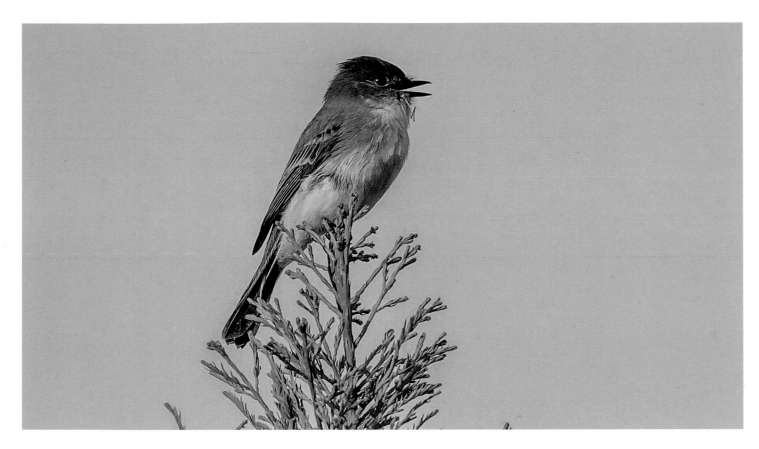

Male Eastern Phoebes sing, over and over, their raspy *fee-bee, fee-bee-bee*, the song that gives them their name. All phoebe males sing energetically at first light. After a male attracts a mate, his singing rate decreases; unmated males may sing throughout the day.

In 1803, when he was about 18 years old, John James Audubon tied silver threads to the legs of Eastern Phoebes nesting on his Pennsylvania property to see if they'd return the following year. This first bird-banding experiment in America was successful: the next spring, Audubon caught two phoebes with thread still remaining on their legs.

PAIRING UP AND NESTING

From early spring until summer, phoebes focus on nesting. All three species raise about two broods each year, depending on climate. In the southern nesting range of Black and Say's Phoebes, some pairs raise three broods, while Say's in Alaska may produce just one.

All three phoebes once nested strictly in caves and on rock outcrops and other sheltered natural structures, but a great many have adapted to human settlements, expanding their population and range as a result. Say's Phoebes, for example, have extended their range north directly along the Alaskan pipeline; some even nest right on the structure. Like all phoebes, they build their mud and moss nests on sheltered rock faces, buildings, and other solid structures, and the pipeline apparently fits the bill where few other nest sites exist.

All phoebes are exceptionally faithful and, as Audubon observed, return year after year to the same nest sites and often the same mates. As soon as phoebes arrive in spring, they start defending their territory, attracting a mate and building a nest.

Female phoebes construct the nest; their mate is usually singing or observing from nearby. Eastern and Black Phoebes use a lot of mud in the nest; all three species work in available plant fibers. The Eastern Phoebe adds a lot of green moss, which makes its nest both lovely and easy to identify. Where they are plastered against a vertical substrate, Eastern Phoebe nests are shaped as a half-hemisphere, as are all Black Phoebe nests. When Eastern Phoebe nests are mainly supported on the bottom, they are shaped as a hemisphere, as Say's Phoebe nests always are. Females may sleep in the nest even before eggs are present.

Incubation in all three species doesn't begin until the clutch is complete or almost complete, but phoebe eggs seem hardy enough to withstand some freezing nights. Only the female Eastern Phoebe incubates. Male Black Phoebes sometimes incubate, and we aren't certain whether male Say's Phoebes do or not.

A female Eastern Phoebe lands with a beakful of animal hair for nest lining. Built on windowsills, porch lights, and other structures, Eastern Phoebe nests always contain a large amount of moss. They use rootlets and mud for the base and cup, and line the cup with soft grasses, fur, and hair.

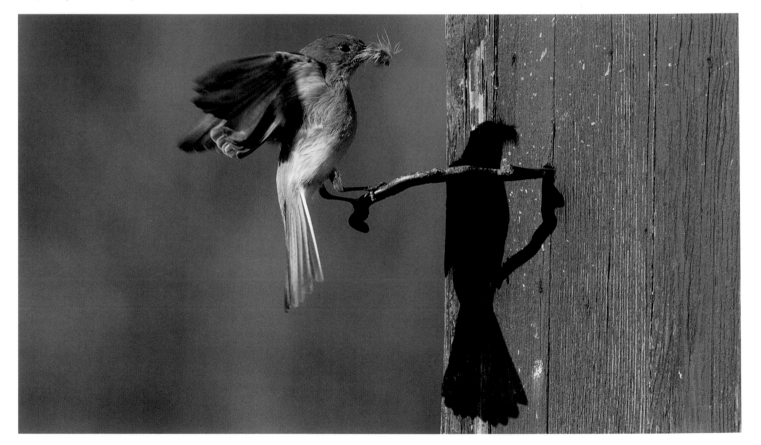

PARENTING

All the eggs in a clutch tend to hatch within a few hours of each other in cool-weather conditions, but over a period of a few days during hot spells, probably because embryos in eggs laid during warm weather get a jump start on development even before incubation begins.

All phoebes feed young nestlings small insects and spiders. As the chicks grow, the parents start bringing larger insects including moths, dragonflies, and beetles. They may also bring bees and wasps, which they usually first beat against a branch; this kills the insect and often breaks off its dangerous stinger.

Phoebe females (and some Black Phoebe males) brood the nestlings regularly. Males feed the chicks, too, though less persistently. If a female Eastern Phoebe dies while chicks are tiny or during cold periods, the nestlings are likely to die too, because the male doesn't brood. If the father dies, the mother can raise the chicks on her own, but any new mate she accepts will usually kill her chicks to force her to start a brood of his offspring more quickly.

Nestling phoebes usually poop while the attending parent is still there to carry off the fecal sac. When the chicks are about 14 days old, they start backing off the nest to poop. With porch nests, this is often when people start getting irritated by their presence.

RANGE NOTES

Associated with water, Black Phoebes are found near streams, lakes, birdbaths, fountains, and rocky coasts in their Southwestern range. Say's Phoebes tend to avoid waterways as well as forests and, unlike the other phoebes, use little or no mud in their nests. They nest in open country, ranging farther north than any other flycatcher, all the way up into Alaska.

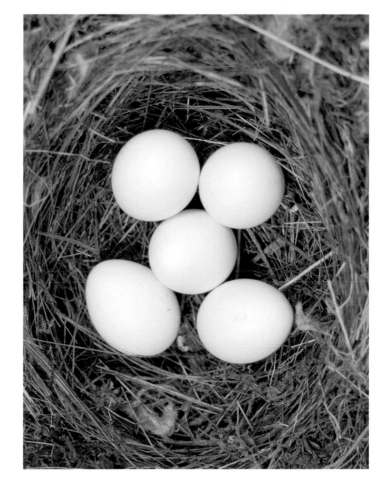

This Eastern Phoebe nest contains five eggs, typical for the species. In some regions, about a quarter of all Eastern Phoebe nests contain a cowbird egg. Fortunately, this nest contains only phoebe eggs. (See Cowbird's Choice on page 97.)

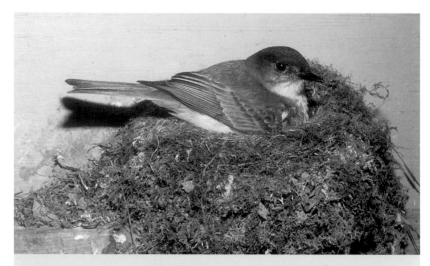

INCUBATION. Most Eastern Phoebes nest on or in buildings, bridges, and other human structures. This incubating female built her nest on a shelf in a barn. Few Eastern Phoebe nests are ever exposed to sunlight.

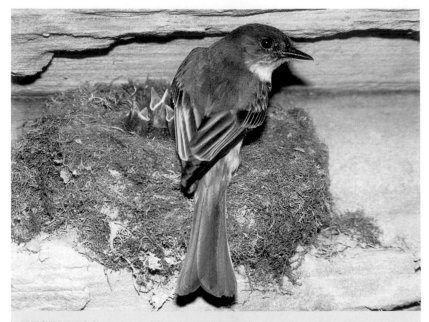

NESTLINGS. Eastern Phoebe nestlings beg for food at their nest on a rock ledge. The tiny birds' eyes are still closed. They sense the arrival of a parent by how the nest bounces when the parent alights, and then they pop up like tiny jack-in-the-boxes. The parents have a powerful instinct to put food (such as small insects and spiders) in those bright little mouths.

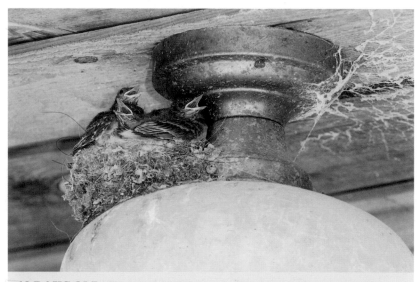

12 DAYS OLD. These nestlings' wing feathers have grown in, but they still have downy heads and backs and very short tails. If undisturbed, they should fledge in about four days. If frightened off the nest at this point, they could be injured in a crash landing. Flapping their wings in the nest will strengthen their muscles and improve their coordination for their first flight.

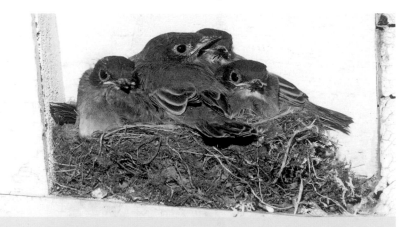

NEAR FLEDGING. By the time the young have been in the nest for two weeks, flapping and exercising for several days, the nest is getting squashed. The mother may reuse the nest for a second brood, but not until she's made significant repairs.

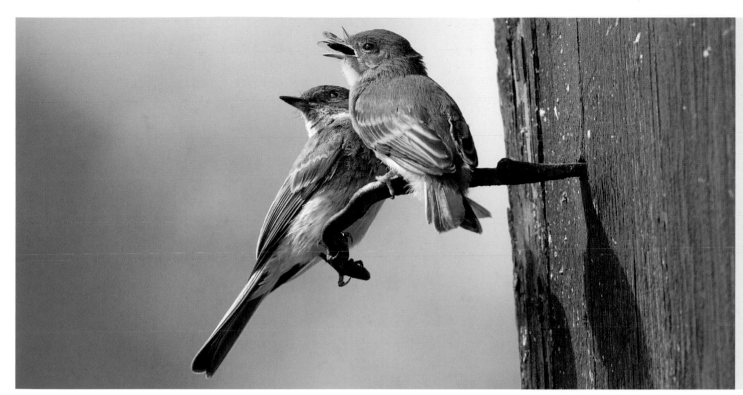

The Eastern Phoebe fledgling in the foreground is swallowing a large insect brought by its parent behind it. As the young get more coordinated, they start catching their own food, with the parents supplementing their diet for another week or so.

FLIGHT PATH

If a predator or person approaches a nest before phoebe nestlings are about 12 days old, the chicks sit tight. They start fluttering their wings when 13 days old; at that point, disturbances can make them flutter from the nest. Because phoebes often nest on ledges with no lower branches to catch clumsy chicks, they may die if they hop or fall out of the nest before about 16 days, when they are more fully feathered and can make a fairly successful first flight.

Some phoebes may remain in the nest as long as 20 days before fledging, and a fledged brood may sit together in dense cover for a few days, making it easy for their parents to find and feed them.

Parents start re-nesting 7 to 14 days after their first brood has fledged. They probably need most of those days to continue feeding their first brood as they help the young birds achieve independence.

COWBIRD'S CHOICE

In some regions, about a quarter of all Eastern Phoebe nests contain a cowbird egg. Mother cowbirds usually dump a phoebe egg before laying their own. When the cowbird hatches, a large shell fragment often "caps" a phoebe egg; the thicker shell makes it virtually impossible for the chick within that egg to hatch. Cowbird nestlings aren't aggressive toward their nestmates, but their huge size and the fact that they usually hatch first make them the first targets for feeding. Most or all nestling phoebes in a nest with a cowbird don't survive. Cowbird parasitism is very rare in Black and Say's Phoebe nests. (See Brown-Headed Cowbirds, page 185.)

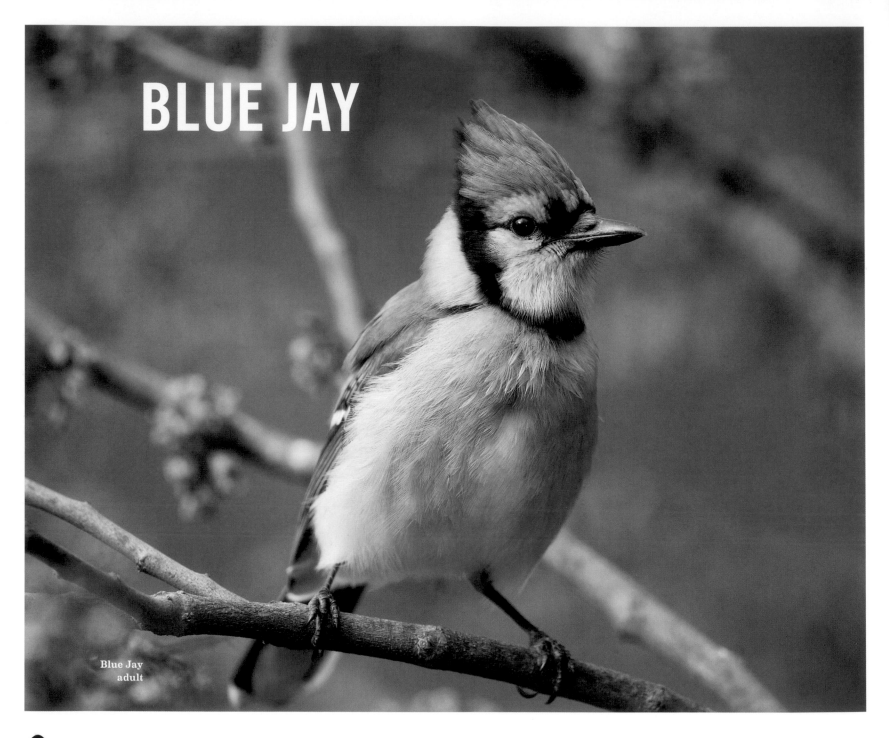

BLUE JAY

Blue Jay
adult

In spring, Blue Jays perform noisy social displays, moving in loose flocks through woodlands and suburban neighborhoods and along shorelines. They fly short distances and then land to perform intense bobbing displays while calling loudly. Flocks fragment and rejoin, and other jays join in or drop out along the way.

Intelligence, curiosity, industriousness. Devotion to family and community. The Blue Jay, one of the most beautiful birds in North America, embodies all those qualities in a 3-ounce package topped off with a perky crest. Blue Jays migrate, although some remain in the farthest reaches of their northern range all winter.

PAIRING UP AND NESTING

The Blue Jay's raucous spring social displays may help sort out conflicts over breeding space. Observations of banded birds show that most of the birds in these noisy flocks are already paired off. Some Blue Jays begin nest-building around mid-March, even as many jays are still migrating. Jays maintain long-term pair bonds and may mate for life.

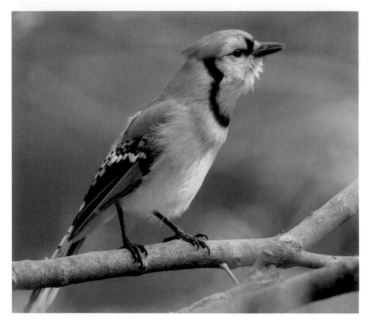

Male and female build the nest together: he gathers materials and she does the actual construction. They build the main structure from sticks and twigs (including some pulled, with effort, from living trees), supplemented with dry leaves, bits of birch bark, Spanish moss, grasses, or other plant fiber. Jays near human habitation are known to weave in bits of paper, cloth, string, magnetic tape, and plastic. All jays line the cup with rootlets and other fairly soft fibers and may finish with soft, wet leaves, which the female shapes to her form by pressing her breast against them.

Blue Jays build their nests in both deciduous and coniferous trees, usually 10 to 25 feet up. Many first nest attempts by Blue Jays are abandoned, possibly because they discover a cat or other lurking predator, or a human watching them too closely. Most people who have jays of any species nesting in or near their own backyard never suspect it.

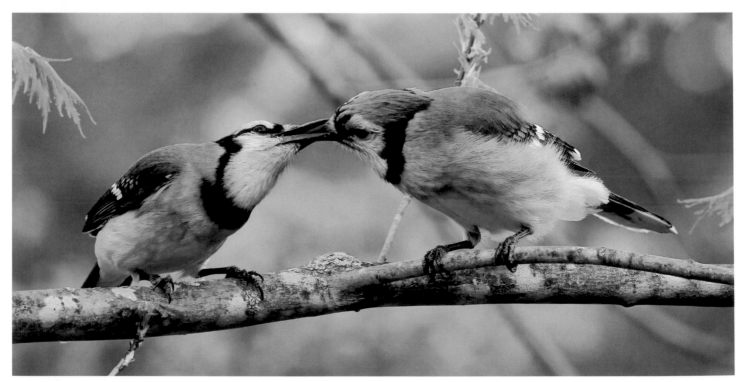

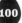

PARENTING

Female jays incubate while males bring food. When the clutch is first completed, the mother incubates for at least 40 minutes out of every hour, increasing her stint until by the final days before hatching, she leaves only for moments. Incubation lasts 16 to 19 days; the entire clutch usually hatches on the same day.

Inside the egg, a developing chick grows cramped just before hatching. Its head is curled under one wing with the tip of the bill and egg tooth pointed toward the smaller end of the egg. The hatchling opens and closes its mouth frequently as it struggles, scraping the egg tooth against the inner shell and using its wings to force the cracked egg open. Parents may eat the eggshell fragments.

Baby songbirds poop immediately after a feeding, when the attending parent removes the fecal sac. While nestling jays are very young and not digesting completely, the parent may sometimes eat the fecal sac. To dispose of it, they may carry it in their bill or put it in the **gular pouch** (a throat sac that serves as a storage bag the way chipmunk cheeks do) to carry it away from the nest.

CRYPTIC COLORING

Blue Jay eggs are protected from sharp-eyed predators by their cryptic coloring, or camouflage. As a species, Blue Jays are accused of raiding other birds' nests, but scientists have found little evidence of that behavior.

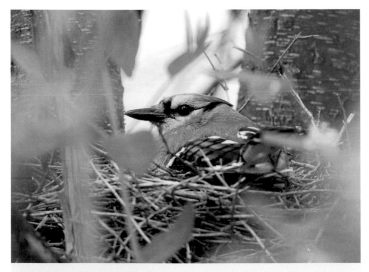

INCUBATION. Well hidden in shrubbery, a female Blue Jay incubates her eggs. She leaves the nest only briefly, to preen, defecate, or be fed by her mate.

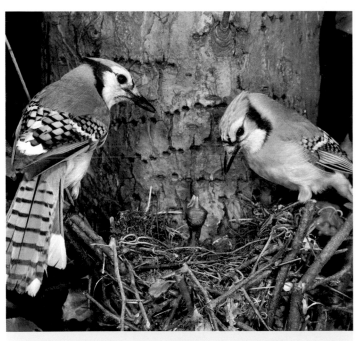

HATCHLINGS. These altricial Blue Jay chicks hatched naked with eyes closed. Within hours they raise their heads to the nest rim and beg. Their eyes open in 5 days.

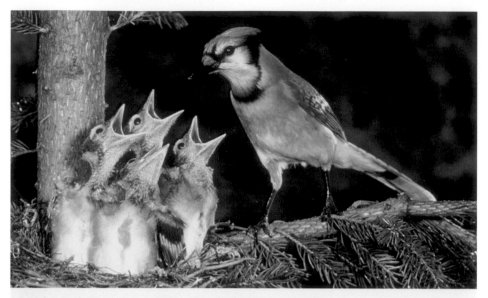

11–14 DAYS OLD. Four nestlings beg from their parent. Their eyes are fully open, their bodies well feathered, and their wing feathers at the brush stage, partially broken out of their sheaths. Their throat feathers are just starting to emerge through the skin. They no longer need brooding, so both parents provide food.

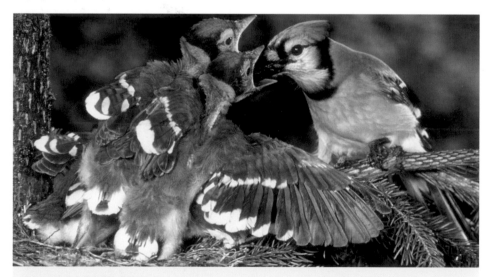

ALMOST FLEDGED. Strong and active, Blue Jay nestlings stand up in the nest to vigorously beg from their incoming parent. Their wing feathers are well grown, but their tail feathers are still very short.

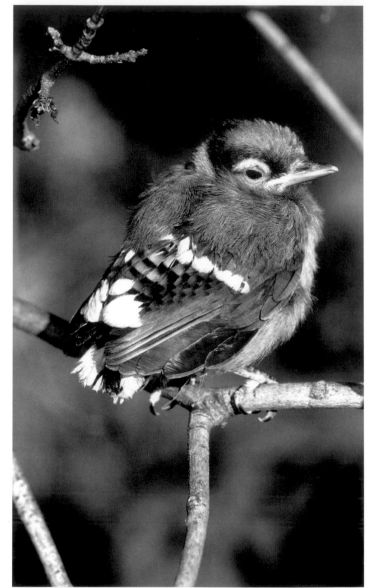

JUST OUT OF THE NEST. Short wings and a tiny tail identify this Blue Jay as a fledgling. Some nestlings may perch outside the nest for a few days before the brood fledges, even venturing short distances, but return to be fed. When 16–21 days old, the brood usually leaves the nest together, but the young birds fly only short distances at first.

FLIGHT PATH

By the time jays fledge, 16 to 21 days after hatching, they are very active, hopping to nearby branches and returning to the nest for feedings. Young jays tend to stay together after fledging, and parents feed them for another month or two. Once their tails reach full length, it's hard to identify jays by age in the field.

Fledgling jays are extraordinarily appealing, with big dark eyes, bright red mouths, and tiny tails. They are interested in everything going on around them, and they notice and learn from their siblings. When one young Blue Jay samples a caterpillar, its siblings watch closely, and are soon sampling caterpillars, too.

Blue Jay pair bonds seem to be permanent, the two staying together year-round until one dies. Banded individual Blue Jays are known to have lived at least 17 years in the wild.

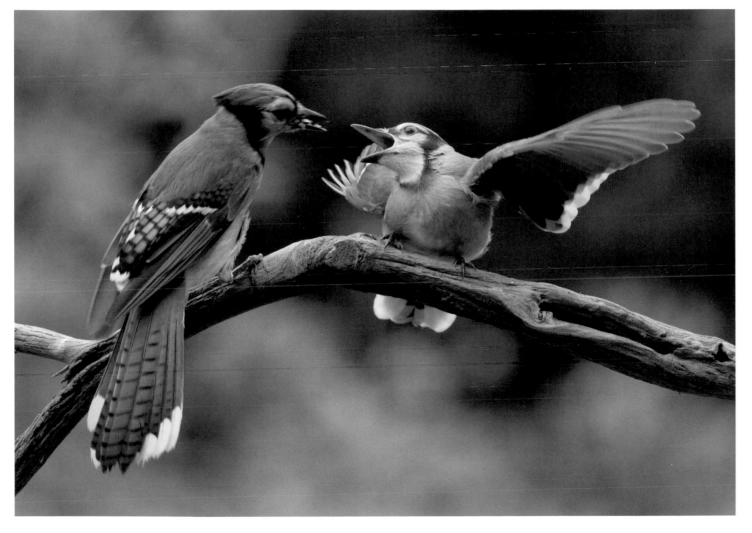

LEFT
A week or two out of the nest, a Blue Jay fledgling begs from its parent. Its wing and tail feathers are well developed, so it can now fly strongly. Blue Jay families can be quite conspicuous and noisy at this stage, the young begging relentlessly as they fly after their harried parents.

AMERICAN CROW

American Crow
adult

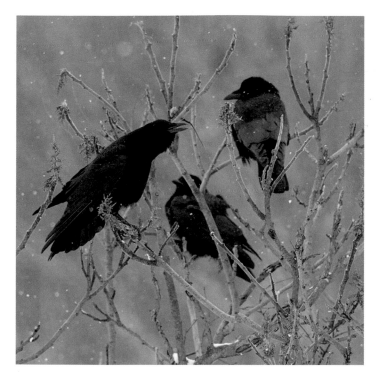

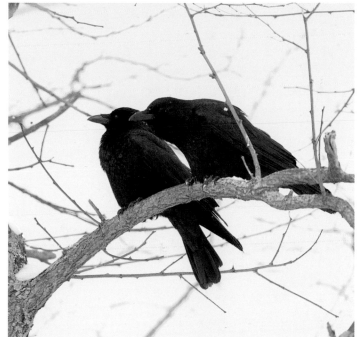

LEFT
American Crows live in extended families, defending a year-round territory in which they nest and forage. They communicate through a wide variety of calls and body postures.

RIGHT
As the breeding season nears, members of a pair often sit close together, engaging in allopreening and billing, in which they gently touch and grasp each other's bills.

Famous for their cleverness, crows compare favorably to humans in many ways, especially their family lives. Mated pairs remain together with more durable bonds, separating and divorcing far less frequently than human couples. Both crow parents, with help from their offspring from previous years, raise new broods of young each year with steady patience. Crows are self-sufficient yet essential members of their community.

PAIRING UP AND NESTING

Within the sightline of people throughout North America every day of the year, crows still manage to keep their private lives private. Researchers at the Cornell Lab and elsewhere have teased out important facts about their breeding habits.

Crows mate for life and stay bonded to their mate throughout the year. This may be why they have few courtship displays. In their bowing display, one crow jerks its head up and down a few times, then bows, clacking its bill. Crows perform this display during courtship and other situations as well.

Surging hormones and increasing day length prompt crows to nest. Many people consider crows carrying sticks as the first sign of spring. Both male and female bring nesting materials, helped by offspring from previous years. The breeding pair constructs the bulky nest of twigs, the mother shaping the inner cup and lining it with fine fibers such as pine needles, dead weeds and grasses, soft bark shreds, and animal hair. Crow nests are often used in subsequent years by Merlins (small falcons) and medium-sized owls.

TOP LEFT
A crow pulls up dead plant material to line its nest in a suburban backyard. Both members of the pair build the nest, sometimes helped by their adult offspring from previous years.

TOP RIGHT
A close-up of a crow's nest containing five eggs. Notice the different materials used in each layer of the nest: large twigs outside, dry grasses next, and reddish-brown bark shreds lining the cup. The nest can be up to 19 inches across.

BOTTOM
A crow's nest with eggs sits high in a white pine. Crows usually hide their nests in the upper third of a tree, often in a crotch near the trunk or on a horizontal branch. They prefer conifers, but will settle for deciduous trees, and often nest near last year's nest, sometimes in the same tree.

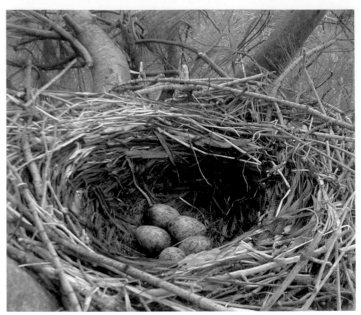

PARENTING

The mother crow starts to incubate after her clutch of three to nine eggs is complete. She incubates all night and 86 to 90 percent of daytime as her offspring from previous years forage and feed her. When off duty, she stretches her legs and wings, defecates, preens, and hurries back to the nest, usually without eating anything. While she's incubating, her mate stays within sight, perched somewhere conspicuous to guard her. If the pair doesn't have helpers, he spends some time away finding food.

The father and helpers spend more time at the nest when the first eggs start hatching, after 16 to 19 days, but now they're less focused on feeding the female and more curious about the hatching process. The eggshells disappear within a few hours or a day of hatching; the birds may eat the shells, carry them off, or just toss them out of the nest.

Brooding the chicks almost continuously for 9 to 14 days after the first egg hatches, the mother leaves only to poop, preen, and stretch a bit. Her mate and their helpers feed her and the chicks. As the nestlings grow and start maintaining their own body temperature, they start needing more food; now their mother starts foraging and feeding them, too.

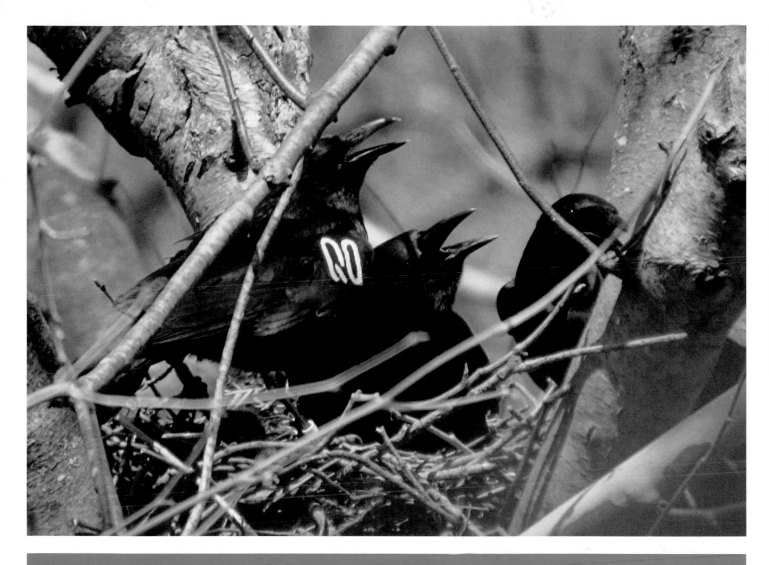

Three adult crows attend a nest. Thanks to wing tags put on birds by researchers at the Cornell Lab of Ornithology and other New York institutions, these crows can be identified and their relationships to one another and to the nestlings can be worked out. This is how we know that crows often breed cooperatively: sons or daughters from previous years help raise their own younger siblings. The entire family participates in feeding the young.

CAWS AND EFFECT

Crows have more than 20 distinct calls, including many variants of the familiar *caw*, differing in quality, duration, and function. A **cawing display**, in which the calling crow partly spreads its wings, fans its tail, and swings its head down and up, may be employed during territorial defense. The **assembly call** is an intense and raucous series of long drawn-out caws, summoning nearby crows to help drive off a predator (frequently a Great Horned Owl).

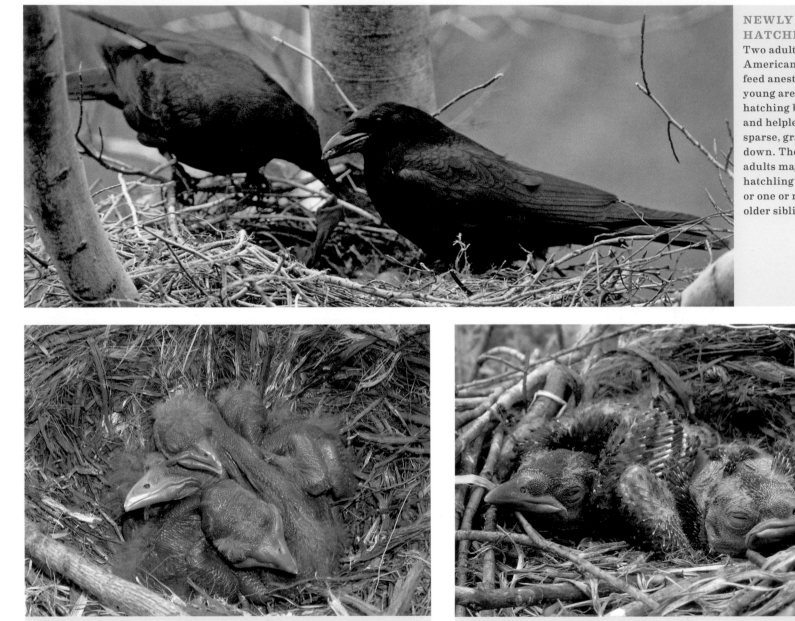

NEWLY HATCHED. Two adult American Crows feed anestling. The young are altricial, hatching blind and helpless, with sparse, grayish down. These two adults may be the hatchling's parents or one or more of its older siblings.

8 DAYS OLD. Four crow nestlings huddle in their nest. Sparse gray down covers crowns and backs; eyes are still closed, not fully open until 10 to 13 days of age. Dark feather tracts are developing under the skin; pinfeathers will break through at 10 to 11 days.

14 DAYS OLD, GROWTH SPURT. Eyes still not quite open and wing feathers at the **brush stage** (partially broken free of their sheaths), these nestlings still have downy crowns. Their bodies grow the fastest between 8 and 18 days, their wings outgrowing their already strong legs.

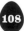

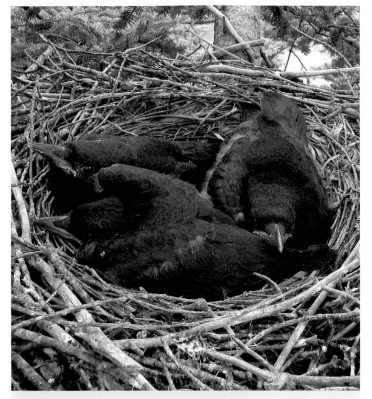

25 DAYS OLD. These nestlings are fully feathered but still show a few wisps of down. Soon they will begin flapping their wings; some may start venturing out of the nest, along branches and back again, days before fledging. The parents may place food on nearby branches to encourage them.

FLIGHT PATH

Crow chicks remain in the nest for at least a month. When they first fledge, their tails are still short and they can only hop from branch to branch. It takes several days to develop flight skills. Fledglings depend almost entirely on their parents for feedings for weeks after leaving the nest. Once they can fly well enough, their parents lead them to areas to find their own food.

Gradually growing independent, they remain in close contact with their family and neighbors for life. Many of them help their parents raise a few broods of siblings before starting their own families.

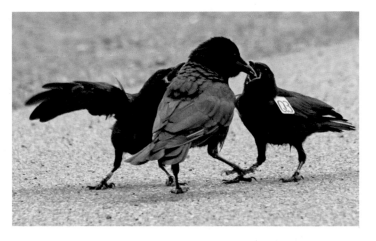

Two American Crow fledglings beg for food from a parent or one of the family's helpers. Before their wing and tail feathers are fully grown, they fly awkwardly and must be fed by adults.

FAMILY FIRST

West Nile virus, which hit upstate New York in 2002 and 2003, is far more lethal to crows than to most animals, including humans. Crows die too quickly to transmit the disease, but their sudden deaths serve as our first warnings of danger.

When dead crows with individual tags began to appear in Ithaca, New York, scientists at the Cornell Lab were able to track and study family ties. After one adult male lost his mate and young to the disease, he spent the remainder of the nesting season helping his neighbors raise their young.

A different adult male died along with the nesting pair in an adjacent territory; his surviving mate took over caring for the neighbors' young. The following year, those adopted crows helped her raise her next brood.

Like humans, crows put themselves and their families first, but they seem to care about their wider community as well.

TREE
AND
BARN
SWALLOWS

Barn Swallow
adult

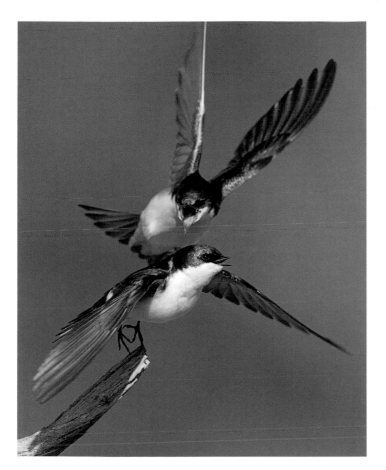

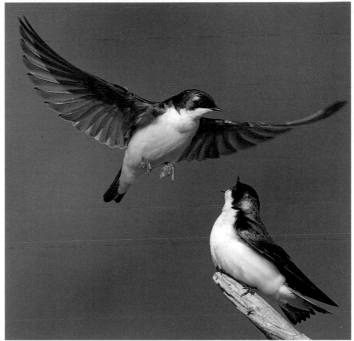

LEFT
A territorial Tree Swallow chases a challenger from a perch near a nest box. Competition over nest sites can be intense.

RIGHT
A courting male Tree Swallow perches near his nest site, pointing his bill upward and flicking his wings at an approaching female. If interested, she joins him, and together they may investigate the nest hole.

"One swallow does not a summer make." That line, coined by Aristotle about 350 BCE, describes the Barn Swallow, one of the most widespread bird species in the world, native to five continents. Barn Swallows that breed in North America migrate to Central and South America for the winter. Tree Swallows, in contrast, are strictly North American, and don't migrate nearly as far.

PAIRING UP AND NESTING

Tree and Barn Swallows often nest in large, loose groups, but each pair maintains a small territory around the nest.

TREE SWALLOWS

Tree Swallows travel in huge flocks, sometimes numbering in the hundreds of thousands, that may swirl around like tornadoes. They return to northern states earlier than most swallows and can survive colder temperatures because they're able to digest berries when flying insects aren't available. During severe weather and during migration, they may roost communally in cavities, sharing body heat.

In early spring, male Tree Swallows arrive, followed shortly by the females. They find and defend breeding territories in wetlands and fields, preferring areas near water over which they forage for flying insects. Severe cold snaps can kill many, especially after nesting begins, when the birds are more reluctant to roost communally. Fortunately, Tree Swallow numbers are fairly robust, so their populations survive these setbacks.

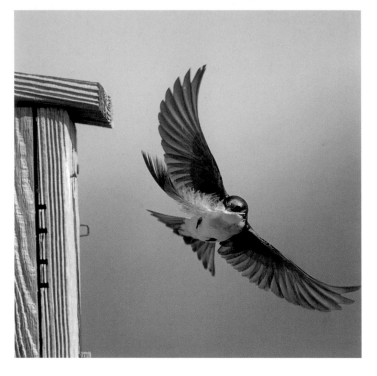

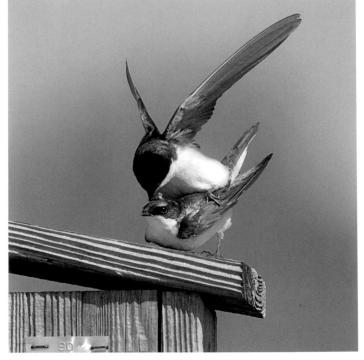

LEFT A Tree Swallow carries a feather to use as nest lining in a nest box. Feathers are valuable commodities, often causing chases and midair battles as swallows try to steal them from each other.

RIGHT Tree Swallows copulate near their nest site. The male hovers above the female, giving distinctive ticking calls as she crouches and raises her tail. He lands on her back, fluttering his wings and grasping her head feathers for balance; he then maneuvers his tail sideways and under hers to make cloacal contact.

Courtship and territoriality are noisy, with constant chattering calls as both male and female chase and squabble with neighboring pairs. They nest in abandoned woodpecker holes, crevices in dead trees, and nest boxes. Male Tree Swallows battle vigorously to defend nest sites, pecking at one another's head and back in midair, on the ground, inside the cavity, or atop the nest box. Occasionally one combatant dies, especially if it cannot escape within a cavity or if it drowns when they're tussling over water. Females chase and may fight each other, but less often

Females chase and may fight each other, but less often and less violently than males.

and less violently than males. Fights in both sexes are much more frequent in areas where the birds outnumber potential nest sites.

When a female Tree Swallow accepts a male's cavity, she starts collecting nesting material on the ground and takes charge of nest construction. The nest is made of grass, pine needles, mosses, rootlets, animal hair, and sometimes human-made items such as cellophane and cigarette filters. The female presses her body into the nest material, shuffling around to form a cup-shaped depression.

Once the basic nest is constructed, the pair, especially the male, may wander far and wide looking for feathers with which to line the nest. When prairie-chickens disperse after performing their dances on spring mornings, Tree Swallows swoop in to snatch feathers the chickens lost in clashes with competitors. Gull colonies and poultry farms provide feathers, too, and duck feathers are plucked from the surface of ponds and lakes or in midair, floating on the breeze.

The more feathers in a nest, the shorter the incubation and nestling periods, the larger the nestlings, and the better chance of fledging. The feathers may provide insulation or a barrier to parasites; research is inconclusive.

BARN SWALLOWS

Arriving later in spring than Tree Swallows, Barn Swallows pair off within two weeks of arrival. They prefer to mate with the available Barn Swallow with the longest, most symmetrical tail.

Once cave nesters, Barn Swallows now gravitate to human structures, nesting under bridges, in culverts, in barns, on the eaves of houses, and in other protected places, but seldom in small cavities. Not nearly as territorial or combative as Tree Swallows, Barn Swallows often nest within a few feet, or even inches, of their neighbors. In one study, about half of all nests included some chicks fathered by a male other than the one raising them.

Both male and female Barn Swallows collect mouth-sized mud pellets to build their nests. Large groups congregate at mud puddles and muddy shorelines to collect the pellets, which they may mix with grasses or other fibers. They carry these pellets to the nest site, a vertical wall preferably above a sturdy support.

After constructing a mud shelf large enough to sit on, the male and female build up the sides. The female shapes the cup. They finish the basic nest in four to eighteen days (depending on weather and the availability of mud), line it with grass, and finish it with feathers. They recognize their own nest in a colony by both its position and visual features. When a pair of Barn Swallows is away from the nest, others in the colony may steal lining materials.

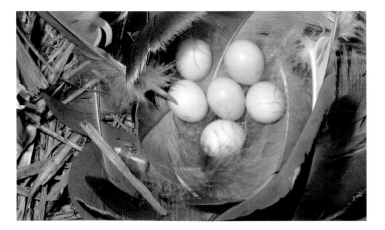

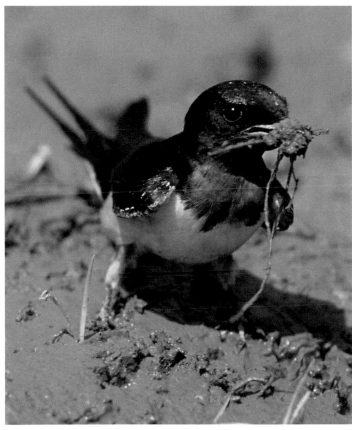

BOTTOM LEFT
Six white Tree Swallow eggs, snug in their feather-lined bed. The parents arrange the feathers with quills pointed under the nest cup, the vanes curling up to cover the eggs.

BOTTOM RIGHT
Barn Swallows rarely come to the ground except when nest-building. They gather beakfuls of mud, often including a little wet grass, from the edges of puddles, ponds, and lakes. They carry these mud pellets to the nest site to build up a cup-shaped outer nest that they line with grass.

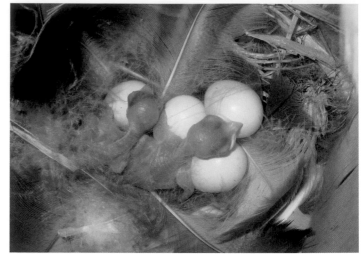

TOP LEFT
A male Tree Swallow peers from the nest cavity entrance, acting as sentinel until his mate returns. The female alternates incubating in bouts of up to 15 minutes with short flights off the nest, waiting to hear the male's chirp nearby before she departs to feed. He doesn't bring her food.

TOP RIGHT
Two tiny Tree Swallow hatchlings lie helplessly on their feathery bed beside their unhatched siblings.

BOTTOM
A Tree Swallow clings to its nest cavity, holding a beakful of insects for its young. The bird's mate arrived first; its tail feathers are visible in the cavity.

PARENTING

Usually, only female Tree Swallows incubate, though males help in some western populations and during severe weather in the East. They incubate for 11 to 20 days, varying with weather conditions. Male Barn Swallows often incubate, though only the females bear a brood patch. Barn Swallow eggs hatch after about 13 days, with extremes at 12 to 17 days.

As nestlings beg for food, their eyes still sealed shut, the comparative sizes of their open mouths seem to show the parent which is hungriest. As soon as a nestling consumes a morsel, it hunkers down and poops, giving the others a chance for a meal. In both species, the parents carry off fecal sacs for the first 10 to 15 days; then they lose interest and droppings collect. By this time, Barn Swallow young back off the nest to poop (this is when many people lose patience with the swallows nesting on their front porch). The droppings accumulate in a mess inside Tree Swallow cavities and nest boxes.

Swallows forage on the wing for flying insects, including flies, dragonflies, damselflies, mayflies, butterflies, and moths. Finding enough for themselves and their young in wet, cold, or windy weather, when insects do not fly, can be challenging.

FLIGHT PATH

The young of both species fledge when 15 to 25 days old and are strong fliers from the start. Barn Swallow young return to the nest to roost for a few nights; Tree Swallow young seldom return. As they grow independent, they join flocks of swallows.

Both species often reuse their nest for a second brood and in subsequent years. Barn Swallows add new mud and replace the lining. Tree Swallows build a new nest above the old one.

Many people clean out Tree Swallow boxes. When birds reuse nest boxes that have not been cleaned, the nestlings are subjected to a higher load of parasites, but nests in these boxes seem to succeed as well as those that are cleaned every year.

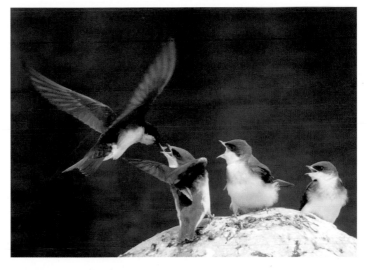

TOP
A Tree Swallow flies in to feed begging fledglings. At this stage, the young fly well for short distances. Parents often fly close to a fledgling during its first flight, chirping agitatedly.

BOTTOM
A begging Tree Swallow nestling reaches out of its nest box to receive an in-flight meal delivery from its incoming parent. Tree Swallow young stay in the nest for 15 to 25 days, far longer than most songbirds. Their flight feathers reach about 85 percent of adult length at fledging.

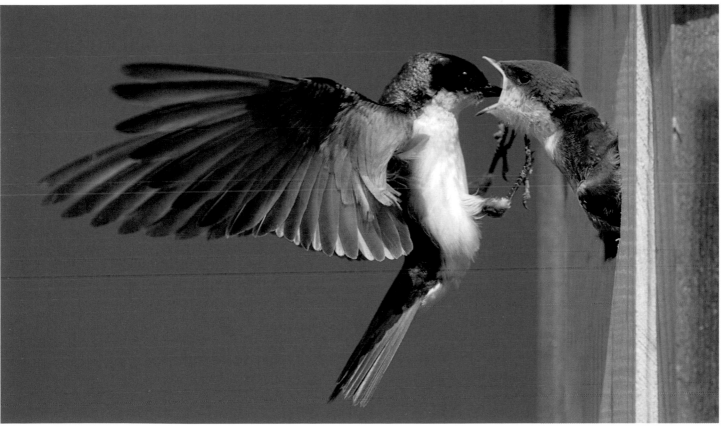

CHICKADEES AND NUTHATCHES

Black-capped Chickadee

CAROLINA AND BLACK-CAPPED CHICKADEES AND TUFTED TITMOUSE

Even during the coldest weather, titmice and chickadees often sing. Tufted Titmice whistle a song that sounds like *peter, peter, peter.*

Beginning on the winter solstice, with the severest temperatures still ahead, days start growing longer and a handful of our tiniest, toughest winter residents are already preparing to breed. The frigid air is filled with their songs — the ethereal *hey, sweetie!* of chickadees and the piercing *peter, peter, peter* of the Tufted Titmouse.

Black-capped and Carolina Chickadees spend the winter in sociable flocks composed of pairs of adults that bred the previous year, single adults that have lost a mate, and young birds that hatched the previous summer. Usually, those young birds are not the offspring of any of the adults and do not have siblings in that flock. At the previous summer's end, each young chickadee left its parents and siblings to join a flock made up of strangers. This may help ensure that as chickadees choose mates over the winter, young birds will not end up pairing with a close relative.

Even though chickadees form pairs in winter, most of their flock activities focus on finding food and shelter and avoiding predators. But during free moments even in January, males occasionally sing their clear, whistled songs.

Males and females each have a position within their flock's social hierarchy. The frequency and strength of songs confirm each male's place on the social ladder. The highest-ranking male and highest-ranking female end up pairing, second-ranked male and second ranked female, and so on.

LEFT
Black-capped Chickadees sing a clear, whistled *hey, sweetie!*

RIGHT
Despite their tiny beaks, chickadees can dig out their own nest cavities in soft, rotten wood, especially in aspen or birch trees. They sometimes nest in birdhouses, especially when we stuff them with wood shavings or sawdust for the chickadees to clear out. Chickadees can nest at just about any height, from near the ground to high up in a tall tree.

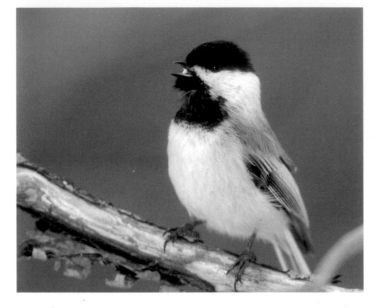

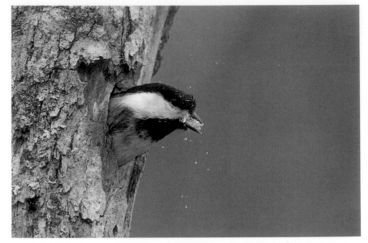

As winter progresses into spring, those pair bonds strengthen. If a paired Black-capped Chickadee dies after other pair bonds in the hierarchy are established, its mate will accept a young, low-ranking chickadee that gets to jump up the social ladder to assume the lost partner's place.

Tufted Titmice are close relatives of chickadees; their range overlaps Carolina Chickadees more than it does black-caps. Like chickadees, they begin singing in winter, their whistled song often interpreted as *peter, peter, peter.* Unlike chickadees, Tufted Titmice usually remain on or near their breeding territory all winter, spending the season in small family units of one adult pair and, often, one of their offspring from the previous summer. Come spring, most young titmice go off and find a mate, but some occasionally remain with their parents, helping them raise a new batch of young. This behavior is not found in any other American chickadee or titmouse.

Territorial year round, titmice don't need to establish new territories come spring. Chickadees do: on fine days, pairs may separate from their flock for a while to claim and start defending a nesting territory. During bad weather and when searching for

SURVIVORS

At dawn on February 2, 1996, the official weather station thermometer in Tower, Minnesota, read -60° F (-20° C), the coldest temperature ever recorded in the state. News reporters gathered to report on and celebrate the endurance of an intrepid man who had slept out in a well-insulated snow fort with a camp stove that night.

No one on the scene paid any attention to the many Black-capped Chickadees calling in the background. Those tiny birds, weighing a third of an ounce, had been out all night, too, naked as jaybirds, each sleeping in its own tiny tree cavity. The chickadees didn't consider their overnight survival a triumph; it was just business as usual. And on this coldest dawn in Minnesota history, these chickadees were not just making the usual *chickadee-dee-dee* calls — they were also whistling their *hey, sweetie!* spring song.

food, they gravitate back to their flock, which won't completely break up until late April or May.

Throughout the year, titmice and chickadees sleep in woodpecker holes, natural cavities, bird boxes, and other little crevices. Chickadees often excavate their own cavities in birches or aspens. They also roost in trees with harder wood, taking over a cavity excavated by another bird or created naturally, such as at a rotten knothole. Tufted Titmice are more dependent on already-existing cavities.

Though sociable, chickadees and titmice seem to need more personal space than many songbirds. At feeders, they take turns grabbing a seed and flying off to eat in seclusion rather than feeding side by side like finches. And in their roosting cavities, even on the coldest nights, chickadees rarely share body warmth by huddling. After male nestlings fledge, virtually none will share a cavity with another chickadee again in their lives; females will share cavity space only with their own young while incubating eggs and brooding chicks.

PAIRING UP AND NESTING

As spring advances, already established pairs of chickadees and titmice focus on settling down to raise a family. After a pair finds or excavates a nest cavity, they work together to build the nest, using vegetation for the cup and fur and soft plant fibers for the lining. They find clumps of fur here and there, pulling some off animals, dead or alive. One of the authors watched a Tufted Titmouse pluck fur from a road-killed red squirrel, and another pluck hairs from the tail of a sleeping raccoon.

Building the nest together is one of the activities that help strengthen the bond between mates. If a nearby chickadee male sings more than a particular female's mate, however, she can't help but gravitate to him occasionally, so some of her young may have a father different from the male raising them. Fortunately, male chickadees never demand paternity tests.

After clearing out a cavity, chickadees build a cup nest from mosses and other fibers, lining it with soft fur they may pick directly off animals or from clumps offered by people. This chickadee is taking a beakful of alpaca fiber from a hanging ball. They also take wads of dog or cat fur people pull off brushes after grooming pets.

Despite their tiny size, chickadees and titmice produce more eggs in a single clutch than most songbirds do. A day or so after her nest is ready, the Black-capped Chickadee female starts laying one egg early each morning until she has a clutch of six to eight eggs. Sometimes she produces even more: a nest with nine is fairly common, and one chickadee clutch contained 13 eggs. Titmice weigh significantly more than chickadees but produce similar-sized clutches.

One of the authors watched a Tufted Titmouse pluck fur from a road-killed red squirrel, and another pluck hairs from the tail of a sleeping raccoon.

These birds literally put all their eggs in one basket — unless a nest is destroyed early in the process and the pair starts over, this will be their only shot at raising young for the year.

TOP LEFT
Eight Black-capped Chickadee eggs rest on a bed of moss, animal fur and hair, and wood shavings. To keep the eggs warm and moist while she's gone, and perhaps to hide them from predators, the mother often covers the eggs with nest material before leaving.

TOP RIGHT
Four tiny Black-capped Chickadees have just hatched; at least two siblings are still inside their eggs. The soft nest materials protect their fragile skin. Even before their eyes open, they pop up at their parents' arrival. The adults eagerly stuff food into those large, brightly colored mouths.

BOTTOM
A Carolina Chickadee brings a caterpillar to its 12-day-old nestlings. Their eyes are open and their feathers still encased in sheaths.

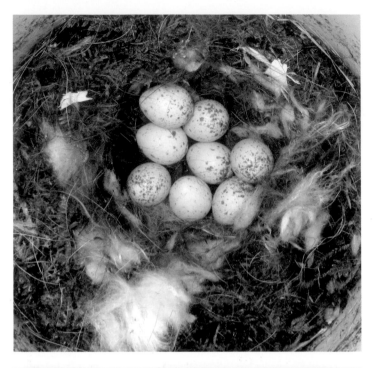

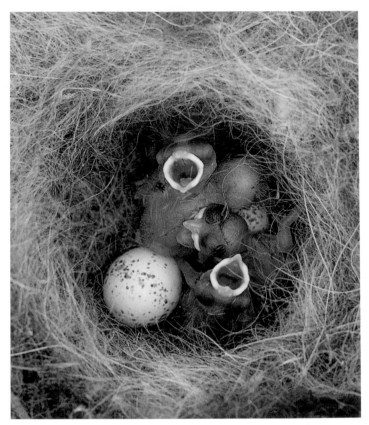

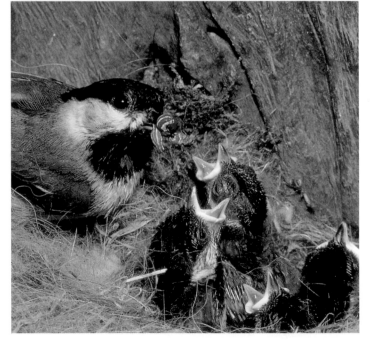

PARENTING

Only females incubate the eggs. The female chickadee spends about 75 percent of daylight hours and all night on the job until the eggs hatch in about 13 days. Her mate spends his time searching for food for the two of them; he feeds her while she's both on and off the nest. For the first few days after the eggs hatch, when the nestlings can't regulate their body temperature, the male continues bringing food for the entire family while the female broods the nestlings. As the chicks grow in size and hunger, the female starts searching for food, too, and both parents feed them fairly equally by the time they are about a week old. Tufted Titmouse parents occasionally get help from a youngster they raised the previous year.

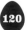

FLIGHT PATH

Trees and shrubs provide a built-in safety net for nestlings that grown up in open cup nests — lower branches that can catch little songbirds hopping out of the nest before they can fly. Cavities, however, are usually dug into the trunk or other part of the tree with no such safeguards. Unless frightened by an intruder, nestlings in cavities don't leave the nest until they are more mature and can fly to a safe spot where they can build up their flight muscles.

Chickadee and titmouse fledglings remain dependent on their parents for two to four weeks after leaving the nest. Neither reduced feedings nor parental aggression seem to force the young away — they just suddenly move on. One or two titmice may remain with their parents through their first winter, but it is unpredictable.

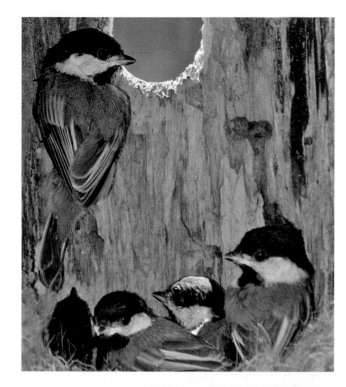

TOP
These five Black-capped Chickadee nestlings are almost ready to fledge. If an intruder frightened them from the nest now, they'd usually survive, but the longer they remain in the nest, the stronger their first flights will be and the better their chances of survival. The chickadee at the entrance will most likely be the first one fed next time a parent arrives.

BOTTOM
Chickadee fledglings persistently beg for food even as they start catching insects and spiders on their own. Fledglings have perfect plumage and yellow mouth linings, while adults, like the one on the right, look bedraggled after focusing entirely on family obligations for so many weeks. After the chicks depart, adults molt into fine new feathers that will carry them through the coming winter.

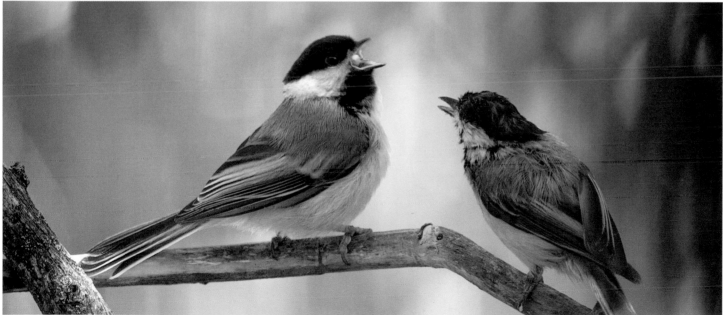

RED-BREASTED AND WHITE-BREASTED NUTHATCHES

White-breasted Nuthatch
male

Frequent and popular visitors at many bird feeding stations, nuthatches seem to spend their lives topsy-turvy, facing down rather than up as they wind about tree trunks, peeking into bark crevices from a different angle and perspective than other birds. Although they often associate in loose feeding flocks with other birds, they seem to maintain personal space, giving them a standoffish demeanor.

Found across most of the Lower 48 and southernmost Canada, the White-breasted Nuthatch is a non-migratory species preferring deciduous forests. The Red-breasted Nuthatch, about half the weight of the white-breasted, is far hardier and associates with fir and spruce trees. Its breeding range extends north into Alaska and most of Canada, south below the northernmost tier of U.S. states only in mountains and in coniferous forests along the West Coast. It wanders irregularly in winter.

In winter, both species associate with chickadees, titmice, and other birds in feeding flocks. Both find small insect larvae and pupae in tree bark, and in winter both feed primarily on seeds. Red-breasted Nuthatches specialize on small conifer seeds, and the larger White-breasted Nuthatches on acorns, beechnuts, and other mast. Both come to feeders for sunflower seed, suet, peanuts, and peanut butter.

PAIRING UP AND NESTING

Established pairs of White-breasted Nuthatches remain on their territory year-round. Unmated males spend a lot of time in winter singing to attract a female onto their territory. When a female approaches, the male continues to sing and to display the plumage on the back of his head — the darker the nape feathers, the more attractive he appears. If she stays near, their courting behaviors may advance to exchanging *hit-tuck* notes and courtship feeding.

The Red-breasted Nuthatch's wandering ways make attracting a mate trickier. In years when a pair doesn't migrate, they may remain on their breeding territory all winter, ready for the next breeding season. New pairs seem to form after birds return to the breeding territory. A male starts by singing the courtship song, swaying and presenting his back to the female, perhaps to show her how dark his head feathers are. If she accepts him, they engage in courtship flights and feeding before they mate.

White-breasted Nuthatches nest in natural cavities, old woodpecker holes, and nest boxes. They sometimes enlarge the entrance hole but seldom excavate their own. Both sexes bring material, but the female constructs the nest, covering the floor of the hole with bark flakes and lumps of earth, then shaping a nest cup of grasses, rootlets, and bark shreds, and finally adding a lining of fur, wool, hair, and feathers. One lined her nest with wadding from an old, discarded mattress.

Red-breasted Nuthatches usually start excavating their own nest cavity as a pair, and then the female hollows out the inside chamber while the male brings her food. Unmated males may begin excavating one or more entrance holes and singing near them in an attempt to attract a mate. Although associated with conifers, Red-breasted Nuthatches seem to prefer aspens for nesting, probably because the soft wood is easy to dig into. They toss sawdust and woodchips out of the entrance hole, letting them accumulate at the base of the tree. Excavation takes up to 18 days. The female uses various fibers to construct the nest and lines it with fur, feathers, and other soft materials.

Incubation lasts about 13 days for both species. The female keeps the eggs toasty; her mate provides some of her food.

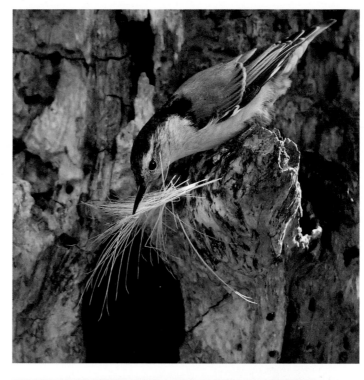

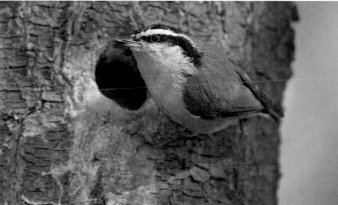

During cold weather, he brings food most frequently, allowing her to remain on the eggs for longer periods; in hot weather, she can spend more time off the eggs, finding her own food.

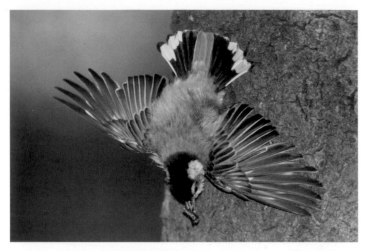

TOP
This male White-breasted Nuthatch performs a distraction display, spreading his wings and swaying. Either male or female may do this to startle and distract an approaching predator, such as a chipmunk or squirrel.

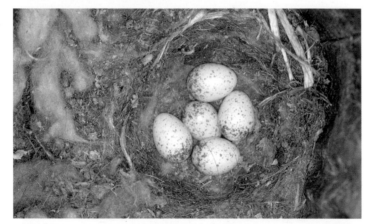

MIDDLE
Five White-breasted Nuthatch eggs lie in their well-insulated nest of grasses, shredded bark, and pine needles, lined with animal hair and strands of wool.

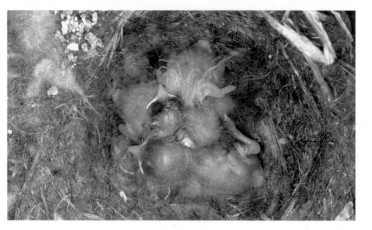

BOTTOM
Four newly hatched White-breasted Nuthatch nestlings huddle in their nest, awaiting a parent's food delivery. Very little research has been published about nestlings of this species, because they only occasionally use nest boxes and their natural cavity nests are hard to access.

DEFENSE STRATEGIES

Both nuthatches have their own special ways of deterring predators from their nests. Red-breasted Nuthatches paint the entrance hole, in and out, with sticky resin from various conifers, probably to deter predators and nest competitors. Both adults carry globules of resin in their beaks or on bark scraps and use pieces of bark to apply it, the only known use of tools for this species. Males work the resin around the outside of the cavity entrance; females focus on the inner walls of the entrance, especially when they start incubating.

They continue applying resin five to ten times per day during incubation and brooding. They're adept at diving into the nest at high speeds to avoid getting the sticky substance on their feathers, although a female was once found dead, stuck to the resin at her nest.

White-breasted Nuthatches also use their bill to smear a substance on their nest cavity to ward off predators, but in their case they choose a crushed beetle, stink bug, caterpillar, or other insect that gives off a bad smell or noxious defense chemicals. They may also add strong-smelling material to the nest — one nest lining contained cigarette butts. If the nest is threatened directly, White-breasted Nuthatches perform distraction displays, swaying with outspread wings; this may startle a squirrel or other potential predator.

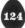

PARENTING

Both parents feed the young. Only the female White-breasted Nuthatch broods the nestlings, but a male Red-breasted Nuthatch may occasionally share incubation duties with his mate, and may roost in the nest cavity overnight. In both species, both parents feed the young insects, and both parents fly away with fecal sacs, dropping them at some distance from the nest. The nestlings seem to develop as typical songbirds do.

FLIGHT PATH

Red-breasted Nuthatches first leave the nest between 18 and 21 days after hatching; it takes the larger White-breasted Nuthatches about 26 days to fledge. Fledglings of both species associate with their parents for at least two weeks, possibly longer.

Because so few nuthatches are banded as nestlings and tracked as individuals, it's not known for certain whether they remain together in family units over winter, as some titmice do, or whether the young disperse, as some chickadees do. With increasing use of nest cams, some nuthatch mysteries may soon be solved, but these easily observed backyard birds may keep some of their secrets from us for many years to come.

TOP
Inside the nest cavity, a male White-breasted Nuthatch offers a large caterpillar to its well-feathered, almost grown nestlings. Which will receive it?

BOTTOM
Sitting next to its sibling, a Red-breasted Nuthatch fledgling stretches its wings as the two wait for their parents to feed them. They stay with the adults for at least two weeks after fledging. Some may remain in family groups through the winter.

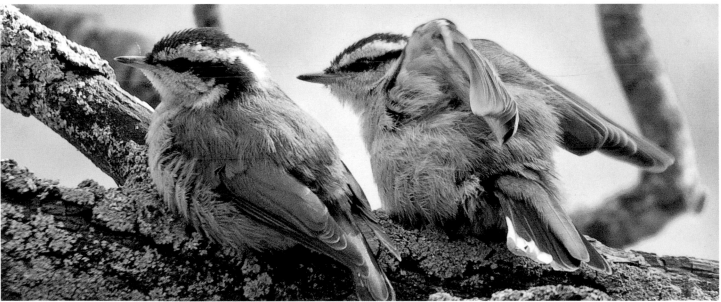

HOUSE WREN

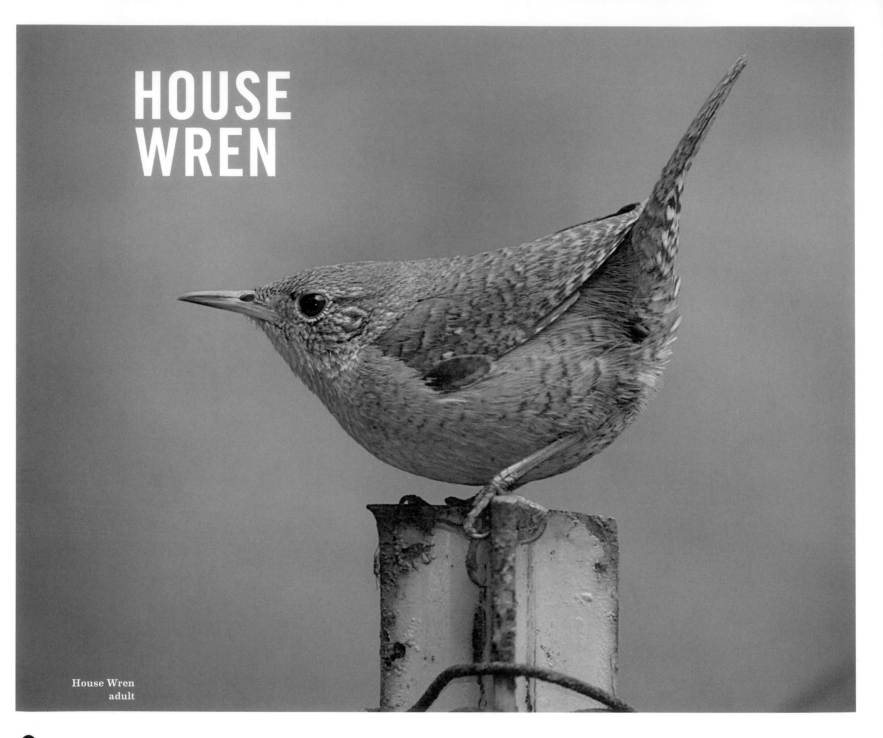

House Wren
adult

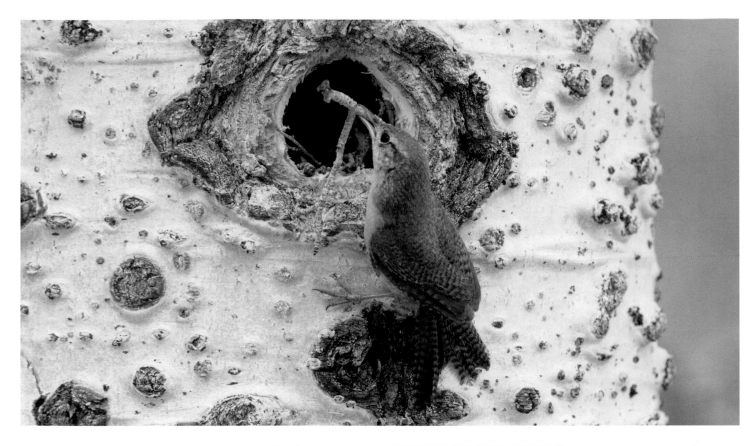

A male House Wren brings a stick to the entrance of an old woodpecker cavity in an aspen. As soon as he claims a territory, the male starts filling empty cavities with sticks. The female chooses one cavity for her actual nest.

House Wrens weigh a mere third of an ounce (about 10 grams) — you could mail three with a single stamp. Mortality is so high that even though each pair raises about two fairly large broods each season, few wrens reach their first birthday and populations remain steady. Fortunately, once House Wrens survive their first migrations and first winter, their life expectancy is longer. One bird banded in 1984 in New York was retrapped and released a full nine years later, still healthy.

PAIRING UP AND NESTING

In spring, as soon as male House Wrens arrive on territory, they claim every potential nest site they find. These are usually woodpecker holes, other tree cavities, and birdhouses, but can include empty cow skulls, fishing creels, watering pots, tin cans, hats, boots, shoes, the nozzle of a pump, holes in walls, mailboxes, overalls hanging on a clothesline, and even the axle of a car that was driven every day.

When a male discovers a possible site, he starts filling it with sticks — often hundreds — building a platform with a depression for the nest cup. He also piles up twigs above the platform that serve as a barrier between the entrance hole and the nest itself.

LEFT
A House Wren packed this nest box almost to the top with sticks. The actual nest is tucked out of sight in a depression in the back right corner. The sticks often form a barrier between nest and entrance, possibly to protect against cold weather, predators, or cowbirds. The stick platform also raises the nest so its lining stays dry if rainwater leaks in.

RIGHT
A male House Wren displays to his mate (out of sight above him at their nest hole) by quivering his wings and singing excitedly. A similar display occurs during territorial defense against intruding male wrens.

When his loud, persistent singing attracts a female to his territory, he acts like a tiny real estate agent, showing her each of his little properties as a "fixer-upper." If she chooses one, she immediately gets to work, finishing the platform and nest cup, and then lining the cup with soft materials such as grasses, soft inner bark, and fur or hair, finishing it off with feathers. Sometimes spider egg sacs are included in the nest. The spiderlings from these sacs may consume nest parasites that otherwise could harm the wrens.

She may make 300 or more trips to the nest site during construction before she lays her first egg. She lays one egg per day in early morning.

Steady incubation begins when she has a full clutch of three to ten eggs, and the eggs hatch in the order laid, sometimes all on the same day. Some males may feed females during incubation, but most spend that time singing and staying close to, but not on, the nest when the female needs a break.

THE FAMILY LIVES OF SELECTED SPECIES

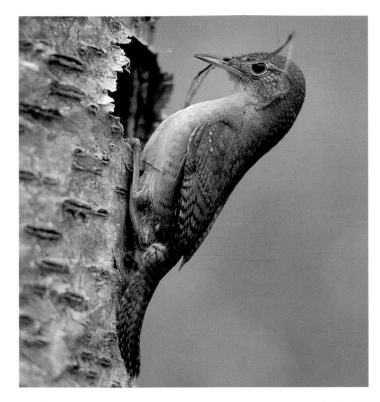

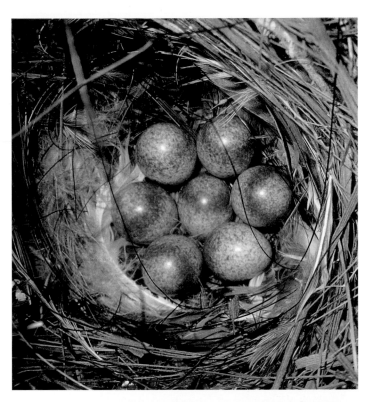

TOP LEFT
A female wren brings a beakful of grass as nest material. After pairing, she finishes off the stick platform and nest cup, which she lines with soft grasses or inner bark, animal hair or fur, and feathers.

TOP RIGHT
This House Wren nest contains seven eggs. House Wrens produce one or two broods per year, often switching mates between broods. The female incubates alone for nine to sixteen days; incubation is shorter later in the season.

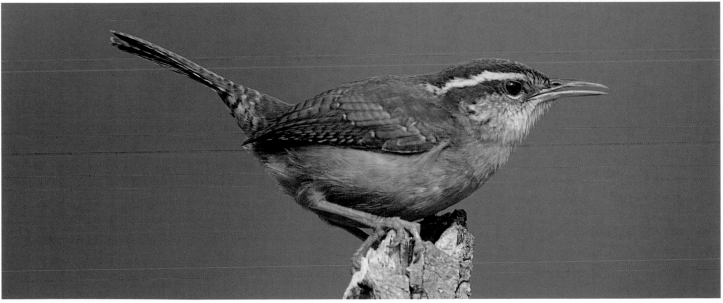

BOTTOM
Carolina Wrens also nest in boxes. They are non-migratory, and mated pairs remain together year-round. Pairs of many of their tropical relatives sing complex duets, but only the male Carolina Wren sings its loud *tea-kettle, tea-kettle, tea-kettle* song. Many of their nesting behaviors are similar to those of House Wrens.

NEWLY HATCHED. Four House Wren nestlings lie next to an unhatched egg. Altricial, they hatch with eyes closed and mostly naked except for sparse, dark down. The yellow color showing through the skin at their rear ends is the remains of the yolk sac, which nourished them inside the egg.

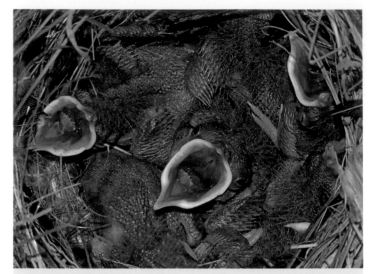

HALF-GROWN. Begging nestlings show their orange gapes edged with pale yellow flanges. Now half-grown, their eyes are almost fully open, pinfeathers cover their wings, and dark feather tracts show on their heads and along their backs.

15–17 DAYS OLD. House Wren nestlings near fledging age are packed together in their nest. They are fully feathered although their wings and tails are not yet adult length, and their bills are still edged with swollen pale yellow flanges.

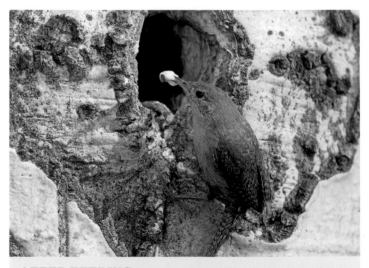

AFTER FEEDING its young, a House Wren backs out of the nest cavity with a fecal sac that it will deposit on a branch 40 to 100 feet away from the nest. Parents also carry similar-looking spider egg cases into the nest. The spiders may control insect pests.

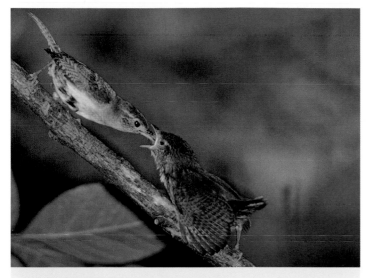

A HOUSE WREN adult feeds its fledgling. Now the chick's wings are almost adult length, but its tail is still quite short. For nearly two more weeks, the parents will feed it (depending on whether the female has switched mates and/or started a second brood).

PARENTING

About 12 days after the last egg was laid, the first egg hatches and the father House Wren is suddenly very busy. Until the hatchlings can regulate their body temperature, he spends his time searching for food while mom broods the chicks to keep them warm. As they grow, both parents feed them.

FLIGHT PATH

When the first-hatched chick is 15 to 17 days old, the chicks fledge, all within just a few hours. Rarely, the smallest isn't ready to fledge and gets left behind; that one invariably dies because the parents are so focused on keeping track of the others.

Around this time one of the parents (usually the female) may grow restless and be drawn to a new mate's territory. Back at the nest, the remaining male may start singing to attract a new mate, even while caring for the fledglings. He shows her some of the cavities he's already filled with sticks. If a female accepts one, she finishes the nest and starts laying eggs while

he attends to his previous brood. Switching mates like this allows each individual to maximize the number of chicks raised each year.

House Wrens wearing U.S. Fish and Wildlife Service leg bands have survived more than nine years.

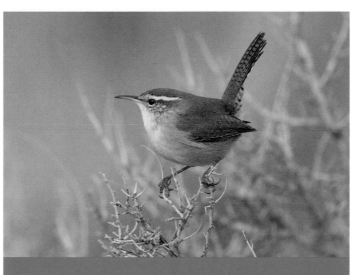

BEWICK'S WREN

Bewick's Wren was once the common "house wren" of the Appalachian Mountains and the Midwest. Its disappearance coincided with the range expansion of House Wrens, who puncture the eggs of birds on their territories and may have especially targeted Bewick's Wrens as competitors for nest sites. Pesticides and competition with introduced House Sparrows and European Starlings also figured in the species' decline in the East.

Fortunately, Bewick's Wrens are doing well over most of their range in the West. Non-migratory populations are monogamous over a nesting season and possibly from year to year. Birds of both sexes seldom wander far from their nesting territories at any time of year.

BLUEBIRDS AND ROBINS

Eastern Bluebird
male

EASTERN, WESTERN, AND MOUNTAIN BLUEBIRDS

It's easy to understand why we humans associate bluebirds with happiness, because how can we not feel happy seeing them and hearing their soft, lovely song on beautiful spring mornings? Other birds may have equally pleasing songs, but few sing from as conspicuous perches as bluebirds do. And the easily observed habits of Eastern, Western, and Mountain Bluebirds stir our hearts in ways that more secretive birds simply cannot.

The legendary "bluebird of happiness" notwithstanding, bluebirds are surely no happier or sadder than other birds. In fact, bluebird life can be fraught with bickering, physical attacks, and matings outside of the pair bond. Males fight other males, females fight other females, males and females fight one another, and they all fight with Tree Swallows. From one-quarter to three-quarters of all bluebird broods can have at least one chick sired by a male other than the one raising them. Despite all that drama, most bluebirds stick with their social mate, often remaining together even through winter and never asking for paternity tests.

PAIRING UP AND NESTING

Eastern Bluebird pairs get established after a male selects a nest box or cavity and then performs a nest demonstration display. When a female is near, he brandishes some nesting material at the entrance hole, carries it in and out again, and then perches atop the nest site and waves his wings. If she enters the nest cavity, that seals the deal.

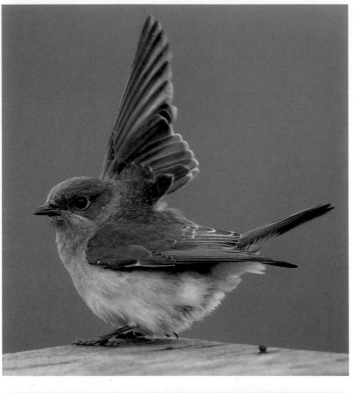

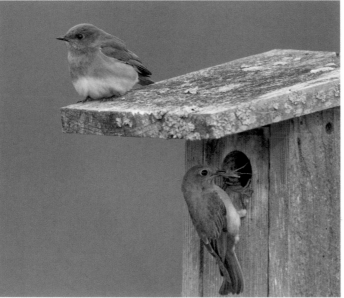

Then it becomes her responsibility to build the nest, constructing it from grasses and pine needles and lining it with finer grasses and sometimes feathers or horsehair. Once paired the male and female patrol their territory boundaries, both sexes aggressively keeping out intruding bluebirds, especially near potential nesting sites.

The female begins laying eggs after the nest is complete, from the very next morning to as much as three weeks later. She lays one egg early each morning until she's produced a clutch of two to seven eggs, most often five eggs in spring or four later in summer. When the clutch is complete, she starts incubating. Many males, especially in migratory populations, feed their mate during nest-building and incubation.

She incubates all night and then takes a fairly long break first thing in the morning to eat and stretch after her long fast. She takes occasional, shorter breaks during the day. Incubation lasts an average of 14 days, longer in colder weather and shorter in hot weather.

PARENTING

The entire clutch usually hatches within 24 hours. During the heat of summer, some of the first eggs laid may start developing before incubation even begins and may hatch days before the last eggs do.

Both parents feed the young and carry off fecal sacs. They split duties fairly evenly except in cold weather, when the mother broods the tiny nestlings more; then the father must spend more time searching for food and feeding them.

The nestlings seem to get along well with no squabbling at all. They remain in the cavity for 17 to 21 days and are usually fairly strong fliers from their first flight. If frightened out of the nest prematurely, they will not be able to return easily, though some birds have managed to climb into the nest again. The fledgling siblings huddle together for warmth, and crouch, freeze in position, or fly away when frightened. They also bathe, preen, and learn how to catch their own food.

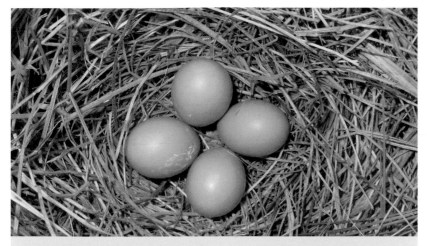

EGGS. This Eastern Bluebird nest contains the typical four eggs, but clutch size may vary from two to seven eggs, usually pale or sky blue in color, but occasionally white. Bluebirds may produce as many as three broods per season.

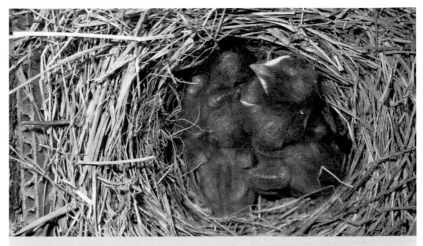

1–2 DAYS OLD. An Eastern Bluebird nest with four nestlings. Altricial, they hatch naked except for sparse, grayish down, and with eyes closed. Dark feather tracts are developing on their crowns and along their backs. Their wing feathers will start to break through the skin in another day.

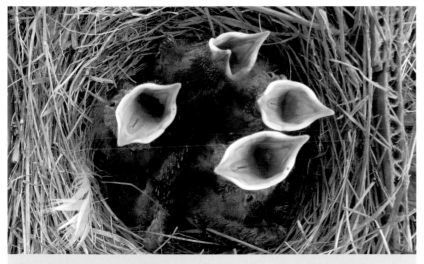

8 DAYS OLD. Four nestlings beg, showing bright yellow gapes edged with white, their mouths becoming redder closer to the throat. Their eyes have opened and their feathers, especially on their wings, are growing rapidly, although their heads are still downy. They now can maintain their own body temperature, and so are seldom brooded during daytime.

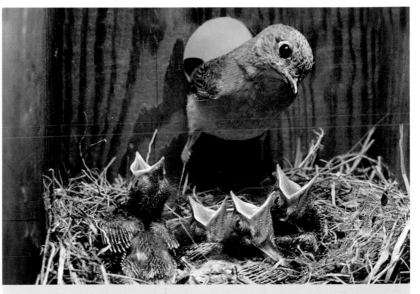

WEEK 2. Inside the nest, four bluebird nestlings beg from their mother. The pinfeathers on their wings show they are in their second week of life. The young are fed more in early morning than later in the day.

LEFT
An Eastern
Bluebird female
carries a fecal sac
out of her nest box.
Like other birds,
bluebird nestlings
often defecate after
being fed. The adult
grasps the fecal sac
as it is produced
and flies out of
the nest entrance,
dropping the sac a
distance away.

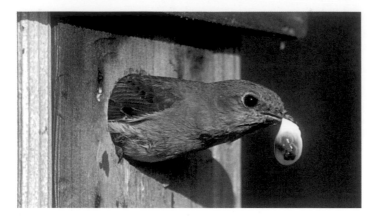

LEFT
An Eastern
Bluebird female
carries a fecal sac
out of her nest box.
Like other birds,
bluebird nestlings
often defecate after
being fed. The adult
grasps the fecal sac
as it is produced
and flies out of
the nest entrance,
dropping the sac a
distance away.

RIGHT
An Eastern
Bluebird fledgling
takes its first flight
from the nest box
where it was raised.
Bright blue wings
and tail identify
this one as a male.

FLIGHT PATH

Bluebird young stay in the nest for 17 to 21 days, significantly longer than many open-cup nesters because, without a safety net of leafy branches beneath the nest, these hole-nesting birds must fly well when they fledge. As fledglings leave the nest, they flutter to the nearest perch, hopefully a spot with some safe cover. Given their open habitat, this may be as far as 150 feet from the nest. They stay near cover for seven to ten days, becoming bolder and stronger, finally able to fly with their parents over longer distances. A week or two after leaving the nest, bluebirds start dropping from perches to catch insects on the ground. They're about half as effective as their parents at first, but they're quick learners. Within another week or two, they'll be finding their own food and become independent.

Fledglings from early broods usually leave their parents' territory once they can fend for themselves, particularly when the adults have started the next brood, at which point they may act aggressively toward the young birds.

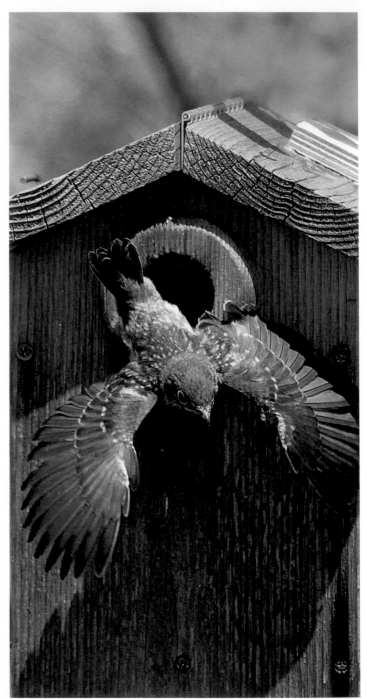

At this point, juveniles from first broods of the season start associating with other juveniles, wandering away from their family territories, and forming flocks. Young from the last brood of the season often remain with their parents longer, sometimes through the winter.

In spring, the process of nesting starts all over. Pairs from the previous year are often likely to remain together, especially if they were successful rearing young together.

Mountain and Western Bluebirds are fairly similar to Eastern Bluebirds in their nesting habits. All three bluebirds are social, joining large flocks in late summer and wandering together throughout winter. And all three nest in cavities. In some cases, Western Bluebird pairs have help raising young, by offspring from previous years or earlier nests that year, or by unattached adults, especially males. This **cooperative nesting** is exceptionally rare in Eastern and Mountain Bluebirds.

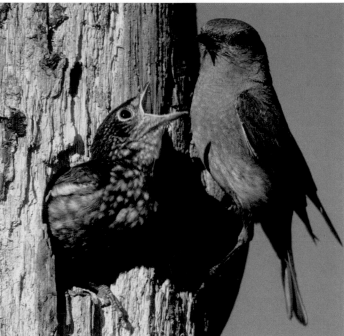

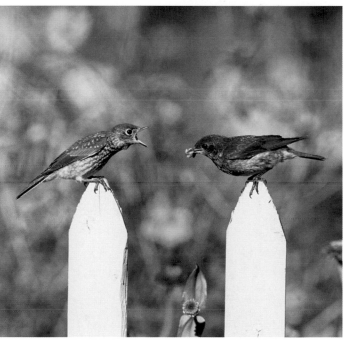

TOP
An Eastern Bluebird nestling pleads with its mother to feed it, but she arrived without food. Just before fledging, parents may feed chicks less often, or bring food but not let the young take it, to coax the young birds to make that first leap into the world.

BOTTOM LEFT
A female Eastern Bluebird perches amid winterberry fruits in late autumn. Bluebird young from late-season nests frequently overwinter with their parents.

BOTTOM RIGHT
An Eastern Bluebird fledgling begs from its father. Young bluebirds may be fed by their parents for up to three weeks after leaving the nest.

AMERICAN ROBIN

The quintessential backyard bird, the American Robin is by far the continent's most common thrush and among its most abundant songbirds. Robins breed over virtually all of Canada and the continental United States except the desert Southwest and the southernmost parts of some Gulf States — and those areas are where many may spend the winter.

In spring and summer, when males sing their lilting song, robins are most conspicuous; they're much quieter in fall and winter, even as they move about in huge, sociable flocks. A single feeding group of robins, numbering in the dozens, hundreds, or even thousands, may descend upon a neighborhood nearly unnoticed to devour mountain ash berries, crabapples, or other fruits.

Many fruit trees produce abundantly one year and not at all the next, but robins are naturally nomadic and capitalize on this. Flocks move about restlessly, seeking new food sources, where they settle in only until the food supply starts dwindling. There are occasional squabbles in winter flocks, but overall the birds dine and chatter convivially.

We rarely notice robins until suddenly, just as snows are melting in spring, there they are, running around on patches of exposed lawn. They may have been there all along, but the change in weather stimulates territoriality and a switch in diet. Their seemingly sudden "arrival" corresponds to when the average day/night temperature reaches 37°F (3°C).

Increasing day length and rising temperatures break up the winter flocks. Two males feeling the first surges of territoriality may start singing and fighting, and even before other males grow territorial, their heart rate and blood pressure rise as they hear other males singing. Soon they're all growing restless and moving northward, while the females remain in flocks a week or

two longer. In winter, robins may have squabbled a bit over a berry, but they grow far more belligerent when worms suddenly become available. Even birds still in flocks will make sharp calls and leap into the air to defend their worms.

PAIRING UP AND NESTING

Robins inspired the saying "The early bird catches the worm," having a different daily schedule than most birds due to their specialized diet. Earthworms are closest to the ground's surface at night and early morning, before the sun drives them underground for the day. Robins find worms visually, so males start singing well before dawn, while it's still quite dark out. This "dawn song" is more rapid and energetic than the song they'll sing throughout the rest of the day. The dawn singing bout ends when the light level is just high enough for spotting worms. After breakfast, males return to their singing perches to

AT HOME IN SUBURBIA

No bird has adapted as well to the typical backyard habitat as the robin, a bird which scientists believe is far more abundant today than in the ages before European settlers arrived in America. Colonists brought many of their favorite trees and garden plants from Europe, inadvertently importing new species of earthworms to areas that had been devoid of worms since the Ice Age and inviting robins into areas where they'd not formerly been found.

When lawns came into fashion in the late 1800s, robins had even more opportunities to search out the abundant new food source, and the sudden proliferation of ornamental fruit trees augmented their winter diets as well. Mud for nest construction became easy to find along the edges of paths and roadways and in gardens. And window ledges and other structures on houses opened up a whole new niche for nesting.

A welcome sign of spring, the American Robin's song is a string of clear, whistled phrases — *cheerily, cheery-up, cheery-up, cheerily* — rising and falling in pitch but steady in rhythm, pausing and repeating. The robin is one of the first birds to sing each day, often starting before dawn, and it's among the last to quiet down in the evening. At dawn, the song is more excited and pours forth without pauses.

sing on and off throughout the day, with another intense singing bout after sunset.

A territorial robin's persistent singing is usually enough to keep other males at a distance, but if one does appear, they fight. Occasionally two robins feel an equal claim to a territory and squabbles may last for hours or days, but usually a single battle is enough to determine which bird is most forceful and the other moves on. Robins are so abundant and winter over such a wide range that each male must maintain this high-intensity territoriality for many weeks to fend off new males passing through.

A territorial robin's persistent singing is usually enough to keep other males at a distance, but if one does appear, they fight.

The same assertive singing that repels other males from a robin's territory lures arriving females. Females are much quieter, but equally territorial toward their own sex. Males don't get to choose their mate but readily accept whichever female first appears on their territory. It's up to her to chase off any females who arrive later.

Territories range in size from less than an acre to many times that. The size of a defended territory depends on how much food, water, and nesting materials, especially mud, are available, and how many robins are competing for it.

TOP
An American
Robin attacks
its reflection in a
window, mistaking
it for an intruder
in its territory.
Most territorial
encounters
between rival
birds end quickly,
unless the intruder
stands its ground.
From this bird's
viewpoint, the
reflection on a
human-made
surface is an
intruder that won't
go away!

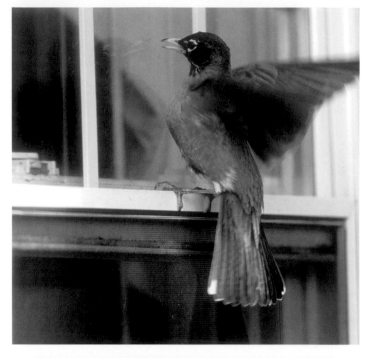

BOTTOM
An American
Robin, whose dark
head suggests he's
a male, holds a
beakful of leaves
and mud as nesting
material. The male
may investigate
the nest site before
building begins
and may bring
nesting material to
his mate, but the
female selects the
site and builds
the nest.

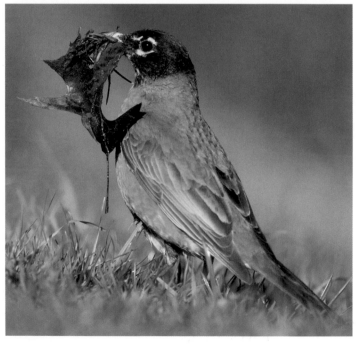

REFLECTIONS

Robins of both sexes ward off every competitor that they detect on their property — sometimes even their own reflection. Because they nest so close to and even on our houses, a robin may suddenly spot his or her image in a window or car mirror. He or she will instantly raise the head feathers and assume an aggressive posture, but the reflected robin will match the pose. A male may fly to his favorite perch and start singing. The reflection won't sing back, confirming the robin's firm ownership of the territory, but when he returns to the window, there's the imposter, still aggressive. The next step, whether the robin is a male or female, is to try to chase the invader away.

A few birds do understand reflections. Laboratory studies have shown, for example, that magpies marked with a small spot on their upper breast that they can't view directly will try to preen it off if they see their image in a mirror. But robins simply don't understand the concept. When males or females try to chase their image away, the reflections don't turn tail but, rather, match them blow for blow. Some robins eventually give up and either abandon their own territory or avoid the window area, but a few grow fixated. These constant battles are annoying and frustrating for people living behind the windows, but are even more of a problem for the poor robins, who are losing valuable time needed for proper nesting behaviors, as well as risking injury.

The most merciful thing we can do is break the reflection by covering the outside of the window for a few days. Fortunately, although the problem is not unusual, it's not too common. Most robins, even those nesting right on window ledges, pay no attention to their reflections and can focus on the business at hand.

When a female arrives on the territory, the male spends most of his non-singing time following her about, sometimes bringing her nesting materials as she selects the site and constructs the nest. It usually takes five to seven days to build, but if weather is unfavorable or she gets fixated on a window reflection, it can take two weeks or longer. The pair copulates frequently throughout the day during this time.

The female usually builds the first nest of the year in a protective evergreen tree; later nests are built higher in deciduous trees or, on prairies, on the ground. For the bird's size, the nest is bulky and heavy, and so is built on a fairly sturdy substrate. About a third of the nest's dry weight may be mud; the rest is grasses, twigs, and other fibers.

The date of laying the first egg, about three or four days after the nest is completed, depends on many variables, including general weather patterns, temperature, day length, and availability of nesting material and food. Robins lay their eggs later in the day than most birds, often at mid-morning or even early afternoon. This is probably due to their diet of worms; they can't afford to waste the best time for worm hunting in early morning. One egg is laid each day, with a rare gap of a day.

Some females begin incubating after laying the second egg, but many don't start incubating or attending the nest until

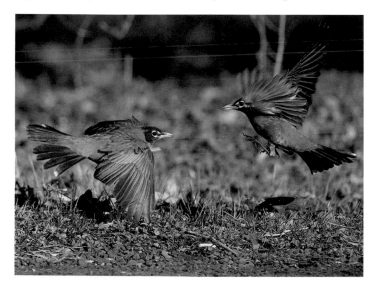

Each parent feeds the nestlings about six or seven times per hour.

they have a full clutch. This leads some people watching robins nesting at their window to fear a nest with eggs has been abandoned. But once the clutch is complete, the female will spend 60 to 80 percent of her day incubating. She leaves the nest for feeding bouts on and off throughout the day, starting about 25 minutes before sunrise when worms are most conspicuous. Males seldom bring food to incubating mates.

PARENTING

The eggs hatch in the order in which they were laid over about two or three days. Each parent feeds the nestlings about six or seven times per hour. Each nestling receives about 3.5 ounces of food, in about 35 to 40 meals, every day. One nestling is fed at each feeding bout. Each parent usually arrives at a predictable location on the nest rim, so nestlings closest to that spot may get fed more often than the others. The parents tend to feed the most conspicuous mouths first, so the nestling that reaches up highest and closest to the feeding parent's bill is most likely to be fed on that trip.

TOP RIGHT
A female American Robin incubates for 12 to 14 days, taking short breaks every 40 minutes or so throughout the day to fly off and feed. Robin nests are found from low branches in shrubs to high treetops, as well as on stumps, among roots in road banks, on rocky ledges, and on human-made structures such as roof gutters, outdoor light fixtures, or under the eaves of buildings.

BOTTOM LEFT
Two robins get into a territorial scuffle in early spring. Competing males intimidate each other by running toward one another in a crouched posture. If neither backs down, altercations may escalate into brief fights, the birds grappling with each on the ground or in midair.

 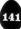

Once a nestling is comfortably full, it no longer begs as assertively, and the hungrier a nestling is, the more assertively it begs. The first to hatch has a slight size advantage, and nestlings that are more assertive and get the best positions near where the parents arrive will grow faster, but when food is adequate, all the young are likely to fledge. Interestingly, one

For the first few days after hatching, the female broods the tiny nestlings much of the day, especially when temperatures are low, while the male does most of the feeding.

researcher found that whichever parent provides the most feedings, the father or mother, tends to feed the largest chick most often, and the parent that feeds less often tends to focus more feedings on the smallest.

For the first four days or so, the parents regurgitate grubs, worms, and fruits into the nestlings' mouths. As the chicks grow, the parents start bringing whole insects to thrust into the nestlings' wide-open gapes. As summer progresses and more fruits become available, they're offered in addition to insects and worms. Older nestlings can spit out cherry pits and other indigestible materials.

Nestlings produce a fecal sac quickly after eating, while the parent is still present to carry it off. A lot of undigested food remains in the droppings of very young nestlings; the adults eat these fecal sacs. But once bacteria levels in the nestlings' guts start digesting the food more completely, the adults carry off the sacs to drop away from the nest.

For the first few days after hatching, the female broods the tiny nestlings much of the day, especially when temperatures are low, while the male does most of the feeding. By the time the nestlings are about a week old and can maintain their own body temperatures and keep one another warm, the female no longer broods even at night, retreating to a nearby branch to roost.

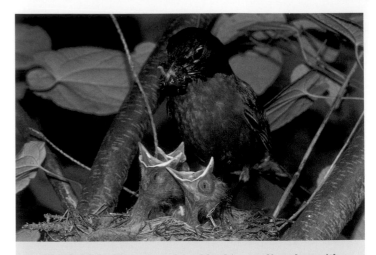

4 DAYS OLD. These four-day-old robin nestlings beg with bright yellow gapes. Altricial, they hatched with sparse white down and eyes closed, but now their down is gray and their eyes partly open. Both parents feed them soft invertebrates such as beetle grubs, caterpillars, and earthworm sections, supplemented with fruit when available.

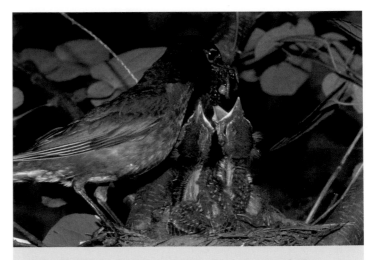

10 DAYS OLD. A male American Robin brings a large beakful of prey for its nestlings. They now have feathered crowns with only a few wisps of down remaining. Tracts of developing feathers are visible on their backs and wings.

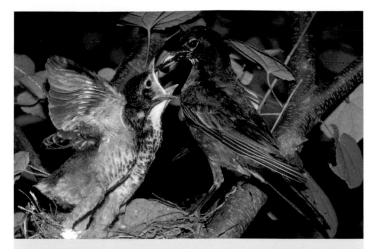

14 DAYS OLD. A male brings honeysuckle berries for two nestlings that beg and flap their wings vigorously. By now, the young are well feathered, their spotted bellies and flanks showing the rufous colors of adults. Their wing feathers are still partially encased in sheaths, and their tail feathers have hardly emerged at all. Nevertheless, they will fledge shortly (usually before 16 days old).

FLIGHT PATH

Robin nestlings grow quickly, reaching their maximum weight when nine or ten days old. After that, as their feathers grow, their bodies lose weight for a few days before they fledge. When undisturbed, they fledge about 12 to 14 days after hatching, but they grow fearful of intruders several days before that. If frightened out of the nest prematurely, their parents may find and continue to feed them, but their chances of survival are greatly reduced.

Usually the entire brood fledges within a day or two. The male focuses mostly on fledged young while the female keeps feeding the chicks still in the nest. When all have fledged, both parents follow and feed them for several days. The female repairs her nest or builds a new one and lays a new clutch, but continues feeding the fledglings on and off until she starts incubating the new eggs. The male remains with them until the new eggs hatch, sometimes roosting near the first brood for several days more.

Baby robins get far more than just food from their parents, especially after they fledge. They follow their parents, learning where and how to obtain food, the best places for roosting, what to do when danger appears, and how to socialize with other robins. After they are on their own, they join with other young robins and unmated adults in loose flocks.

When the first nesting is successful, a pair of robins usually produces a second brood, and sometimes a third. They re-nest if they lose a clutch of eggs or nestlings. By late summer, as adults finish raising their last broods of the year, territoriality has ebbed and they gravitate to a fall feeding flock. They'll wander about with other robins into the winter until those "first robins of spring" start the cycle all over again.

Now with fully grown wing and tail feathers, this juvenile robin resembles an adult but still has pale spots on its back and wings and dark spots on its breast. It often calls to its parents but no longer depends on them for food. In early autumn, it will join other robins, eventually migrating with them to wintering areas.

NORTHERN MOCKINGBIRD

Northern Mockingbird
adult

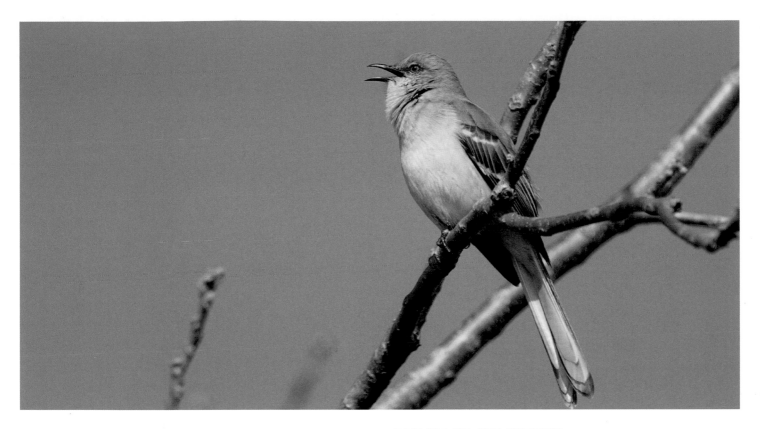

A Northern Mockingbird sings in spring. As the breeding season gets underway, territorial males sing their long series of phrases throughout the day and often into the night (particularly during a full moon). Mockingbirds often mimic the songs of birds around them, including those of cardinals, blackbirds, orioles, Killdeer, jays, and hawks.

Both male and female mockingbirds sing, adding to the song repertoire over the years. Males may have more than 200 distinct, identifiable phrases, repeating each song type two to six times before shifting to another. They acquire these phrases by imitating what they hear: other species (birds and other animals, sometimes even humans), machines, and other mockingbirds. Their songs may signal potential mates that they are experienced and fit, and long singing bouts serve as indicators of a bird's endurance.

PAIRING UP AND NESTING

Unattached male mockingbirds sing, often all night long. An unpaired female, attracted by the song, may join the male in a flight display. At first, he chases her. If she responds favorably, the two fly around the territory for more than a half hour, frequently stopping to perch together. These tours often include potential nest sites and berry-producing trees and shrubs, as if the male were showing off his territory's best features.

The nest is typically constructed in a shrub or tree. The female shapes the lining of natural fibers along with trash such as dental floss, aluminum foil, paper, shredded cigarette filters, plastic Easter-basket grass, laundry lint, tea bags, bandages, cotton, and twine. Nests are never used more than once. Pairs may build six nests in a single season, not all receiving eggs.

TOP
Spreading his wings and tail to show his flashy white patches, a male Northern Mockingbird runs along the edge of a roof, performing his territorial boundary dance. Often two males face each other across a shared boundary. If neither backs down, they may chase or grapple with each other on the ground or in midair.

BOTTOM
This composite photo shows a male mockingbird's flight display. While singing from a high perch, he suddenly jumps into the air, flapping his wings, and parachutes down with open wings. During the display, he shows off his white wing patches, singing all the while.

Mockingbirds mate on the ground near a shrub or other retreat where they can quickly escape danger. The male sings before, during, and after copulation. The female begins incubating with the penultimate egg. Incubation lasts for 12 to 13 days. She continues to find her own food; her mate seldom feeds her.

Mockingbirds stay mated for the entire breeding season, and sometimes for life. But DNA tests indicate that many broods show extra-pair paternity, and some include a chick produced by a different female with the territorial male.

Males and females divvy up responsibilities so that they can start a new brood while the previous brood is still dependent. Pairs in northern areas raise two to three broods in most seasons, and in Florida they often raise four.

PARENTING

All the eggs in a clutch usually hatch within 24 hours. Both parents feed the young a variety of animal prey (including small lizards in Florida), adding fruit in late summer. During beetle outbreaks, beetle larvae may be the main food offered. They give each nestling about three to five food items per hour.

Mockingbird males have the greater role in nest defense, though both birds attack potential predators. They can recognize individual humans and selectively mob researchers who intrude repeatedly on their territory.

Nestlings grow quickly, their eyes starting to open and their pinfeathers visible by the time they're three days old. Females brood the chicks after feeding them, spending about a quarter of their day brooding while the chicks are tiny. By the fifth day, their eyes are completely open, and in a day or two their feathers open up. They can maintain their body temperature by the time they're seven or eight days old; at this point, the female stops brooding altogether.

Both parents remove fecal sacs up until the day before the nestlings fledge. The chicks usually leave the nest on the 12th day after hatching.

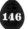

MOONLIGHT SERENADE

Unattached male mockingbirds often sing without a break throughout entire nights, especially during a full moon. Frustrated people ask how they can get them to shut up. The answer is as simple as it is impossible: just find the poor guy a mate.

NEST-BUILDING. The male starts several nests before choosing one. He builds a twig foundation and the female lines it with grasses, rootlets, dry leaves, and sometimes pieces of trash.

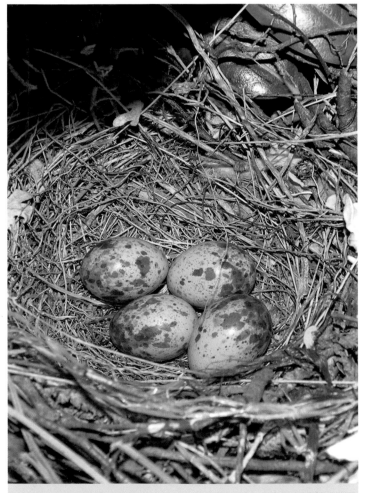

TYPICAL CLUTCH. A mockingbird nest with four eggs. Only the female incubates, for 12 to 13 days.

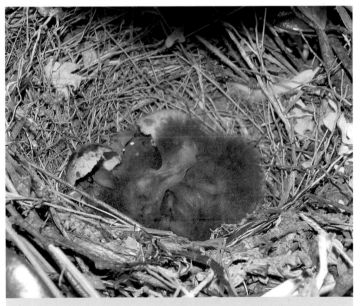

HATCHING OUT. Mockingbirds hatch weak and helpless, with eyes closed and gray natal down on their heads and bodies. Parents usually remove eggshell fragments soon after the chicks hatch.

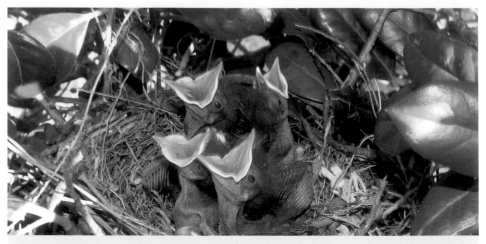

MORE THAN 5 DAYS OLD. Four Northern Mockingbird nestlings beg with bright yellow gapes. Their eyes are now completely open.

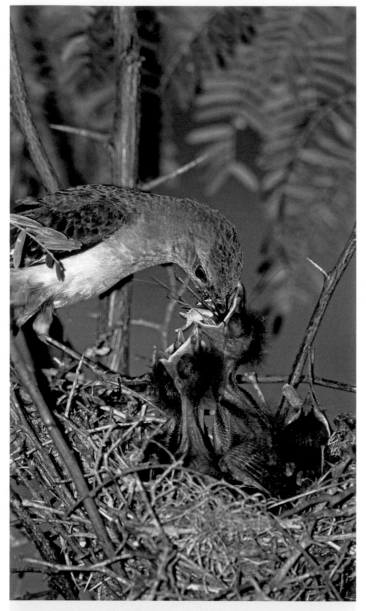

LESS THAN 5 DAYS OLD. An adult mockingbird feeds a katydid to its nestlings. Their eyes are still closed but their developing wing feathers are visible, as are dark feather tracts along their backs and sides. Both parents feed the young, mostly insects and spiders, supplemented with fruit as available.

MOBBING. A Northern Mockingbird boldly swoops after a cat that has come too close to its nest. Breeding mockingbirds engage in **mobbing** behavior, repeatedly attacking potential threats, including cats, dogs, squirrels, various birds, and humans. The male takes the greater role in defense, but pairs may launch joint attacks against birds such as crows, kestrels, and hawks.

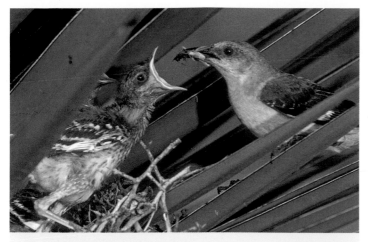

NEAR FLEDGING. A Northern Mockingbird nestling stands up on strong legs to beg from its parent. The young bird is well feathered with prominent black and white wing markings. By 12 days of age, a nestling's wing feathers are completely out of their feather sheaths and it is ready to fledge.

FLIGHT PATH

Fledglings lose weight for a few days after leaving the nest. Both parents feed them for several days until the male begins to build a new nest foundation. After he's finished, he resumes feeding the fledglings as the female constructs the new nest lining and then lays and incubates the eggs. Most fledglings survive to become independent.

Independent juveniles gather in small flocks. Their foraging skills are weak at first, but practice and experience improve their efficiency. Some start singing in fall, and by the following year will be making their first attempts, occasionally successful, to attract a mate and start the whole process all over again.

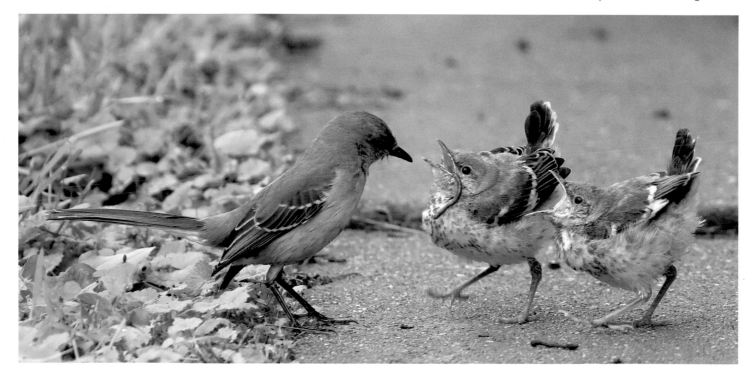

Two mockingbird fledglings beg from their parent, who has just fed one of them an earthworm. Their strong legs enable them to run around on the ground immediately after leaving the nest, but they can't fly well for another eight days. During this time they are extremely vulnerable to predation by house cats.

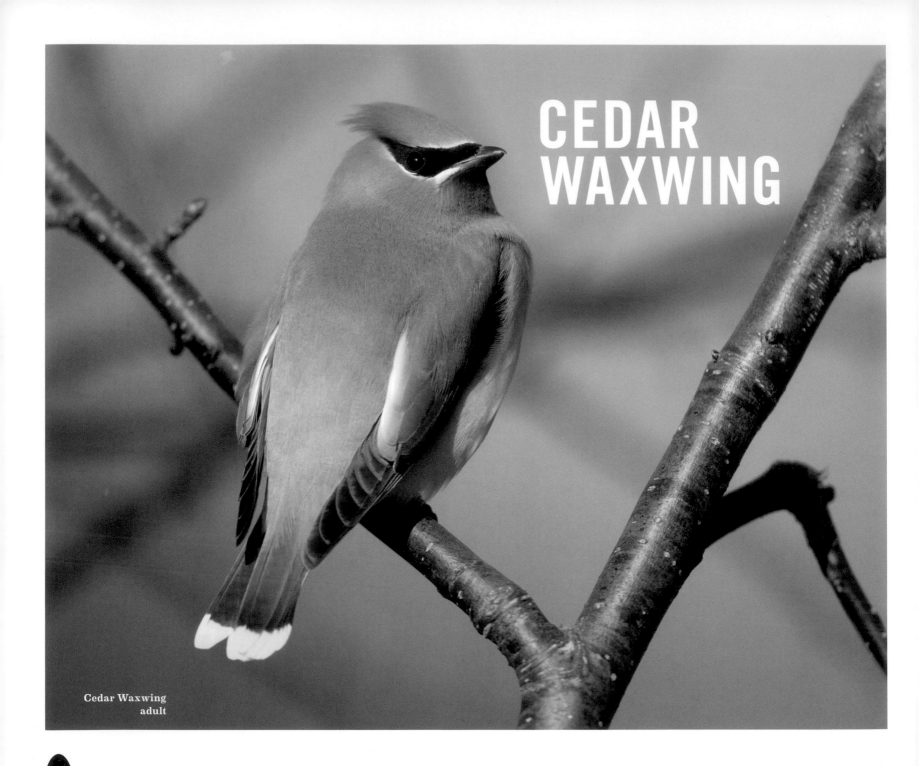

CEDAR WAXWING

Cedar Waxwing
adult

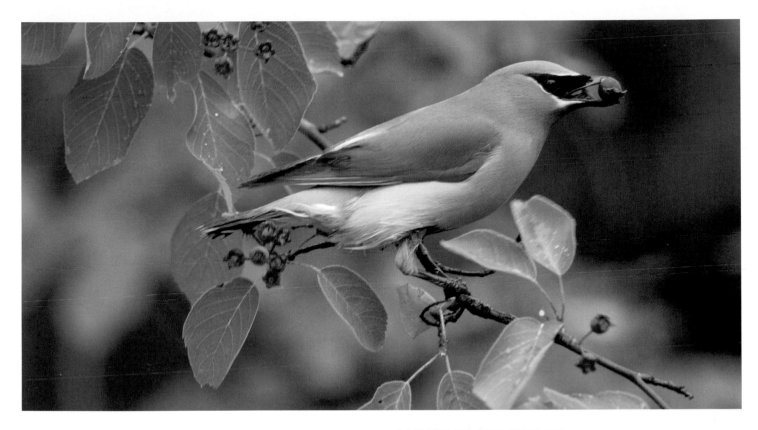

This Cedar Waxwing is apparently a young adult, because it lacks the red waxy droplets present on the tips of the wing feathers of older adults. The number of waxy tips increases with age.

The Cedar Waxwing seems a most improbable bird. The smooth sleekness of its plumage, so different from most birds, looks almost unnatural. Waxwings defend little or no nesting territory; sometimes more than 20 pairs may nest in a single acre. In situations where waxwings nest in a cluster, the young may all fledge within two days, suggesting that social groups somehow synchronize nesting.

PAIRING UP AND NESTING

One of the last songbirds to start nesting in summer, Cedar Waxwings wait until fruits start ripening. Based on winter flock behaviors, some birds may pair off during winter or even remain paired through the year. Pairs remain together at least for the entire breeding season.

Waxwings appear to select their mates from within their social flocks, each preferring the oldest mate it can attract. With age comes experience: the more years a bird has lived, the more likely it is to have survived and learned from dangerous situations. Waxwings grow more effective at attracting older mates as they, too, get older. The red waxy feather tips that give them their name are signals of a bird's age and maturity, and on average, are more numerous in older birds. Birds with the most red tips pair off first, leaving those with fewer red tips to one another.

A flock of Cedar Waxwings feeds on fruit in late winter. These sociable birds associate in flocks throughout the year, although flocks are largest during winter. Even while pairs are nesting, they may join small groups when heading to fruiting shrubs or trees.

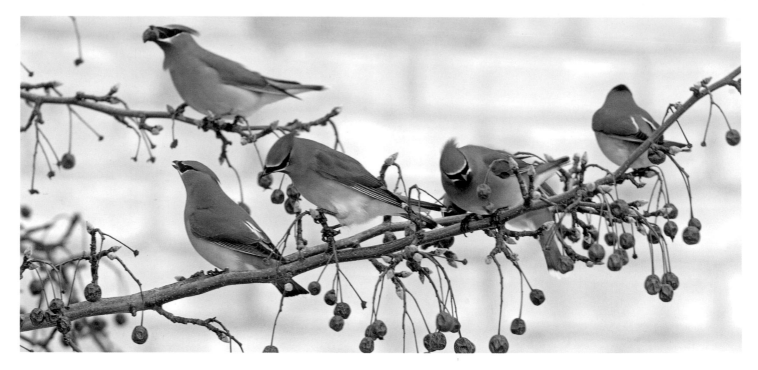

Waxwings begin courting within winter and migratory flocks. Two birds first hop toward one another on a perch, sometimes touching bills, in a ritual called *courtship hopping.* The male offers a berry, petal, or insect; if the female doesn't find him suitable, she ignores his overtures. If she does approve of him, she hops toward him and they pass the item back and forth, repeating until the female eats it up.

Construction takes five to six days during which the birds make as many as 2,500 or more individual trips to the nest.

The female seems to choose the nest site, often at the edge of a wooded area or in an isolated tree or shrub in an old field. The nest is usually placed in the fork of a horizontal branch or at the trunk, at just about any height. Both birds gather twigs, grasses, cattail down, mosses, string, horsehair, dead leaves, bark, ferns, flowers, pine needles, and man-made materials such as pieces of cloth, paper, or string. They sometimes take their nest materials from other waxwing nests. The female weaves the bulky cup together. Construction takes five to six days during which the birds make as many as 2,500 or more individual trips to the nest. Females begin laying within a day or two of completing the nest, one egg early each morning.

Cowbirds seldom parasitize waxwing nests, perhaps because the waxwing's late nesting season begins after the peak of cowbird egg-laying. If a cowbird egg does appear in a nest before incubation begins, the waxwings usually toss it out; in the rare cases that a cowbird egg is accepted, there is no evidence that the cowbird survives to fledge. Waxwings feed their young so much fruit that the diet doesn't have enough protein to sustain a growing cowbird.

The male feeds his mate while she incubates, bringing nearly all the food to her and the chicks for the first day or two after they hatch. He brings her mostly fruit, but as soon as hatching occurs, he switches to bringing insects almost exclusively for two or three days, visiting three or four times per hour.

PLEASE PASS THE BERRIES

The extraordinarily sociable nature of waxwings is exemplified in one endearing habit: birds pass food items, including flower petals and berries, from one bird to the next. This usually occurs between pairs, but three or more may pass an item back and forth before one finally swallows it. As two birds mouth a berry, especially a frozen one, they may soften it for digestion as well as cement their social bonds, so pairing off in winter may be as good for their stomachs as their hearts.

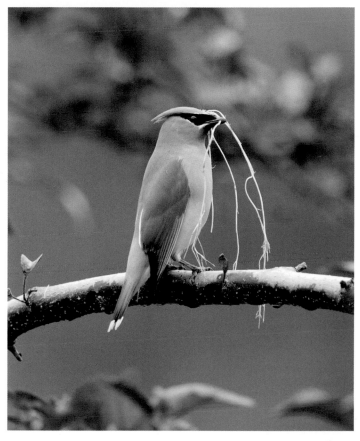

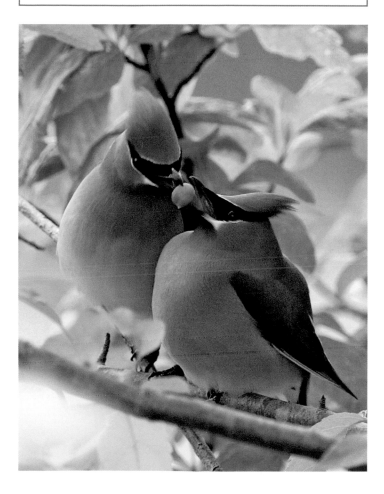

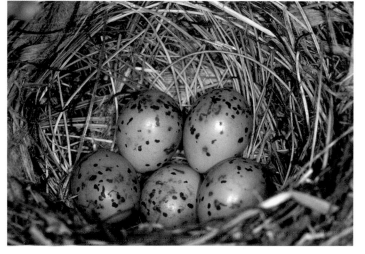

TOP RIGHT
A Cedar Waxwing holds nest material. The male and female bring material to the nest site, but she does most of the building. Waxwings may steal nest materials from other birds' nests, including those of Eastern Kingbirds, Baltimore Orioles, American Robins, and Yellow Warblers.

BOTTOM LEFT
A waxwing pair exchanges a berry. In their main courtship display, the male and female pass a berry, insect, or flower petal back and forth with a hop. Sometimes the item is inedible, or no object is passed, but the birds still touch bills symbolically.

BOTTOM RIGHT
These Cedar Waxwing eggs will be incubated for 11 to 13 days. Late nesters, waxwings lay eggs from June through early August, sometimes still raising young as late as September. This timing likely coincides with fruit availability.

PARENTING

Immediately after hatching, waxwing nestlings seem barely able to hold their heads up, bright red mouths agape only for feedings. The female broods them almost constantly for the first three days or so, as the male brings food. The nestlings gape when they hear a sound, sense the nest vibrating, or are suddenly shaded, all signs that a parent has just alighted with food.

Even on their first day out of the egg, the chicks can swallow berries whole, regurgitated by adults. The parents may bring as many as 12 dogwood berries or eight chokecherries in a single visit to the nest. They press a berry or insect into the nestling's throat. If the chick doesn't immediately swallow it (a sign that it's not very hungry), they will take it out and feed it to another nestling. Within four days the female spends half the day off the nest, helping her mate gather food.

The nestlings' eyes open when they're six or seven days old, and within two or three days they start to vocalize, perch more steadily, and stretch and preen. Now the straw-like sheaths covering their developing feathers rapidly disintegrate, their feathers open, and the female stops brooding. At two weeks, their juvenile plumage is complete except for their stubby little tails.

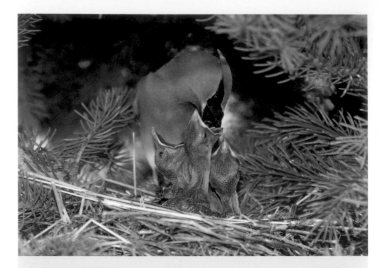

6–7 DAYS OLD. A parent feeds a honeysuckle berry to one of its nestlings, whose eyes have just opened. For the first few days after they hatch the male waxwing feeds them insects; after that, both parents feed them increasing amounts of fruit.

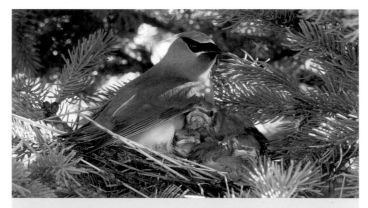

BROODING. A female waxwing broods her nestlings. For the first three days after they hatch, she spends 90 percent of daylight hours on the nest. Throughout the incubation and brooding period, the female receives food for herself and the young from the male.

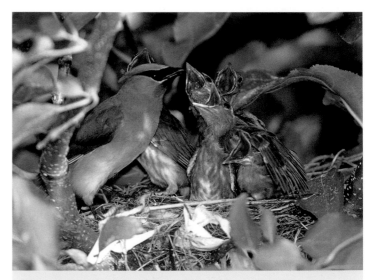

14 DAYS OLD. With bright red gapes accentuated by pinkish-purple flanges in the corners of their bills, nestlings beg from their parent. By now they are well feathered with distinctive brownish streaks and mottling on their bellies. Their wing feathers are well developed, although not yet adult length.

THE FAMILY LIVES OF SELECTED SPECIES

FLIGHT PATH

Waxwing young usually fledge when about 15 or 16 days old. The male continues to feed them for six to ten days longer; the female will do so only if she's not re-nesting. Within a few days, the family starts associating with a flock. By summer's end, large waxwing flocks will be swirling through the air from one good feeding spot to another, feasting on the late summer cornucopia of fruit and swarming insects.

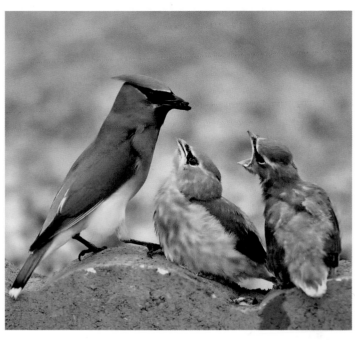

TOP RIGHT
An adult Cedar Waxwing brings fruit for its two begging fledglings. The young remain near the nest area for several days. They're capable only of short flights at first, and depend on meals from their parents.

BOTTOM LEFT
This waxwing fledgling's tail is tipped with orange, rather than the typical yellow. The orange color is due to a red pigment from the berries of an introduced species of honeysuckle. If a young bird is fed many of these berries while its tail feathers are still growing, the tips of the feathers will be orange.

BOTTOM RIGHT
This juvenile waxwing has found a crabapple bonanza! A short time after leaving the nest, juvenile Cedar Waxwings start forming small flocks with other juveniles and eventually become proficient at flycatching and feeding on fruit.

YELLOW
WARBLER

Yellow Warbler
male

A male Yellow Warbler sings his song, often transcribed as *sweet, sweet, sweet, I'm so sweet,* to claim a territory and attract potential mates. On spring mornings, as early as an hour before sunrise, he may repeat the song 10 times per minute. Yellow Warblers occasionally sing in flight.

North America is home to more than 50 species of wood warblers: small, colorful songbirds that generally winter in Central and South America. Some are rare with extremely localized ranges; others are widespread. The Yellow Warbler has the largest year-round geographical range and the largest North American breeding range, found at least seasonally throughout almost all of the United States and Canada down to northern South America.

PAIRING UP AND NESTING

Although found in many habitats, Yellow Warblers are most associated with willows or, in the tropics, mangroves. They nest in willow thickets along streams and in wetlands, and in shrubby field edges, power-line cuts, and other areas with dense low shrubbery. Since they feed almost entirely on insects, they fly north only after ice clears and trees begin leafing out, when emerging aquatic insects and caterpillars grow suddenly abundant.

Like many territorial birds, male Yellow Warblers defend their territories against other males with song, chases, and, as a final resort, brief fights. The more chestnut streaking on a male, the more aggressively he defends his territory.

LEFT
A female Yellow Warbler brings a beakful of fine grasses for her nest, 3 to 10 feet above the ground, in a vertical fork of a shrub. She started with a deep cup of grasses, fine bark strips, and other plant fibers, binding the materials together with spiderwebs and securing the nest to supporting twigs.

RIGHT
This Yellow Warbler nest contains four eggs cushioned by fluffy white nest lining.

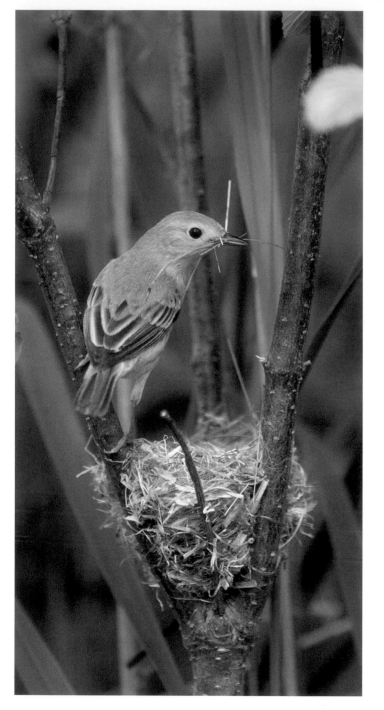

FAMILY SECRETS
THE GREAT COVER-UP

Brown-headed Cowbirds (see page 185) frequently lay their eggs in Yellow Warbler nests. The Yellow Warbler is one of only a few species that can recognize cowbird eggs, but its bill is too small and weak to eject them. Instead, if they have fewer than two of their own eggs in the nest, the pair will often build a new floor on top, burying the cowbird egg along with any of their own eggs, and start a new clutch. One Yellow Warbler nest consisted of six floors, with at least one cowbird egg sandwiched within each layer.

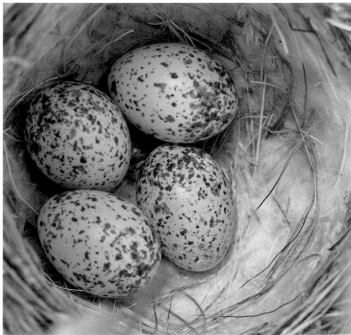

When females arrive, males have already staked their claims on territories, which are small, often less than half an acre, and invariably contain at least one stand of willows or alders. A territory may lack important resources, such as drinking water, so Yellow Warblers occasionally wander more than a third of a mile to meet these needs.

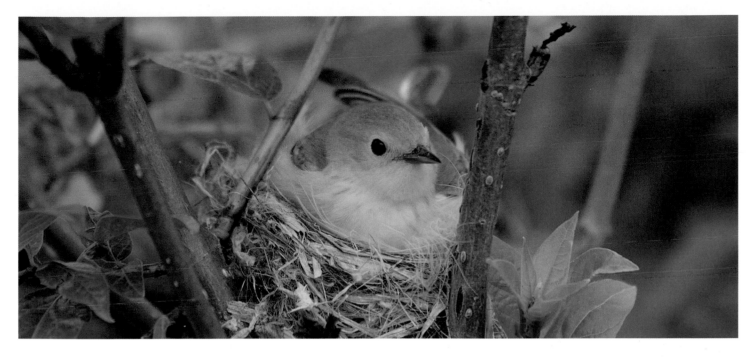

The female Yellow Warbler incubates her eggs for 10 to 13 days. During this time, her mate sometimes brings food to her. The female also broods the young and may shade them in the heat of midday.

When the first males arrive in spring, while recovering from the rigors of migration and before females and many rival males are present, they may sing sporadically, shortening or even skipping their dawn singing bouts. As the nesting period approaches, those early morning bouts get longer, more frequent, and more robust, and by the time a male's nest contains eggs and nestlings, he may sing the dawn song each day for 30 to 45 minutes without a break.

When a female enters his territory, he's likely to chase her on and off for a few days. Once she pairs with him, she'll start building the nest. As the nest grows, she starts soliciting mating by crouching, quivering her wings, and calling softly.

The nest is a lovely structure, made from grasses, strips of bark, and fine fibers. When set in a deep fork in a tree, the nest may be deep, too. If it contains no cowbird eggs (see box on previous page), the nest typically contains four to five eggs laid at 24-hour intervals, usually soon after sunrise. The female has a brood patch and does all the incubation, often beginning a day or so before the clutch is complete. In one case, brooding periods during the day lasted about 22 minutes, and the time off the eggs about five minutes. The male occasionally brings the female food during incubation.

As the nest grows, she starts soliciting mating by crouching, quivering her wings, and calling softly.

PARENTING

The eggs hatch in about 11 or 12 days; the interval between first and last can be a day or two. The helpless nestlings can do little but open their mouths at first but are fed by both parents and grow and develop quickly. Their eyes open when they are about three days old, and they fledge eight to ten days after hatching. By that time, each parent may make up to 16 feeding trips per hour throughout the day to satisfy their hungry offspring. Yellow Warblers raise only one brood per year.

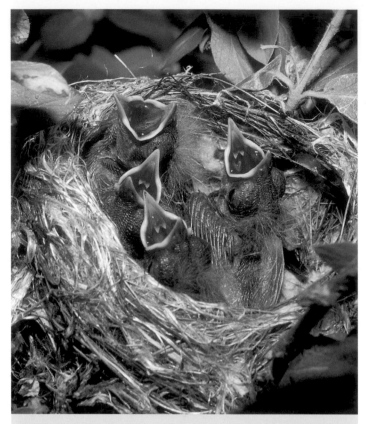

3 DAYS OLD. Four Yellow Warbler nestlings beg to be fed, each colorful gape a red mouth lining edged with yellow flanges. They hatch naked, except for sparse tufts of light gray down, and with eyes closed. At three days old their dark wing feathers are still encased in their sheaths, and dark feather tracts are visible along their backs.

SONG FEST

Yellow Warblers have two song types. Type I, often transcribed as *sweet, sweet, sweet, I'm so sweet,* is used primarily to attract a mate. A male sings this less often as nesting begins, except as he approaches the nest to feed nestlings. Type II, not as easily transcribed, occurs primarily in male-to-male communications — during dawn singing bouts, in encounters with other males, and in spontaneous daytime singing after mate selection.

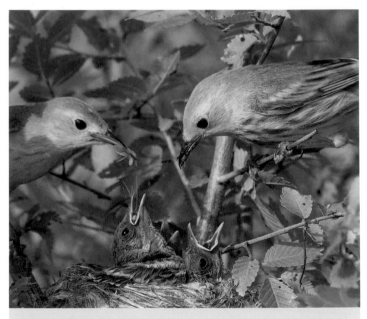

ALMOST FLEDGED. Both parents feed the young a diet of insects and spiders. With their feathered crowns and partly developed wing feathers, these young are almost old enough to leave the nest.

FLIGHT PATH

Researchers have trouble keeping track of active, tiny birds after they scatter from their nests, but observations suggest that at least some Yellow Warbler fledglings remain with their parents for 17 days or more after leaving the nest. These warblers leave their breeding grounds on migration earlier than most species, and are quiet and fairly furtive, seldom observed after chicks fledge. But we'll see Yellow Warblers the following spring: that we can count on.

This Yellow Warbler fledgling still has tufts of natal down on its head and scattered across its back, and its tail seems almost non-existent, but it has quite well-developed wing feathers. This fledgling may stay with its parents for up to three weeks after it leaves the nest.

CHIPPING SPARROW

Chipping Sparrow
adult

The male Chipping Sparrow sings from high perches on top of a tree or shrub or a building roof. At dawn he sings in quick bursts of staccato chips; he occasionally sings at night.

Chipping Sparrow nesting habits can be relatively easy to observe in backyards throughout much of the continent. Chippies often nest at eye level in small conifers, so we can peek in on their progress occasionally until the nestlings' eyes are open. At that point we must keep our distance; they may prematurely fledge if they notice an observer.

PAIRING UP AND NESTING

Female Chipping Sparrows arrive on territories a week or two after males, and within days, the birds pair off. The female builds the nest over three to four more days, placing it low in a thick cluster of leaves or needles in a tree or shrub, usually a conifer, often close to a building that may shelter it from weather. She constructs the nest from fine materials, including rootlets and dried grasses, lining it with more animal hair and fur than most birds use. You may see the tiny birds plucking hairs from live mammals, from horses to golden retrievers. The male stays close, perhaps partly to prevent visits by other males.

The nest is loosely woven and even flimsy. Though light can often be seen through it, the weave is tight enough to hold the eggs. Nests are seldom, if ever, reused, but females often dismantle old nests to salvage the materials. Females seem to grow attached to nest sites, and marked birds often return to the same small stand of trees to nest year after year.

TOP
A Chipping Sparrow surveys its territory from a spring-blooming branch.

BOTTOM
A Chipping Sparrow carries a beakful of animal hair to line her nest. Male and female investigate nest sites together, but the female appears to make the final choice, as well as doing all the building.

SINGING SOCIETY

The Chipping Sparrow's song is a long trill of evenly spaced, dry chips all on the same pitch, beginning softly and becoming stronger until the end. Anyone who wishes to master bird songs should learn this one, because several other birds sing songs that are most easily described in comparison with it. For example, Dark-eyed Juncos sing a similar trill that is shorter and slightly more musical. Pine Warblers sing a more musical version, and Worm-eating Warblers sing a drier, more mechanical trill. Swamp Sparrows sing a much slower variation.

When egg-laying begins, the mother visits the nest only to lay an egg each morning, and is likely to abandon the site if she notices any disturbances. She begins incubating after laying the penultimate egg, sitting for periods of a half hour or so between breaks of about 9 minutes. As incubation advances, she sits more tightly, not flushing, even when someone approaches, until actually nudged. While incubating, she seems rather restless, frequently changing position, pecking at the nest materials, turning the eggs, and fluffing and preening her feathers.

HOSTING COWBIRDS

Chipping Sparrows are frequent hosts of Brown-headed Cowbirds (see page 185). If a cowbird lays an egg in a nest with just one or two chippy eggs, the sparrow often deserts and starts a new nest somewhere else. The more effort a Chipping Sparrow has invested, however, the less likely she is to desert; if she's produced three or more eggs before a cowbird egg appears, she usually keeps attending her nest anyway.

Cowbirds usually remove one egg before laying their own, so if a cowbird egg is present, it generally means the sparrow's own chick production was reduced by one. Hungry cowbirds outcompete the smaller sparrow nestlings for feedings. When food is abundant, a nest can produce three Chipping Sparrow fledglings as well as one cowbird, and only rarely do all the hosts' chicks die while a cowbird successfully fledges.

Despite high parasitism rates, Chipping Sparrow populations remain robust; researchers are still trying to determine how detrimental parasitism is to this species.

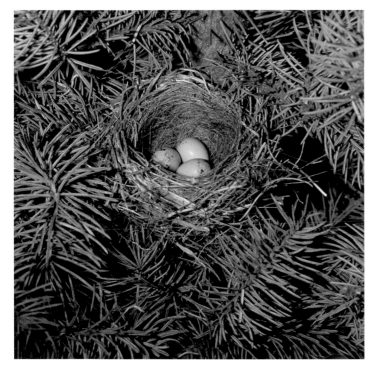

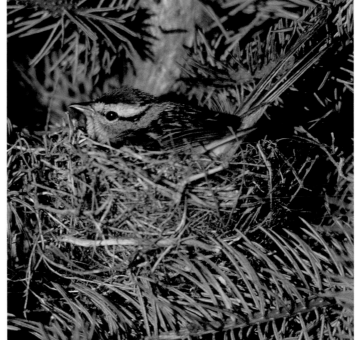

LEFT
A Chipping Sparrow nest containing three eggs amid the needles of a conifer. Notice the lining of hair in the nest. In the days of horse-drawn carriages, the Chipping Sparrow was nicknamed the "hair bird" from its use of horsehair in its nest.

RIGHT
The female Chipping Sparrow incubates the eggs for 10 to 12 days and also broods the newly hatched nestlings. The male often feeds his mate at or near the nest during incubation, approaching with soft chipping calls. The female responds by fluttering her wings and calling.

PARENTING

The tiny, altricial chicks are weak and helpless at hatching, but the moment they feel a nest vibration, they lift their heads and open their capacious mouths. The parents feed them mostly seeds for the first few days, switching to more insects as the young grow. This is unusual; most songbird chicks are given high-protein insects during their early growth stages.

At five days old, the nestlings recognize their parents by sight and sound, and crouch into the nest when they hear anything unexpected. They start making weak sounds when two to four days old, and are audible to our ears by the time they're five days old; their sounds grow steadily louder until fledging.

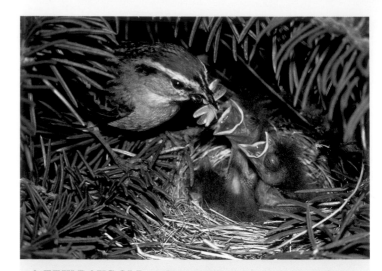

A FEW DAYS OLD. A Chipping Sparrow feeds its nestlings, who beg with yellow-edged red gapes. For the first three days, the male provides all the food, often passing it to the brooding female who transfers it to the young.

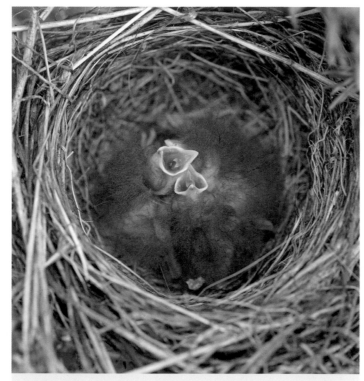

HATCHLINGS. Chipping Sparrows hatch partly covered with wisps of long gray natal down on their crowns and bodies. When begging, they appear to be little more than bulging eyes and gaping mouths. The red mouth lining is edged with creamy yellow flanges, swollen toward the corners of the bill.

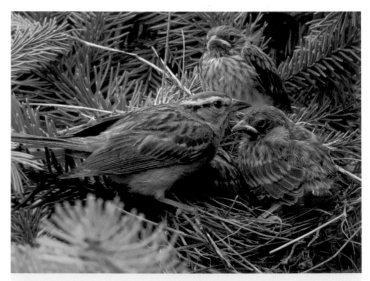

SOON TO FLEDGE. Chipping Sparrow nestlings, 10 days old, perch on the nest rim with a parent (left). Though well feathered, they have tiny tails and stubby wings for several weeks. Although capable of fluttering, when frightened they climb away into the surrounding branches.

THE FAMILY LIVES OF SELECTED SPECIES

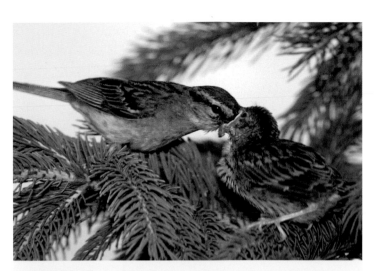

FLEDGING. An adult Chipping Sparrow feeds a fledgling. After the young fledge, the family stays near the nest for several days as the young birds take short flights, gradually moving farther away from the breeding area.

FLIGHT PATH

If undisturbed, Chipping Sparrow young fledge when about 12 days old, but when frightened by a perceived predator, they may leave earlier than that. Their chances of survival are very limited if they leave the nest before nine days old. The young depend on their parents, begging from them with quivering wings, for up to three more weeks, before starting to explore and find their own food. If the female has begun a second brood, the male takes care of the first brood until they reach independence.

Researchers have learned that after nesting has begun, at least some males move through neighboring territories, mating with any willing females they encounter. DNA analysis will determine whether these males produce offspring in these nests and whether, while one male is off visiting his neighbors, other chippies are coming in and mating with his mate.

ON ITS OWN. This juvenile Chipping Sparrow is now independent. Young birds forage in weedy areas in small flocks that slowly increase in size as more young birds and then adults join.

TANAGERS

Scarlet Tanager
male

LEFT
As soon as he arrives on the breeding grounds in spring, the male Western Tanager starts singing his throaty, robin-like song from a high perch to advertise his territorial claim. Pairs may have already formed, since the female often starts building a nest as soon as she arrives. Females sing, too, but usually only after the eggs have hatched.

RIGHT
The Western Tanager nests high in a tree, usually on top of a branch well away from the trunk or hidden in a clump of pine needles. The female builds a flimsy, shallow cup of twigs, grasses, hair, or fine plant fibers and incubates for about 13 days.

Some birds with exceptionally brilliant, conspicuous plumage elude detection and maintain their privacy right in our midst. American tanagers, like most other neotropical migrants — birds that winter in the tropics and breed in North America — migrate at night when hawks and falcons sleep. Cooler air and lighter winds make their marathon journey less physically taxing, and they can use the daytime to forage for food.

PAIRING UP AND NESTING

Tanagers arrive on their breeding grounds under cloak of darkness and, despite gaudy feathers, get busy with nesting activities unnoticed by most human observers. Even savvy birders who recognize the burry songs of tanagers (often compared to a robin with a sore throat) may be hard-taxed to find the brilliantly colored singer among the leaves.

By the time they arrive, their hormonal levels are peaking. Males almost instantly start claiming and defending territories. The male Scarlet Tanager's display is the most elaborate, performed from within tree branches below where the female is perched. Opening his wings and stretching his neck forward, he makes his brilliant red back appear as long and large as possible to contrast with his black wings and tail.

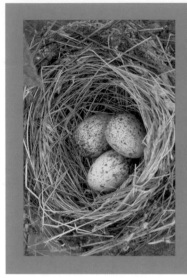

PENTHOUSE SUITE

A rare sight, this Summer Tanager nest contains three eggs. The nest is an open cup of dry grass or other plant fibers, located high in a cluster of leaves or the fork of a horizontal branch, often hanging over a road, dry creek bed, or other opening.

NESTING

In all three tanager species, the female takes three or four days to build the nest. Males don't assist but sing frequently and bring the female food, reinforcing their pair bond, just as a human who isn't good at home improvement projects might play music and bring pizza for the spouse doing the work.

Tanager nests are typically set so high in trees, in branches away from the trunk, that they are hard to observe, and so there are gaps in our data. We know that Scarlet and Summer Tanagers start incubating the eggs as soon as the last egg is laid; that's probably true of Western Tanagers too.

PARENTING

Males make frequent food runs while the females incubate. The eggs hatch in 13 or 14 days. The chicks have a bit of fuzzy down and their eyes are sealed shut. If one is suddenly touched, or if the nest is tapped (as by a parent alighting on it), the chick pops up, mouth open, like a little jack-in-the-box. Usually both adults feed the young, though some males give food to the female to pass to the chicks. Feeding bouts start at first light and continue all day, about every 10 or 15 minutes.

Scarlet Tanagers arrive right as trees are starting to leaf out. Males have only a few days to claim a territory before females arrive, and try to attract their mate before the foliage grows dense, blocking the females' view. Fortunately, females make fast decisions and quickly get down to business.

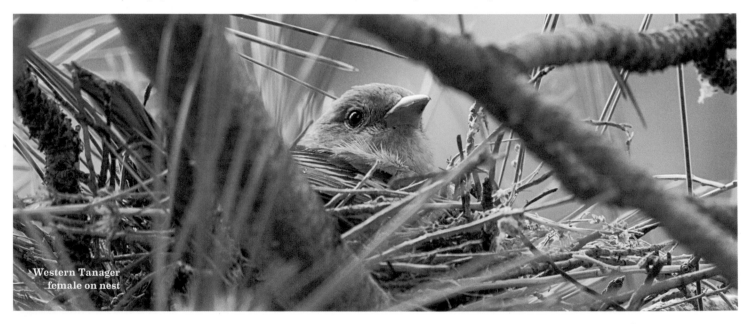

Western Tanager female on nest

THE FAMILY LIVES OF SELECTED SPECIES

Tanagers eat a lot of fruit, in both the tropics and the north, but during nesting season need a lot of protein, which they get from insects and other small invertebrates. The Summer Tanager specializes in bees and wasps. Its bill, longer than that of its relatives, may help protect its face from stings when it snatches large wasps. All three tanager species catch caterpillars and other insects with ease. Tanagers catch the bulk of their meals high in leafy trees, where they conduct most of their activities.

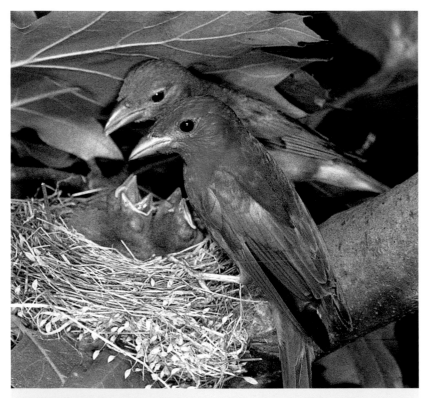

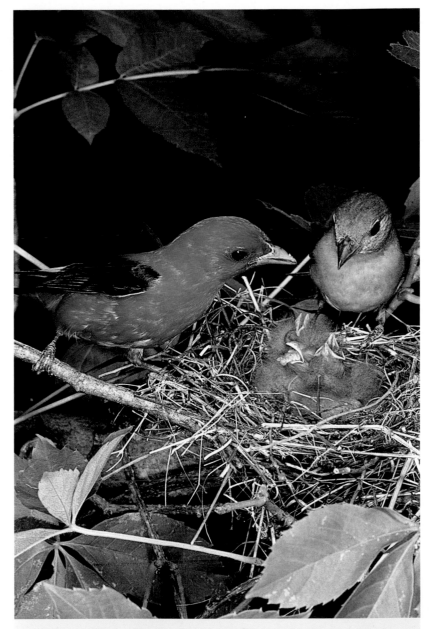

NEWLY HATCHED. A Summer Tanager pair at their nest with begging nestlings. Altricial, the young depend entirely on their parents for food and protection. Their eyes remain closed for five to six days after hatching, and their gapes are edged with yellow flanges.

FEEDING TIME. This Scarlet Tanager pair has just fed one of three nestlings. The young have sparse grayish down on their orange skin, yellow gapes, and closed eyes.

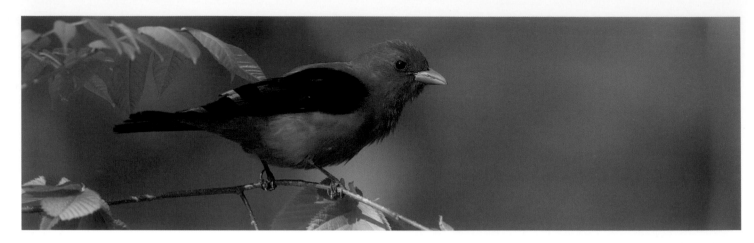

Male Scarlet Tanagers molt into brilliant red feathers in late winter in the tropics. They molt into yellow feathers after breeding, between July and September.

The nestlings grow quickly. Pinfeathers start erupting by the second day, and their eyes start opening on about their fifth day. By seven days old, their feet are strong. If a predator scares them out of the nest at this point, they may be able to survive if they land on a branch or can hop into a low shrub, because their parents will hear their begging sounds and continue to feed them even off the nest. Their chances of surviving grow each day that they safely stay in the nest; the luckiest don't leave until 12 days old.

FLIGHT PATH
When the young birds fledge, they remain on their parents' territory and continue to be fed by them for at least a couple of

> *Many nocturnal migrants have also been shown to have tiny bits of magnetite in their brains, giving them an actual built-in compass.*

weeks. At first they're poorly coordinated and sit quietly, preening their still-developing feathers and studying the world around them, sometimes snapping at nearby insects. As they begin flying more strongly, they figure out how to find their own food.

LONG-DISTANCE TRAVELERS

How do tanagers learn their migratory routes? Many nocturnal migrants learn star patterns during their nestling and/or fledgling stage. In planetariums, scientists have discovered that nestlings and fledglings of some species identify the star that is always seen in the same place (Polaris, also known as the North Star), and use that to identify north. Many nocturnal migrants have also been shown to have tiny bits of magnetite in their brains, giving them an actual built-in compass. Birds such as tanagers may be depending mostly on star patterns when the sky is visible, and using their built-in compass as a backup.

It's unlikely that tanagers migrate in family units, so the young birds must orient and navigate on their own during their first migration. As do many fruit-eating birds, Scarlet and Western Tanagers associate in flocks on their wintering grounds, so young may figure out where to go and how to survive in the tropics by listening for and observing other tanagers.

THE FAMILY LIVES OF SELECTED SPECIES

8 DAYS OLD. A male Western Tanager passes a beakful of caterpillars and a fly pupa to his mate as they feed their young. Both parents feed the young, but the male sometimes passes the food to the female if both are present. The nestlings' eyes open about **7** days after they hatch.

9 DAYS OLD. Western Tanager nestlings are fed by their father. In addition to larvae, they are fed adult insects as large as dragonflies, and berries, if available.

HOUSEKEEPING. A male Western Tanager removes a fecal sac from the nest. For the first 4 days after hatching, the adults eat the fecal sacs, then switch to carrying them away. Older nestlings defecate over the edge of the nest, and their parents grab the sacs so they won't attract predators.

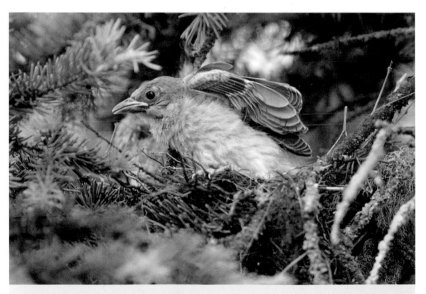

READY TO FLEDGE. A 10-day-old Western Tanager nestling tries out its wings while standing on the nest rim. These young fledged the day after the photo was taken.

 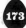

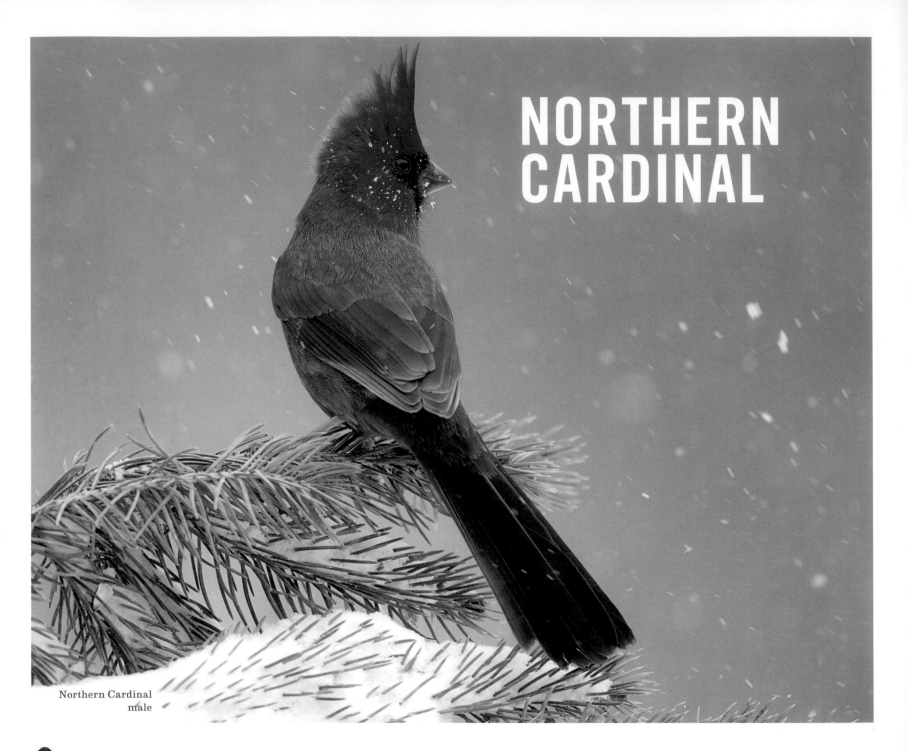

NORTHERN CARDINAL

Northern Cardinal
male

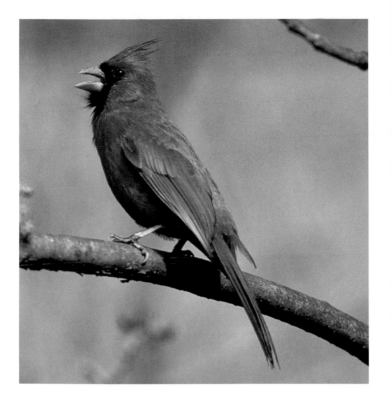

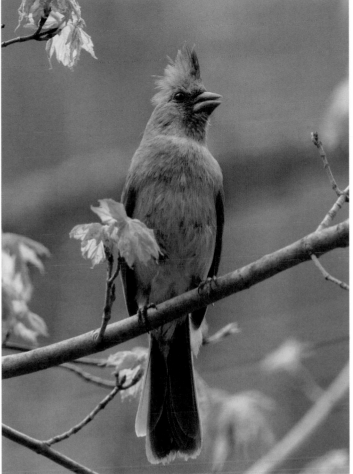

One of the most beloved and recognizable of all songbirds, Northern Cardinals delight us with their beauty and rich whistles. They've been designated the state bird by seven states, more than any other bird. Many sports teams have taken their name, though tipping the scales at just 1.5 ounces (43 g), cardinals couldn't budge a baseball or football; they might have trouble even manipulating a ping-pong ball.

PAIRING UP

Cardinals are non-migratory and spend the winter with their most recent offspring and neighboring cardinals in loose, fluid flocks. In late winter, some male cardinals leave their winter flock to claim a territory; soon their past mate or a new one will join them. On their breeding territory, males chase off other males and females chase off other females; neither helps its partner expel an intruder of the opposite sex. Singing is often enough to keep other cardinals from intruding on an established territory; displays and chases occur more frequently on a new territory that two different birds both want.

LEFT
A Northern Cardinal male sings. Male cardinals are among the first birds to start singing each year, beginning in late winter. The song is a loud series of clear whistles, sweeping upward or downward. Some songs have two parts, often speeding up and ending in a slow trill. They sound like *cheer, cheer, cheer* or *birdie, birdie, birdie.*

RIGHT
The female Northern Cardinal is one of just a few female North American songbirds that sing. The pair sings back and forth while touring potential nest sites. Later in the nesting cycle, the female may sing while incubating, possibly telling the male when to bring her food.

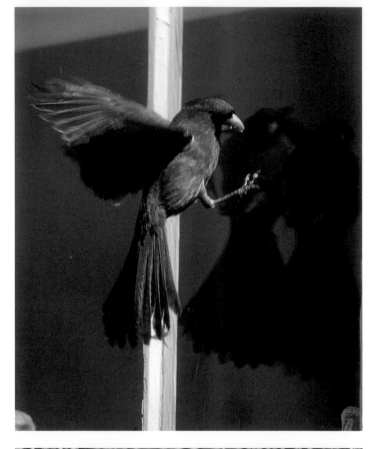

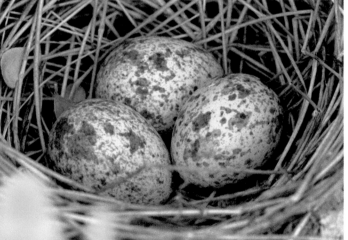

Cardinals sometimes fight, in the air or on the ground, grappling with feet and striking with beaks. Tussles last a few seconds. Like robins, some cardinals wage battle at our windows, the conflict escalating as the image reflects back their aggressive attitude. The best solution is to cover the window from the outside, at least where the bird sees itself.

NESTING

Once a pair has been on territory and shrubs are greening up, nest-building begins. In a charmingly simple ritual, the two examine the nest site: she fluffs her feathers and turns, he follows, and both birds call and manipulate nesting materials with their bills. They may try many sites over a period of two weeks before she selects one and starts building a nest.

The female does the building; the male contributes nesting materials and feeds her as she works. She uses her thick, powerful bill to crush twigs, bending them around her body to shape them, and forms the cup with her body and feet. She normally completes construction in three to nine days, but during spells of bad weather may take two to three weeks. The nests are sturdy and don't fall apart readily. Cardinals use each nest for one brood only, but one study suggested that empty nests remaining on a territory deter predation.

The female starts laying eggs within eight days of completing the nest, sometimes the very next day. She begins incubating the day she lays her last egg, though she may sleep on the nest before that. She alone has a brood patch. The male sometimes sits on the nest, but his role may be to guard the eggs rather than to keep them warm. He brings food to the female while she's both on and off the nest.

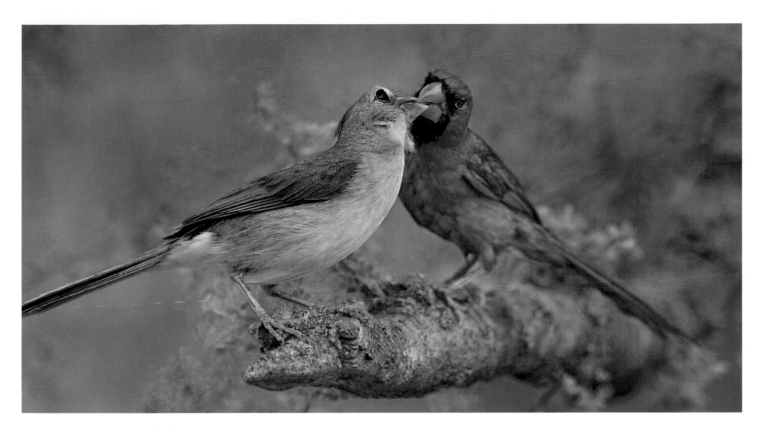

A courting male
Northern Cardinal
feeds his mate.
Some pairs stay
together through
the winter, either
on their breeding
territory or in
flocks. As the
nesting season
approaches, the
male performs
courtship displays
and feeds the
female, a pair-
bonding behavior
that becomes more
frequent as she
prepares to
lay eggs.

Unlike most songbirds, both male and female cardinals sing. Females often sing on the nest, which may help males know when to bring them food. Mated pairs share many song phrases: female songs may be slightly longer and more complex than those of males, especially when on the nest.

Cowbirds parasitize a very high proportion of cardinal nests. In one study spanning several years in southern Ontario, 71 to 100 percent of nests checked between April 30 and July 2 had cowbird eggs or nestlings in them.

Incubation lasts 11 to 13 days. A bump appears on the shell before the egg is pipped. It usually takes over 12 hours for an egg to hatch after pipping, but in one case, it took only 20 minutes from the first break in the shell for the chick to emerge and the female to carry off the shell. Usually all the eggs in a clutch hatch on the same day.

PARENTING

Newly hatched nestlings' eyes are closed, but they can hold up their heads and open their mouths soon after hatching. They are very still when being brooded or when the parents are away from the nest, but instantly stretch up and gape if the nest is disturbed. By eight days old, they are alert and can be frightened off the nest. If undisturbed, they usually fledge when nine or ten days old, but sometimes not until thirteen days old.

Research has found a significant relationship between plumage color and parental care. Males with bright breast plumage and females with brightly colored underwings bring a greater proportion of food for their nestlings than duller-colored cardinals. The brighter the color on both males and females, the more often they feed their young.

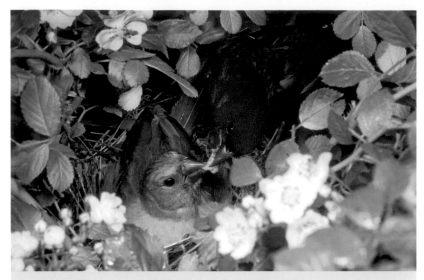

LADY IN WAITING. A male feeds an incubating female on the nest. She incubates for 11 to 13 days, while he brings her food. Sometimes she sings from the nest, which may coordinate his feeding visits. He keeps feeding her while she broods the nestlings; she transfers food to the young.

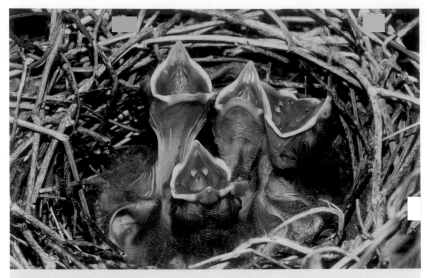

HUNGRY FOURSOME. A few days old, four Northern Cardinal nestlings beg, showing their red gapes edged with whitish yellow. Notice the little arrow-like protrusions on the back of the tongue, which help direct food down the throat. Their skin is a translucent yellow.

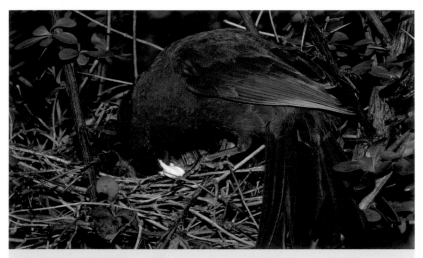

HOUSEKEEPING. A male cardinal picks up a fecal sac. Both parents remove fecal sacs, females more often than males. At first, the adults eat the sacs (which contain useful nutrients that newborn digestive systems cannot absorb). After about 5 days, the adults carry the sacs away from the nest and drop them.

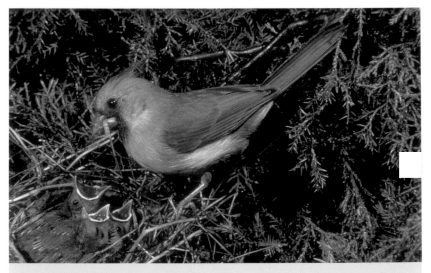

GROWING UP. A female Northern Cardinal brings a green caterpillar to feed one of three begging nestlings. The nestlings are fed mostly insects, including beetles, caterpillars, grasshoppers, and cicadas, with small amounts of seeds and other plant food.

FLIGHT PATH

Newly fledged cardinals are extremely vulnerable to cats. If they don't fledge prematurely, they can fly short distances, but they aren't strong fliers for a few days more.

Both parents feed them for 10 days or so after they've fledged. After that, if there are one or two fledglings, the male feeds them on his own while the female starts a new nest. If there are more, she remains with them longer before starting a new nest. Cardinals may produce eggs in as many as six nests in a single season, but most of these are replacements after predation or nest destruction.

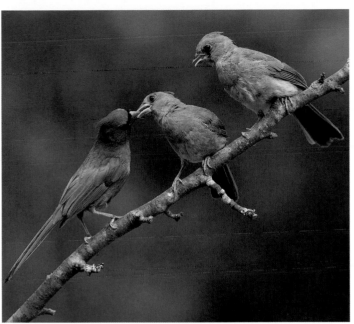

TOP
A Northern Cardinal male feeds one of two fledglings more than two weeks after they left the nest. Broods raised late in the season receive food longer than those fledging earlier in the summer.

BOTTOM
A male juvenile cardinal, molting into adult plumage, resembles an adult female except for browner wing feathers. Juvenile males often have some red on breast and flanks. The bill will be orange by winter.

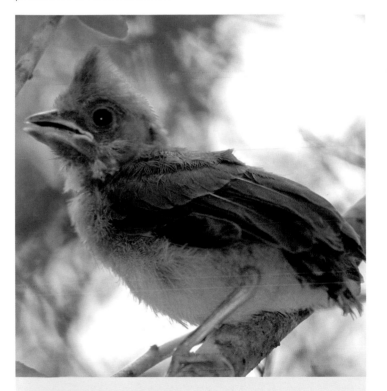

NEWLY FLEDGED. This fledgling has a small crest, very short wings, and almost no tail. The adults may encourage chicks to fledge by tempting them with food or by making chip calls. The fledglings can fly only short distances at first, and for the first week, they rarely move from the branches where they first fledged. Their parents feed them up to eight times an hour.

BLACKBIRDS
AND
ORIOLES

Red-winged Blackbird
male

RED-WINGED BLACKBIRD

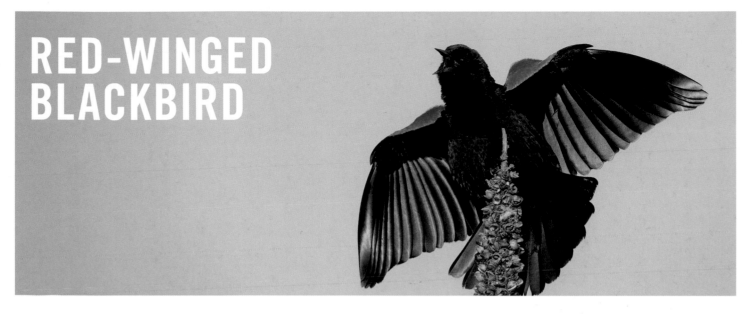

Giving his familiar *conk-la-ree* song, a male Red-winged Blackbird advertises his territory with a song spread, one of several territorial displays given in spring. He sings from a high perch, leaning down to spread his tail and wings and flaring out his scarlet wing patches, or epaulets. The display intensifies when neighboring males are nearby or a female is present.

One of the most abundant songbirds in America, the Red-winged Blackbird is also one of the most aptly named. Only adult males have brilliant red epaulets, or shoulder patches; females and juveniles look rather like sparrows on steroids. Males keep their epaulets mostly hidden when feeding or associating in flocks, displaying them boldly when defending a territory or courting.

PAIRING UP AND NESTING

Male Red-winged Blackbirds provide us with an excellent sign of spring, at least in the cattail marshes where they appear just as ice starts to melt. In the morning, each bird calls and displays his epaulets from his favorite perches and chases and attacks others with relentless vigor as the group works out territorial boundaries. At this point, many marshes are still too frozen to furnish much food, and females haven't yet arrived, so by afternoon, the whole assembly abandons the marsh to feast in fairly peaceable flocks on farm fields and other places where food is available. One of the ways they establish that peace is to keep their bold red epaulets hidden under black shoulder feathers. First thing in the morning, they'll be back to their territorial battles, epaulets fully exposed.

The male red-wing is **polygynous**, meaning he is simultaneously paired to several females. The average number of females on a red-wing's territory is five, but males can attract as many as 15. A very high percentage of nests contain chicks fathered by a male other than the territorial owner. Copulation is difficult to observe due to dense vegetation, but many matings with birds other than the social mate seem to take place while a male is off his own territory and another pays a visit.

Males display in flight and from perches when a new female enters their territory, and the females give chattered calls in response to their mate's song.

Red-winged Blackbirds produce a huge number of loud, easy-to-hear vocalizations, including whistles, squawks, and chatters. The most easily recognized one is their *conk-la-ree* song given by males on conspicuous perches on territory. During the nesting stage, male red-wings constantly make different calls, alerting the females they've attracted to their territory about potential dangers. The speed and variety of his calls tell the females the level of danger. *Check* and *chink* warn of terrestrial predators. A shrill *cheer* and a thin, high-pitched *seeee* warn of aerial predators such as Red-tailed and Cooper's Hawks.

Males don't limit their responses to predators to simple warnings. They take off and divebomb a great many species. A single red-wing can attack a Red-tailed Hawk with such vigor that the hawk turns tail and heads the other way. They're

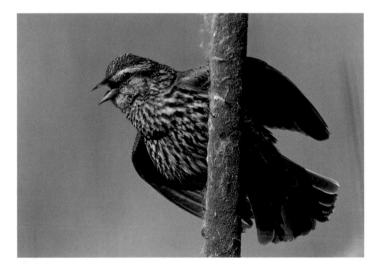

extremely aggressive to anything displaying the color red that crosses their path, as people wearing red shirts, bandannas, or bicycle helmets sometimes painfully discover.

Females start constructing their nest, well hidden in the thick marsh vegetation, almost as soon as they arrive on the territory. Females may be territorial toward other females, but usually the most assertive females focus on the male, trying to strengthen their bond with him to ensure that they'll get the lion's share of his attention. Even if the male doesn't help raise any of the young, females are self-sufficient and can raise a brood entirely on their own.

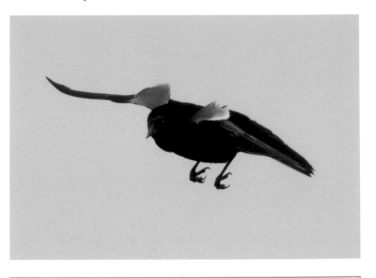

FAMILY SECRETS
COMPARING DADS

The Red-winged Blackbirds that are most successful at attracting females to a high-quality territory can't possibly feed the young of all of their mates. And the amount of care males give their young varies wildly between populations. Barely 6 percent of males fed young at a study site in Washington whereas almost 90 percent did so at a site in Wisconsin. Males are more likely to feed fledged young than nestlings.

Red-wings have smaller broods than most songbirds, averaging just three young. Females re-nest if they lose their brood, but only rarely raise two broods in a single summer.

Even males that don't feed young at all provide essential support to their families, aggressively chasing off potential predators. They're especially conspicuous when chasing crows, ravens, hawks, and eagles.

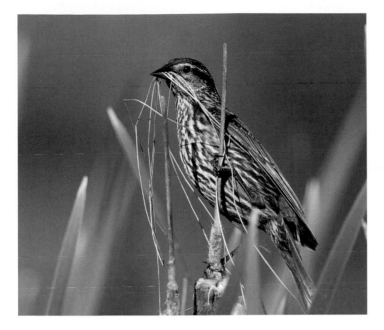

In all American blackbird species, only the female incubates; eggs hatch in an average of 12 to 13 days. Only the female broods the nestlings.

PARENTING

Because the male has several mates, his food contribution at any one nest can be quite variable, sometimes far less than the female's; many males don't feed the young at all. The young are fed a large number of dragonflies and damselflies in marsh habitats, as well as butterflies and moths, flies, grasshoppers, spiders, and other small arthropods. Whichever parent provides a feeding removes any fecal sacs, dropping them over water when possible.

FLIGHT PATH

Blackbirds fledge roughly two weeks after hatching and are independent of their parents within a week or two, and sometimes within days, of fledging. These juveniles quickly join flocks, and the flocks start mixing with flocks of other blackbird species as summer progresses. By fall and winter, blackbird flocks can number in the millions.

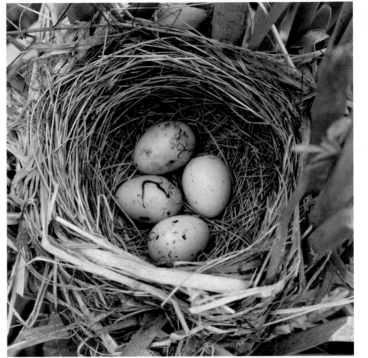

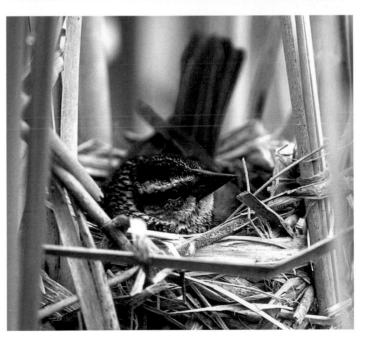

TOP LEFT
A female Red-winged Blackbird carries a beakful of plant stems to build her nest. She winds coarse, wet material around several upright stems to make a platform, adds material on top to make a cup, plasters the inside with mud, and then lines it with fine, dry grasses.

TOP RIGHT
A Red-winged Blackbird nest containing four eggs. Red-wings nest in wetlands and upland habitats, often grouped together. In marshes, the nest is often over water, which helps deter predation. In uplands, it is built low in a shrub or among crop plants.

BOTTOM
A female Red-winged Blackbird incubates in her nest. Meanwhile her mate keeps a lookout for approaching predators. If a predator is detected, males and sometimes females fly up to chase it.

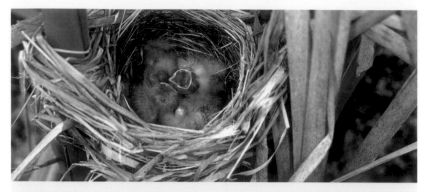

NEWLY HATCHED. Altricial Red-winged Blackbird nestlings hatch with sparse buff or grayish down, eyes closed, and helpless. Their gapes are red, edged with white, with a yellowish spot near the tip of the upper bill.

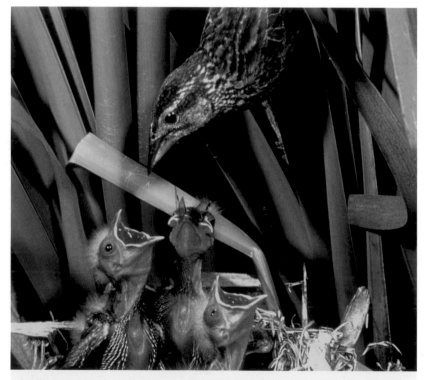

LUNCHTIME. Three Red-winged Blackbird nestlings beg from their mother. The center one has just been fed — the wings of a large insect protrude from its bill. They'll remain in the nest until they're 11 to 14 days old.

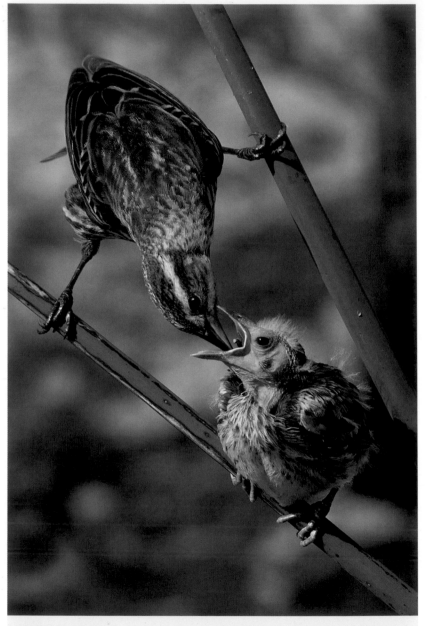

JUST FLEDGED. A female Red-winged Blackbird feeds a caterpillar to a fledgling. Barely able to fly at this age, it stays hidden in the vegetation in its **natal territory** (where it hatched) for up to two more weeks, until it can fly more strongly.

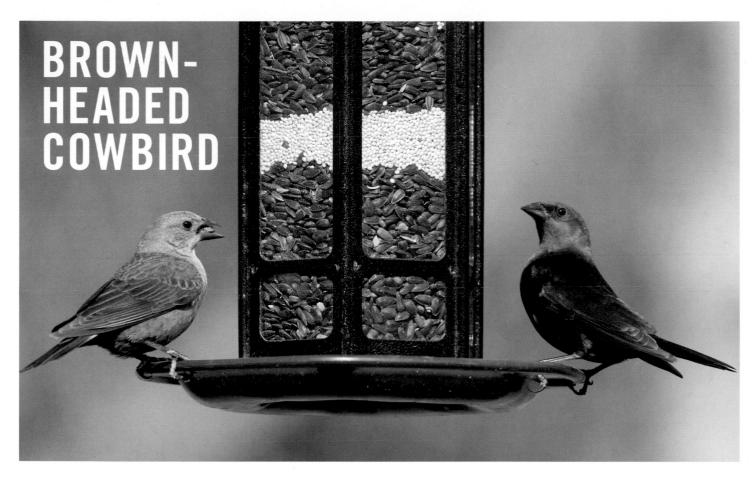

BROWN-HEADED COWBIRD

Brown-headed Cowbird male (R) and female (L) on bird feeder

Rather than claiming a territory and building their own nests, female Brown-headed Cowbirds track other birds doing those things, and deposit their eggs in those nests. These **obligate brood parasites** may quietly watch for nest-building activities, or may fly noisily and alight boisterously, wings flapping, startling nesting birds and thus revealing nest locations. When there are many nests to choose from, cowbirds seem to prefer those with two small eggs.

COWBIRD Q&A

A female cowbird lays one egg each morning, usually before dawn, placing it in the nest of another bird. That female will incubate it, along with her own eggs, and then feed and raise the cowbird chick.

Birds are very protective of their nests, so how do cowbirds get away with this behavior?

Songbirds have a powerful instinct, hormonally driven, to incubate eggs in their nests, even if one is different.

Cowbirds benefit from other birds' behavior. Some older, more experienced female Song Sparrows act aggressively toward female cowbirds, which ironically may make their nests easier for cowbirds to locate than those of inexperienced females.

Cowbirds are fertile far longer than other wild songbirds. Some may produce 40 eggs in a single season.

Cowbirds are far quicker at egg-laying than most songbirds: they typically zip in and out of a nest, leaving an egg behind, in 20 to 40 seconds. One observed cowbird arrived, deposited her egg, and flew off in three seconds flat.

Cowbirds maintain the same number of eggs in the nest by tossing one of the host's eggs, which also reduces the future nestling's competition. Some host birds may count their eggs, possibly in the way that we humans count or by knowing how the clutch feels on the bare skin of their brood patch each day as a new egg is added.

Cowbirds target smaller species. Their eggs are usually larger than the host eggs and so extend a bit above the rest within the nest, so they may receive more heat from the incubating parent than the other eggs do.

Cowbirds develop more quickly within the egg than do most songbirds, often hatching out a day or more before the other chicks, and growing more quickly and to a larger size. Indeed, newly fledged cowbirds are often significantly larger than the adult birds feeding them.

Cowbirds get the lion's share of the feedings. Baby cowbirds do not push out eggs or chicks (European cuckoos do that), nor are they particularly aggressive toward their foster siblings, but their large bodies can inadvertently crush host eggs or nestlings, especially those of tiny species.

DEFENSIVE STRATEGIES
How do birds protect against parasitism?

Cowbird chicks rarely survive longer than three days in American Goldfinch or Cedar Waxwing nests, where nestlings are fed seeds or fruits instead of insect protein.

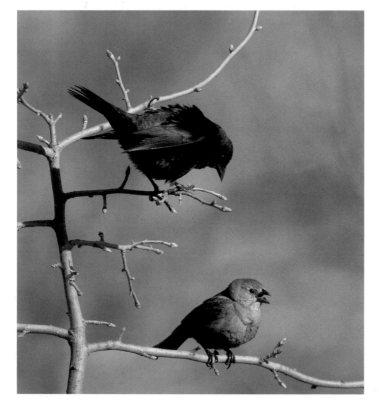

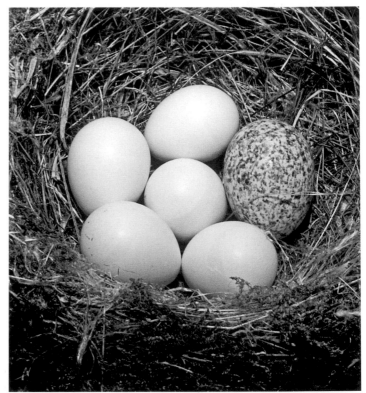

THE FAMILY LIVES OF SELECTED SPECIES

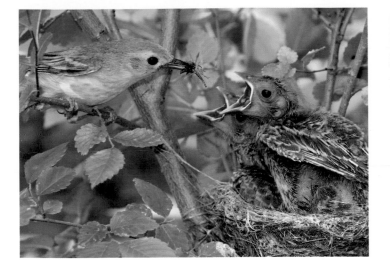

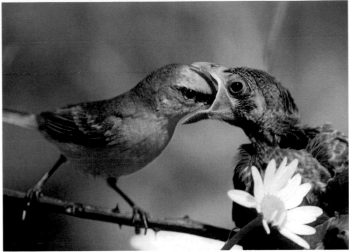

Because the assertive baby cowbird still gets most of the food, however, other hatchlings in that nest are likely to die, too. Fortunately, goldfinches and waxwings nest later in summer than most birds, seldom overlapping the cowbird egg-laying period.

Cowbird eggs are differently colored and noticeably larger than the eggs of most of their host species. Some birds, such as catbirds, can identify the foreign egg, pierce it, and toss it overboard; others, such as Yellow Warblers, can identify the interloper but are too tiny to remove it. Instead they construct a new nest floor on top of the eggs (see page 158) — losing their own eggs in the process.

Why haven't more host birds adopted these defensive strategies?

Cowbirds periodically check on the nests in which they've laid eggs, according to recent studies. If a cowbird discovers an egg missing, it may trash the entire nest.

PAST AND FUTURE

How did cowbirds develop this behavior?

Cowbirds traveled with nomadic American bison, feeding on insects and seeds churned up by hooves in the thick prairie sod. Since the bison constantly wandered, the female cowbird evolved to deposit her eggs in the nests of birds that found food in other ways. As settlers moved in with their livestock and burned off the prairie sod to raise crops, it grew easier for cowbirds to find food and they flourished, expanding their range. Suddenly songbirds that had never before encountered parasitism or developed defensive strategies were raising cowbirds every year.

Why don't cowbirds imprint on the birds raising them? In other words, how do they know they're cowbirds rather than the species they've spent their first weeks with?

Cowbirds demonstrate instinctive behavior at work. When cowbird fledglings can find their own food, they leave their foster family behind and join cowbird flocks. At that point, they no longer associate with the species that raised them.

If they discover an egg missing, they may trash the entire nest.

Female cowbirds reportedly have defended their young against attacking predators, so — although scientists don't know for certain — the nestlings may be exposed to their own species even while in the care of their foster parents. And no matter which species raised a cowbird female, she'll select a wide variety of species to serve as foster parents for her own young.

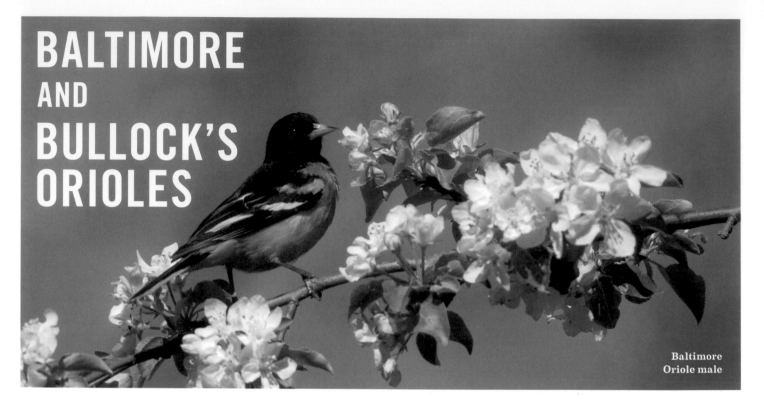

BALTIMORE AND BULLOCK'S ORIOLES

Baltimore Oriole male

Bullock's and Baltimore Oriole plumages share the same colors. Both feed on insects, fruits, and nectar, and both visit bird feeders for sugar water, oranges, and sometimes seeds. Both male and female sing in both species, Bullock's females more than Baltimores. Both weave pendulous, purse-shaped nests from long, fine fibers, placed in large shade trees, usually along streams. Despite all these similarities, the two species are not closely related.

PAIRING UP AND NESTING

The oriole breeding season begins when males return from the tropics to claim territories, singing their loud flute-like songs from the tops of tall trees in open woodlands, orchards, parks, and backyards. The song is made up of short phrases of paired, whistled notes repeated several times. When females return, they, too, sing, often in a duet with their mate. Both sexes also give harsh, chattered calls.

After gathering and combining an unstructured mass of fibers, a female oriole works from what will become the inside of the nest, poking fibers from the inside out and pulling exterior fibers back in with the bill. At times she settles in the bottom of the nest to deepen and shape it with her body, until she has woven a beautiful, gourd-shaped, hanging pouch firmly attached to the surrounding branches. Finally she lines the nest with softer materials such as cottonwood or willow down. Nests take 6 to 15 days to build.

Baltimore Oriole nests tend to be deeper than those of Bullock's and are more often suspended from an inaccessible location such as at the tip of a slender drooping branch. The nests of both species are sometimes fairly visible while under construction early in spring, but soon become surrounded by dense foliage, safely hiding the growing young birds inside.

People are thrilled when birds as beautiful as orioles nest in their yards, so naturally, they want to increase their chances of attracting them. Setting out lengths of dull-colored string, twine, and yarn may help. Orioles seem to prefer the longest lengths they can find, but it's best to offer items six inches or shorter to avoid entanglement.

PARENTING

Nestlings are very quiet for a week after hatching, but then start begging noisily from morning till night, even when the parents are absent, giving loud calls that sound like *dee-dee-dee-DEE*. In both species, both parents feed the young, offering mostly insects during the rapid growth stage before the nestlings are fledged, with increasing amounts of fruit, when available, as fledglings leave the nest.

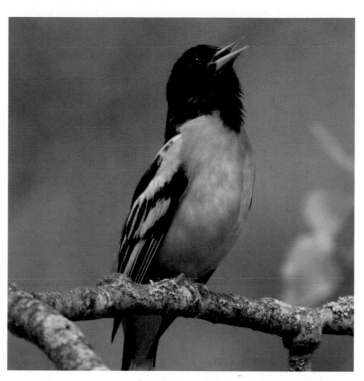

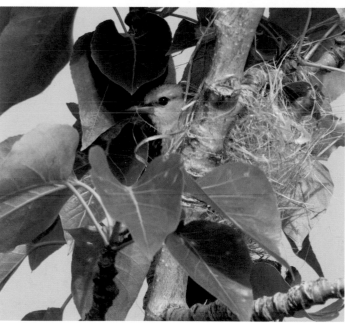

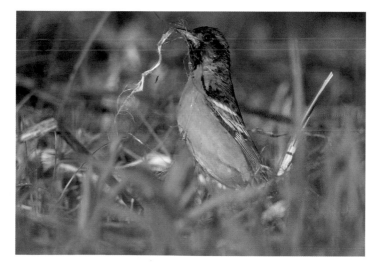

TOP RIGHT
Individual male Baltimore Orioles have characteristic songs by which they can be recognized. Listen carefully, and you may be able to tell if the oriole that returns to nest in your backyard in spring is "your" oriole from the previous year. You may even be able to distinguish your local orioles from those migrating through.

BOTTOM LEFT
A female Baltimore Oriole gathers fine fibers from goldenrod stems for her nest. Other materials may include grasses, shreds of grapevine, other plant fibers, or horsehair, as well as human-made materials such as twine, or yarn — even, in one case, strips of cellophane!

BOTTOM RIGHT
A female Bullock's Oriole sits in her partly finished nest, shaping it with her body. The male may bring nest materials or inspect the nest progress.

TOP
A male Baltimore
Oriole at his nest.
Inside, the female
incubates the
clutch for 11 to 14
days. He closely
attends the nest,
particularly during
his mate's brief
outings to feed
throughout the
day. Sometimes he
feeds her himself.
While she is
absent, he may
peer in to inspect
the nest contents.

BOTTOM LEFT
A female Bullock's
Oriole flies off with
a fecal sac. For
the first few days,
the adults eat the
sacs, which may
contain important
nutrients that
the young birds
cannot yet absorb,
but after that the
adults drop the
sacs some distance
from the nest.

BOTTOM RIGHT
A male Bullock's
Oriole feeds a
caterpillar to a
nestling. Both
parents feed the
nestlings, mostly
insects, including
caterpillars and
the soft parts of
grasshoppers or
dragonflies. Some
fruit is given as it
ripens.

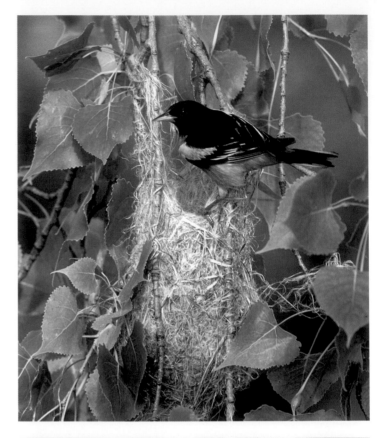

FLIGHT PATH

Baltimore Oriole nestlings fledge when 11 to 14 days old; the whole brood usually leaves together over a few hours. Bullock's remain in the nest a bit longer. In both cases the birds remain with their parents about two weeks more before joining flocks with other orioles.

After nesting, both Baltimore and Bullock's Orioles wander about, during migration and on their wintering grounds, in these loose flocks. A handful of Baltimore Orioles may remain in the South throughout winter, and once in a great while, one visits a bird feeder throughout the winter in one of the central or northern states. Male Baltimore Orioles sing a shorter, less complex song than their breeding song throughout the winter. Once they return to their breeding grounds, males of both species sing most intensely before they attract a mate.

Baltimore and Bullock's Orioles are not closely related. Apparently the similarities trick the birds too, so interspecies pairings still take place, but the young produced virtually never find their own mates and reproduce.

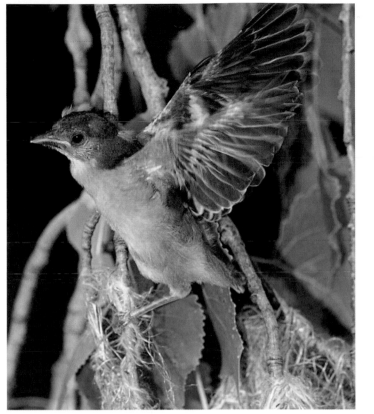

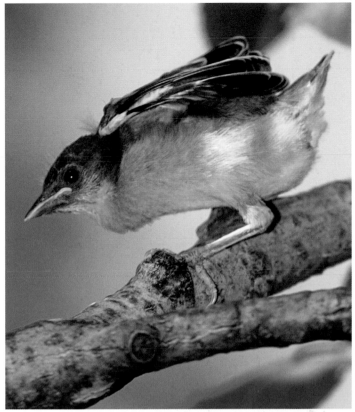

TOP LEFT
A young Baltimore Oriole flaps its wings vigorously before fledging. Orioles can fly short distances upon leaving the nest. Many climb out of the nest and into surrounding branches, where the adults continue to feed them.

TOP RIGHT
A newly fledged Baltimore Oriole flutters for balance as it walks along a branch. It can fly only short distances, but its feet and legs, already adult size, allow it to climb and grip twigs and branches as it moves away from the nest.

BOTTOM
A female Baltimore Oriole feeds a fledgling, which can now fly well. The parents feed juveniles for up to two weeks after leaving the nest, as the family moves away from the breeding territory. Soon the juveniles will form small flocks before migrating.

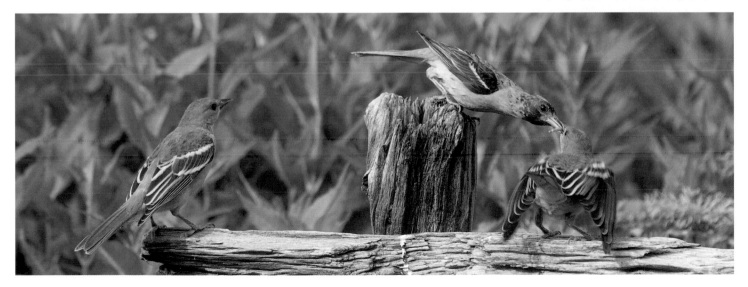

AMERICAN GOLDFINCH

American Goldfinch
male

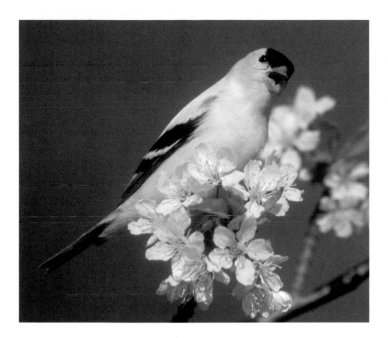

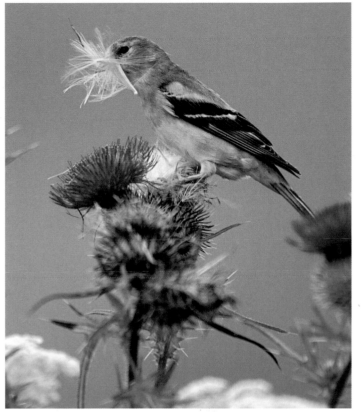

The American Goldfinch is as close to a vegan as any in the world of birds. Throughout the year, goldfinches eat seeds, especially long, delicate ones like those of milkweed and thistle. At feeders, they're especially drawn to nyger or niger (sometimes called thistle), but they're perfectly capable of eating sunflower seeds. Most songbirds feed their young an insect diet, but goldfinch nestlings can thrive on nothing but seeds.

PAIRING UP AND NESTING

Extremely sociable, goldfinches spend much of the year in flocks, and their pair bonds are fluid. Females may mate with more than one male, especially when re-nesting after a nest fails, and even when they successfully raise young together, they are unlikely to select the same male the following year. This may be because males outnumber females, with about eight male goldfinches for every five females. At the time of hatching, the sex ratio is fairly even, but male goldfinches have significantly longer lives than females, skewing the balance.

Displaying males arrive on the nesting territories about two weeks before females do. Males then engage in butterfly flight displays, singing while circling with slow, deep, exaggerated wing beats. As with prairie-chickens, this may draw females to a common area to choose among competing males.

Although they start singing and chasing in late winter, apparently courting, goldfinches nest late in the season, not copulating or producing eggs until spring has ripened into summer.

The male and female search out a nest location together, but the female makes the final choice. She builds the nest, closely guarded by her mate, making a dense, compact cup, lashing it to the supporting twigs with spiderwebs, and lining it with down from the seeds of thistle, dandelion, cattail, or other soft materials. The process takes about six days.

The male and female search out a nest location together, but the female makes the final choice.

The pair copulates frequently during the egg-laying period. Eggs hatch 12 to 14 days after being laid, depending on weather conditions and the female's level of experience. She sits tight while incubating — sleeping, preening, and shifting positions, but remaining on the eggs for up to 90 minutes at a time. The male feeds her on the nest. As he approaches, she makes a high, trilling call; she crouches and flutters her wings, and he regurgitates the goldfinch version of a romantic meal.

PARENTING

Newly hatched goldfinches have just a few wisps of pale gray down on the tops of their heads and bodies. Slits in their closed eyelids develop when they're about three days old; the eyes are completely open within a week. They cannot see their parents at first, but when they feel the slightest vibration at the nest, they instantly pop up and open their capacious mouths while making soft, high-pitched begging calls. At first the male continues to feed the female, and she in turn feeds the nestlings, but within about four days, both parents are sharing duties.

New hatchlings divide their time between sleeping in a crouched position and popping up to gape for food. After they swallow a meal, they poop while a parent is still present to remove it, and then crouch back down. In about a week the chicks grow more active and call more insistently. As they grow more coordinated and curious, they look about, preen, stretch, and back up to poop along the nest rim.

At this point, if an intruder frightens them, they may all flutter to the ground at once. Occasionally some make it to a sheltering shrub, but usually they aren't ready to survive nest departure until they're about 12 days old.

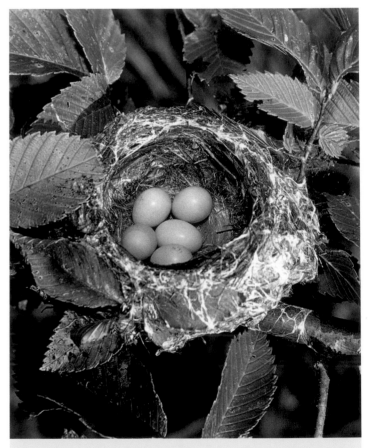

CLUTCH. An American Goldfinch nest with five eggs. The nest is placed in a fork of a shrub or small tree, usually in fairly open habitat such as an abandoned field or hedgerow.

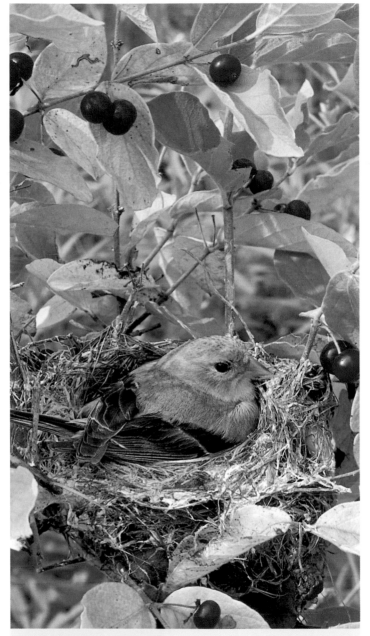

Goldfinches construct their nest from fibers of several weed seeds, especially milkweed and thistle, which also produce the bulk of the food they feed their young. These materials aren't available until summer, so goldfinches must delay nesting far longer than most songbirds. Unlike nearly all American songbirds, goldfinches molt twice a year, their brilliant yellow and black plumage coming in during late winter. Molting depletes energy, so the late molt may also explain the goldfinch's late nesting.

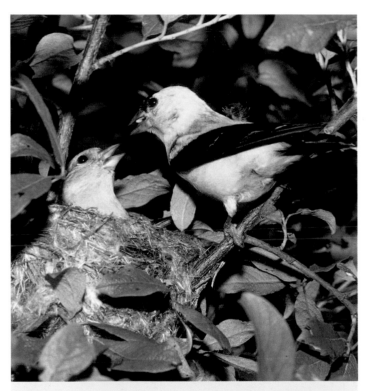

INCUBATION. The female incubates in her nest, surrounded by honeysuckle berries, in late July. It will take 12 to 14 days for the eggs to hatch.

BREAKFAST. An incubating female American Goldfinch calls a high-pitched trill, *tee-tee-tee-tee*, as her mate arrives to feed her.

By the time goldfinches start nesting, most cowbirds have finished laying eggs. A cowbird hatchling won't survive long in a goldfinch nest because it requires much more protein than goldfinches provide. Sadly, newly hatched cowbirds are so voracious that if one does hatch in a goldfinch nest, it gets the lion's share of the feedings until it succumbs; by then, most or all of the goldfinches in that nest have died, too.

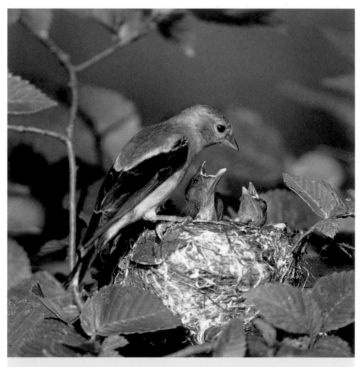

A FEW DAYS OLD. Goldfinch nestlings beg from their mother. For the first few days after hatching, the mother broods them closely while her mate brings all the food. But as the nestlings grow in size and appetite, both parents must feed them.

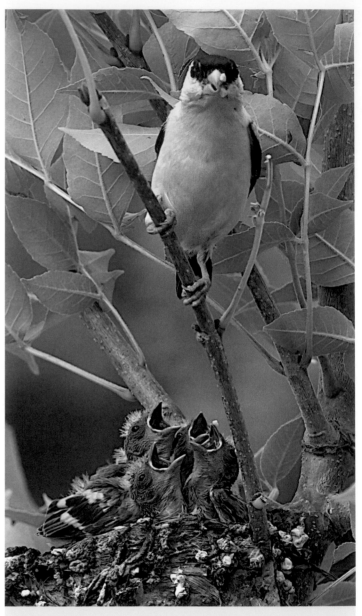

10–12 DAYS OLD. A male goldfinch perches above his nest with seeds for the begging nestlings. If undisturbed, the young birds may stay in the nest another week. By now, the parents no longer remove the nestlings' droppings, which accumulate around the rim of the nest.

ON THE MENU

Parent goldfinches feed their young by regurgitating semi-digested seeds in a slurry the consistency of cake batter, strained baby food, or soft cookie dough, the texture changing as the young birds grow more capable. An emergence of mayflies or other event that makes insects especially abundant may lead goldfinch parents to supplement their feedings with insects, but seeds are the primary diet.

FLIGHT PATH

Fledgling goldfinches remain dependent on their parents for about three weeks. Most goldfinch pairs produce only one brood per season, but experienced females sometimes re-nest soon after their first brood fledges, leaving childcare of the first brood to the fathers as they find a new mate for the second. Because there are significantly more male than female goldfinches, finding a new mate is fairly simple for the females.

Within a few days of leaving the nest, chicks start to pick up food items, and within a couple of weeks are foraging successfully. They gravitate to other goldfinches, and soon are associating with other juveniles and adults in flocks. As more fledglings join them and more and more adults complete their own nesting cycles, the flocks grow larger.

Goldfinches are will-o-the-wisps in the bird world — abundant in one area one winter and completely absent the next. Birds with such unpredictable migratory behaviors are called **irruptive**. Even in dull winter plumage, any day with goldfinches at our feeders feels golden, indeed. In early spring, as brilliant feathers start emerging through dull plumage, we are assured that new goldfinches will soon be arriving on this lovely little planet we all call home.

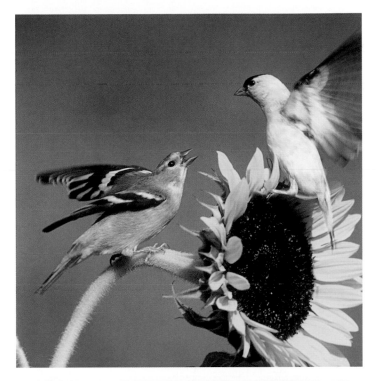

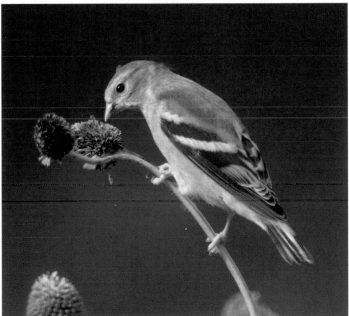

TOP
An American Goldfinch fledgling flutters its wings, begging to be fed by its father at a sunflower. Goldfinch fledglings follow their parents to feeding areas, including backyard bird feeders, giving relentless begging calls that sound like *chup-ee, chup-ee*.

BOTTOM
A juvenile American Goldfinch feeds at a seed head of cutleaf coneflower. Buff rather than white wing bars, and some telltale wisps of down on its head, identify it as a juvenile. Within a week of fledging, young goldfinches start pecking and probing at spent flower heads and weeds gone to seed, gradually foraging entirely on their own.

NESTING FACTS AT A GLANCE

When you hear a courting song in midsummer, you may wonder if that bird is still seeking a partner or simply passing through on its way south. If you find a nest with eggs, you may want to identify the inhabitants. Here are range maps and nesting data to help you understand where these 49 species reside, how many broods they produce, and what a clutch of eggs will look like. As you'll see, even closely related bird species can have different nesting habits and distinct breeding ranges.

MALLARD

TYPICAL CLUTCH SIZE:
5–11

EGGSHELL COLOR:
Creamy or greenish buff

BROOD(S) PER SEASON:
1–2

SPECIES DESCRIPTION:
P. 28

GREAT BLUE HERON

TYPICAL CLUTCH SIZE:
2–6

EGGSHELL COLOR:
Pale blue

BROOD(S) PER SEASON:
1–2

SPECIES DESCRIPTION:
P. 34

RED-TAILED HAWK

TYPICAL CLUTCH SIZE:
1–5

EGGSHELL COLOR:
White or buff with brown or purple speckles

BROOD(S) PER SEASON:
1

SPECIES DESCRIPTION:
P. 40

BALD EAGLE

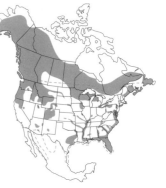

TYPICAL CLUTCH SIZE:
1–3

EGGSHELL COLOR:
Dull white

BROOD(S) PER SEASON:
1

SPECIES DESCRIPTION:
P. 40

TURKEY VULTURE

TYPICAL CLUTCH SIZE:
1–3

EGGSHELL COLOR:
Creamy white tinged with blue or green and with purple to brown spots.

BROOD(S) PER SEASON: 1

SPECIES DESCRIPTION: P. 40

KILLDEER

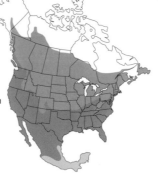

TYPICAL CLUTCH SIZE:
4

EGGSHELL COLOR:
Buff with blackish brown markings

BROOD(S) PER SEASON:
1–3

SPECIES DESCRIPTION:
P. 46

HERRING GULL

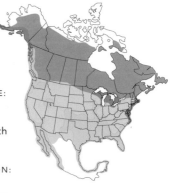

TYPICAL CLUTCH SIZE:
1–3

EGGSHELL COLOR:
Light olive or buff with darker splotches or speckles

BROOD(S) PER SEASON:
1

SPECIES DESCRIPTION:
P. 52

ROCK PIGEON

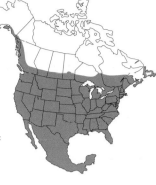

TYPICAL CLUTCH SIZE:
1–3

EGGSHELL COLOR:
White

BROOD(S) PER SEASON:
1–6

SPECIES DESCRIPTION:
P. 58

MOURNING DOVE

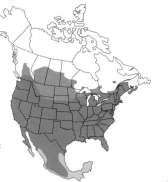

TYPICAL CLUTCH SIZE:
2

EGGSHELL COLOR:
White

BROOD(S) PER SEASON:
1–6

SPECIES DESCRIPTION:
P. 58

GREAT HORNED OWL

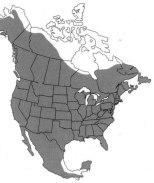

TYPICAL CLUTCH SIZE:
1–4

EGGSHELL COLOR:
Dull white

BROOD(S) PER SEASON:
1

SPECIES DESCRIPTION:
P. 64

RUBY-THROATED HUMMINGBIRD

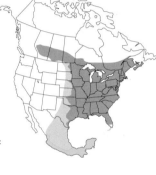

TYPICAL CLUTCH SIZE:
2

EGGSHELL COLOR:
White

BROOD(S) PER SEASON:
1–2

SPECIES DESCRIPTION:
P. 70

ANNA'S HUMMINGBIRD

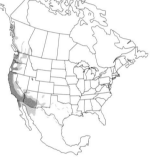

TYPICAL CLUTCH SIZE:
2

EGGSHELL COLOR:
White

BROOD(S) PER SEASON:
2–3

SPECIES DESCRIPTION:
P. 70

RUFOUS HUMMINGBIRD

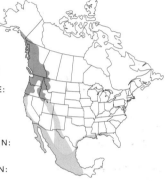

TYPICAL CLUTCH SIZE:
2

EGGSHELL COLOR:
White

BROOD(S) PER SEASON:
1

SPECIES DESCRIPTION:
P. 70

DOWNY WOODPECKER

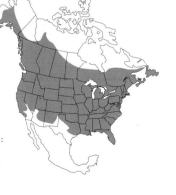

TYPICAL CLUTCH SIZE:
3–8

EGGSHELL COLOR:
White

BROOD(S) PER SEASON:
1

SPECIES DESCRIPTION:
P. 76

HAIRY WOODPECKER

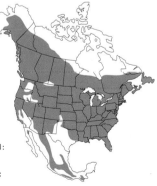

TYPICAL CLUTCH SIZE:
3–6

EGGSHELL COLOR:
White

BROOD(S) PER SEASON:
1

SPECIES DESCRIPTION:
P. 76

KEY:

SUMMER

YEAR-ROUND

WINTER

MIGRATION

NORTHERN FLICKER

TYPICAL CLUTCH SIZE:
5–8

EGGSHELL COLOR:
White

BROOD(S) PER SEASON:
1

SPECIES DESCRIPTION:
P. 82

PEREGRINE FALCON

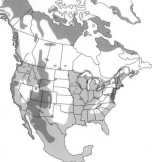

TYPICAL CLUTCH SIZE:
2–5

EGGSHELL COLOR:
Creamy to brownish
with brown, red, or
purple blotches

BROOD(S) PER SEASON:
1

SPECIES DESCRIPTION:
P. 86

EASTERN PHOEBE

TYPICAL CLUTCH SIZE:
2–6

EGGSHELL COLOR:
white, sometimes with
reddish-brown speckles

BROOD(S) PER SEASON:
1–2

SPECIES DESCRIPTION:
P. 92

BLACK PHOEBE

TYPICAL CLUTCH SIZE:
1–6

EGGSHELL COLOR:
Pure white with light
spots on large end

BROOD(S) PER SEASON:
1–3

SPECIES DESCRIPTION:
P. 92

SAY'S PHOEBE

TYPICAL CLUTCH SIZE:
3–7

EGGSHELL COLOR:
White, sometimes with
reddish spots

BROOD(S) PER SEASON:
1–3

SPECIES DESCRIPTION:
P. 92

BLUE JAY

TYPICAL CLUTCH SIZE:
2–7, usually 3–5

EGGSHELL COLOR:
Pale blue or brown with
brownish spots

BROOD(S) PER SEASON:
1

SPECIES DESCRIPTION:
P. 98

AMERICAN CROW

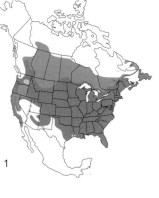

TYPICAL CLUTCH SIZE:
3–9—usually 5

EGGSHELL COLOR:
Pale bluish green;
blotches of brown on
large end

BROOD(S) PER SEASON: 1

SPECIES DESCRIPTION:
P. 104

TREE SWALLOW

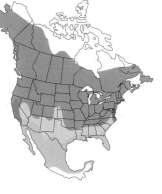

TYPICAL CLUTCH SIZE:
4–7

EGGSHELL COLOR:
Pale pink turning white
within 4 days

BROOD(S) PER SEASON:
1–2

SPECIES DESCRIPTION:
P. 110

BARN SWALLOW

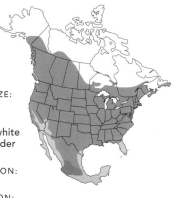

TYPICAL CLUTCH SIZE:
3–7

EGGSHELL COLOR:
Creamy or pinkish white
with brown or lavender
spots

BROOD(S) PER SEASON:
1–2

SPECIES DESCRIPTION:
P. 110

BLACK-CAPPED CHICKADEE

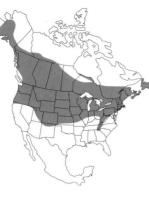

TYPICAL CLUTCH SIZE:
5–9

EGGSHELL COLOR:
White with fine reddish brown spots

BROOD(S) PER SEASON:
1

SPECIES DESCRIPTION:
P. 116

CAROLINA CHICKADEE

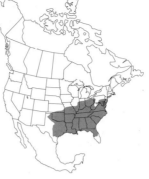

TYPICAL CLUTCH SIZE:
3–10

EGGSHELL COLOR:
White with reddish brown dots or blotches

BROOD(S) PER SEASON:
1

SPECIES DESCRIPTION
P. 116

TUFTED TITMOUSE

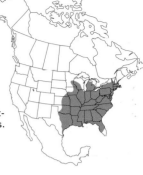

TYPICAL CLUTCH SIZE:
3–9

EGGSHELL COLOR:
Creamy white with chestnut, brown, or lilac spots.

BROOD(S) PER SEASON:
1

SPECIES DESCRIPTION:
P. 116

RED-BREASTED NUTHATCH

TYPICAL CLUTCH SIZE:
2–8

EGGSHELL COLOR:
Creamy or pinkish white with reddish brown speckles

BROOD(S) PER SEASON:
1

SPECIES DESCRIPTION:
P. 122

WHITE-BREASTED NUTHATCH

TYPICAL CLUTCH SIZE:
5–9

EGGSHELL COLOR:
Creamy or pinkish white with reddish brown speckles

BROOD(S) PER SEASON: 1
SPECIES DESCRIPTION: P. 122

HOUSE WREN

TYPICAL CLUTCH SIZE:
3–10

EGGSHELL COLOR:
Whitish or pinkish with reddish brown speckles or splotches

BROOD(S) PER SEASON:
1–2

SPECIES DESCRIPTION:
P. 126

CAROLINA WREN

TYPICAL CLUTCH SIZE:
3–7

EGGSHELL COLOR:
Creamy or pinkish white with fine rusty brown spots

BROOD(S) PER SEASON:
1–3

SPECIES DESCRIPTION:
P. 126

BEWICK'S WREN

TYPICAL CLUTCH SIZE:
3–9, usually 6–8

EGGSHELL COLOR:
White with reddish or purplish spots

BROOD(S) PER SEASON:
1–3

SPECIES DESCRIPTION:
P. 126

KEY:

SUMMER	
YEAR-ROUND	
WINTER	
MIGRATION	

EASTERN BLUEBIRD

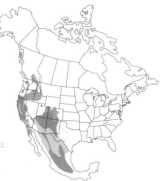

TYPICAL CLUTCH SIZE:
2–7

EGGSHELL COLOR:
Pale blue or, rarely, white

BROOD(S) PER SEASON:
1–3

SPECIES DESCRIPTION:
P. 132

MOUNTAIN BLUEBIRD

TYPICAL CLUTCH SIZE:
4–8

EGGSHELL COLOR:
Paler blue or more bluish white

BROOD(S) PER SEASON:
1–2

SPECIES DESCRIPTION:
P. 132

WESTERN BLUEBIRD

TYPICAL CLUTCH SIZE:
2–8

EGGSHELL COLOR:
Blue or bluish white

BROOD(S) PER SEASON:
1–2

SPECIES DESCRIPTION:
P. 132

AMERICAN ROBIN

TYPICAL CLUTCH SIZE:
2–7; usually 5 in spring, 4 in summer

EGGSHELL COLOR:
Robin's egg blue

BROOD(S) PER SEASON:
1–3

SPECIES DESCRIPTION:
P. 138

NORTHERN MOCKINGBIRD

TYPICAL CLUTCH SIZE:
2–6

EGGSHELL COLOR:
Pale blue or greenish white, splotched with red or brown

BROOD(S) PER SEASON:
2–3

SPECIES DESCRIPTION:
P. 144

CEDAR WAXWING

TYPICAL CLUTCH SIZE:
2–6

EGGSHELL COLOR:
Pale bluish or greenish white with red or brown splotches

BROOD(S) PER SEASON:
1–2

SPECIES DESCRIPTION:
P. 150

YELLOW WARBLER

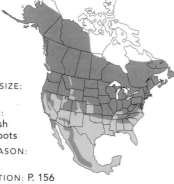

TYPICAL CLUTCH SIZE:
1–7

EGGSHELL COLOR:
Grayish or greenish white with dark spots

BROOD(S) PER SEASON:
1–2

SPECIES DESCRIPTION: P. 156

CHIPPING SPARROW

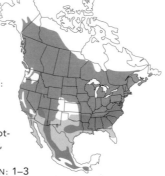

TYPICAL CLUTCH SIZE:
2–7

EGGSHELL COLOR:
Pale blue to white, lightly streaked or spotted with black, brown, or purple

BROOD(S) PER SEASON: 1–3

SPECIES DESCRIPTION: P. 162

SCARLET TANAGER

TYPICAL CLUTCH SIZE:
3–5

EGGSHELL COLOR:
Pale blue or greenish blue with reddish speckles

BROOD(S) PER SEASON: 1

SPECIES DESCRIPTION: P. 168

SUMMER TANAGER

TYPICAL CLUTCH SIZE:
3–4

EGGSHELL COLOR:
Pale blue or green with brown markings

BROOD(S) PER SEASON:
1–2

SPECIES DESCRIPTION:
P. 168

WESTERN TANAGER

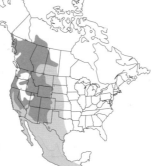

TYPICAL CLUTCH SIZE:
3–5

EGGSHELL COLOR:
Blue or bluish green with gray-brown spots

BROOD(S) PER SEASON:
1

SPECIES DESCRIPTION:
P. 168

NORTHERN CARDINAL

TYPICAL CLUTCH SIZE:
2–5

EGGSHELL COLOR:
Whitish speckled with gray or brown

BROOD(S) PER SEASON:
1–2

SPECIES DESCRIPTION:
P. 174

RED-WINGED BLACKBIRD

TYPICAL CLUTCH SIZE:
2–4

EGGSHELL COLOR:
Pale bluish green to gray with black or brown markings

BROOD(S) PER SEASON:
1–2

SPECIES DESCRIPTION:
P. 180

BROWN-HEADED COWBIRD

TYPICAL CLUTCH SIZE:
Lay their eggs in the nests of other species

EGGSHELL COLOR:
Whitish with gray or brown spots

BROOD(S) PER SEASON:
Produce a maximum of 40 eggs per season.

SPECIES DESCRIPTION:
P. 185

BALTIMORE ORIOLE

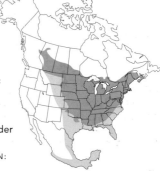

TYPICAL CLUTCH SIZE:
3–7, usually 4 or 5

EGGSHELL COLOR:
pale grayish or bluish white, brown or lavender streaks and blotches

BROOD(S) PER SEASON:
1

SPECIES DESCRIPTION:
P. 180

BULLOCK'S ORIOLE

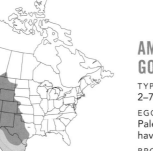

TYPICAL CLUTCH SIZE:
2–7

EGGSHELL COLOR:
Pale bluish or grayish with purplish tint, purplish brown splotches and scrolls

BROOD(S) PER SEASON: 1

SPECIES DESCRIPTION: P. 180

AMERICAN GOLDFINCH

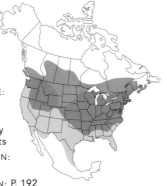

TYPICAL CLUTCH SIZE:
2–7

EGGSHELL COLOR:
Pale bluish white; may have faint brown spots

BROOD(S) PER SEASON:
1, sometimes 2

SPECIES DESCRIPTION: P. 192

KEY:

SUMMER

YEAR-ROUND

WINTER

MIGRATION

GLOSSARY

albumen. Egg white

allopreening. Mutual preening

altricial. Describes chicks that hatch with sparse or no feathers, closed eyes, and no ability to leave the nest for at least a week or two

billing. Gently touching and grasping a mate's bill

brancher. An owlet that leaves the nest and clambers along a branch before it is able to fly

brood patch, incubation patch. A bare patch of skin on a nesting parent's belly that allows transfer of body heat to eggs or chicks

broody. Describes a parent bird's instinct to incubate eggs

cache. To store food

call. A vocalization used year-round to maintain contact with the flock, give an alarm, or communicate within the nest, as distinct from the seasonal song, used for courtship and establishing territory

cloaca. The external opening of the oviduct

clutch. The total number of eggs laid in one nesting stint

cryptic. Colored for camouflage

determinate layer. A female that will produce a certain number of eggs and stop, even if one egg is removed

display. A behavior, characteristic of a species, used particularly by male birds in courtship or defense

egg tooth. A sharp point that develops on a chick's beak while it is still inside the egg, used to break through (pip) the shell from the inside

feather tract. Row of follicles from which feathers will grow

fecal sac. The feces of a hatchling, enclosed in a tiny bundle easy for the parent to remove

fledging. The act of leaving the nest. Usually refers to altricial nestlings, when their eyes are open and they can hop or flit about. Also used to describe the time at which the young bird has finished acquiring its first full set of flight feathers, even though it may not yet be able to fly.

gape. The brightly colored interior of a songbird chick's mouth

gular pouch. A throat sac that may be used for storing food while flying

heronry. A communal nesting area for herons

imprint. A hatchling's instinctive memorization of its parent's features

incubation patch. See brood patch

indeterminate layer. A female that continues laying, replacing any eggs removed from her nest

irruptive. Unpredictable in migratory behavior

mobbing. Grouping together to attack a predator

molt. To shed and replace feathers, usually seasonally

neotropical migrants. Birds that winter in American tropics and breed in North America

nuptial plumes. Specialized feathers displayed during courtship

obligate brood parasite. A bird that lays her eggs in another bird's nest rather than building her own

oviduct. The passageway the egg follows from the ovary to the outside of the body

pinfeathers. Newly emerged feathers that are still enclosed in sheaths

pip. To break a small hole in the shell of the egg, from the inside out

polygynous. Describes a male simultaneously paired to more than one female

precocial. Describes chicks that hatch covered with down, with eyes open, able to follow their parents away from the nest

semi-precocial. Describes chicks that hatch covered with down and with open eyes, but not as mobile and independent as precocial chicks

shaft. A feather's thick central stem

sky dance. An aerial courtship display

song. A vocalization used seasonally, primarily by male birds, for courtship and establishing territory, as distinct from the year-round call

squab. A baby pigeon or dove

talons. A raptor's feet, used for grasping

BIRD ANATOMY

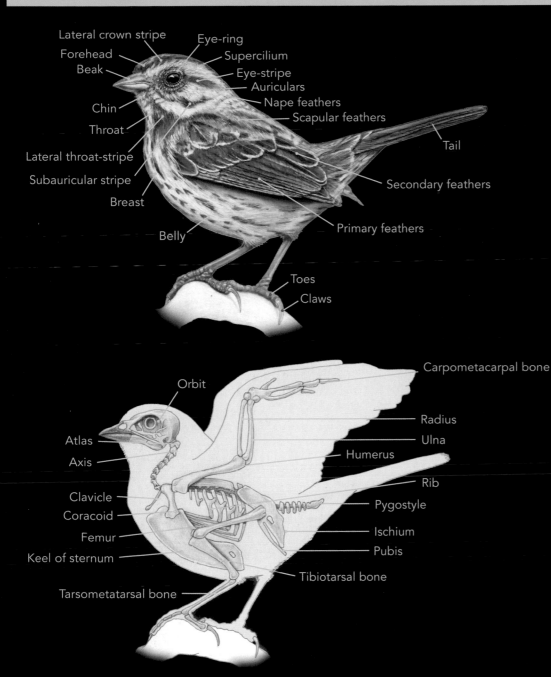

Lateral crown stripe
Forehead
Beak
Chin
Throat
Lateral throat-stripe
Subauricular stripe
Breast
Belly

Eye-ring
Supercilium
Eye-stripe
Auriculars
Nape feathers
Scapular feathers

Tail

Secondary feathers

Primary feathers

Toes
Claws

Orbit
Atlas
Axis
Clavicle
Coracoid
Femur
Keel of sternum
Tarsometatarsal bone

Carpometacarpal bone

Radius
Ulna
Humerus

Rib
Pygostyle

Ischium
Pubis

Tibiotarsal bone

ACKNOWLEDGMENTS

A book is only as authoritative as the writer's resources. Birds of North America Online (the American Ornithologists' Union and Cornell Lab of Ornithology) is the essential reference for up-to-date information about every North American bird. *The Audubon Society Encyclopedia of North American Birds*, by the late John K. Terres, and Arthur Cleveland Bent's *Life Histories of North American Birds* are rich in information not found anywhere else. I also consulted papers and books by professional and amateur ornithologists, too many to list, who study individual species. Miyoko Chu, senior director of communications at the Cornell Lab, reviewed the entire manuscript and made invaluable suggestions. The birds themselves have given me many wonderful glimpses into their private lives, never charging for their time or asking for a modeling fee.

— LE

My husband, Peter Wrege, dedicated biologist and talented handyman, deserves my special gratitude for his constant help and encouragement of my photography career over the years. My sincere thanks go to the many birders, scientists, and bird-loving friends throughout North America who have generously shared information about bird locations, given me logistical help, or offered me access to their properties to photograph birds. Finally, I am forever grateful to the birds themselves. Their lively beauty and fascinating lives have been, and will always be, an endless source of inspiration.

— MR

PHOTO CREDITS

OTHER STOREY TITLES YOU WILL ENJOY

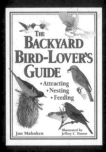

THE BACKYARD BIRD-LOVER'S GUIDE
by Jan Mahnken
This gorgeously illustrated volume is brimming with
information about attracting, enjoying, and under-
standing 135 of North America's most common
species. You'll learn how to feed them, house them,
provide nesting materials, and keep them coming
back year after year. The book includes in-depth pro-
files of individual species with detailed, accurate paintings of birds and
information about their habits, size, breeding range, winter range, habitat,
incubation and nesting periods, preferred foods, and much more.
320 pages. Paper. ISBN 978-0-88266-927-4.

THE BIRD WATCHING ANSWER BOOK
by Laura Erickson
Hundreds of questions answered by the experts at the
Cornell Lab of Ornithology.
400 pages. Flexibind. ISBN 978-1-60342-452-3.

DRAWN TO NATURE
by Clare Walker Leslie
Features a selection of Clare Walker Leslie's jour-
nal pages, arranged to inspire you to do as she
does: look up, look down, look out and around,
bring bits of nature indoors to observe and study,
or take your eyes for a walk around the neighbor-
hood. Using a combination of quick, impressionis-
tic watercolors with more detailed pen and pencil drawings, along with
the written word, Leslie invites you to share in the pleasure of her nature
watching, and to experience the joy of seeing and connecting with
nature wherever you live, amidst the whirl of your daily life.
176 pages. Paper with flaps. ISBN 978-1-58017-614-9.

NATURE JOURNAL
by Clare Walker Leslie
Clare Walker Leslie has transformed what could
have been an ordinary diary into something truly
unique. The text and illustrations offer just the
right amount of inspiration and guidance to help
you begin and succeed at making this book your
own. Short, inspirational quotes and exercises help
guide you through the journaling process.
176 pages. Hardcover. 978-1-58017-296-7.

RAPTOR!
*by Christyna M. Laubach, René Laubach, and Charles
W. G. Smith*
A kid's guide to the birds at the top of the food
chain: eagles, falcons, hawks, kites, ospreys, owls,
and vultures.
128 pages. Paper. ISBN 978-1-58017-445-9.

WHAT'S THAT BIRD?
by Joseph Choiniere and Claire Mowbray Golding
New to birdwatching? With this guide, you'll learn
how birds eat, communicate, and even breathe, as
well as the best ways to observe birds, techniques
for keeping a bird journal, and how to protect
endangered birds. And family-friendly projects,
such as building a nesting platform, a bird arbor,
and a nesting box, enhance your birding experience. The book includes
detailed profiles of 30 common North American birds, featuring family
information, silhouette, habitat, call, size, and general description.
128 pages. Paper. ISBN 978-1-58017-554-8.

**THESE AND OTHER BOOKS FROM STOREY PUBLISHING ARE AVAILABLE WHEREVER QUALITY BOOKS ARE SOLD OR BY CALLING 1-800-441-5700.
VISIT US AT WWW.STOREY.COM OR SIGN UP FOR OUR NEWSLETTER AT WWW.STOREY.COM/SIGNUP.**